Hart Picture Archives

VOLUME 1
A COMPENDIUM

D1232159

Hart Picture Archives

VOLUME 1
A COMPENDIUM

Under the General Editorship of
Harold H. Hart

Hart Publishing Company, Inc. • New York City

COPYRIGHT © 1976, HART PUBLISHING COMPANY, INC.
NEW YORK, NEW YORK 10012

ISBN. NO. 08055-1160-1
LIBRARY OF CONGRESS CATALOG CARD NO. 75-31405

MANUFACTURED IN THE UNITED STATES OF AMERICA

CONTENTS

CONTENTS continued

HOW TO USE THIS BOOK

COMPENDIUM is a collection of 2,228 pictures of many periods, culled from 131 known sources and a few private sources. These pictures have been subdivided into 96 categories.

All of these pictures are in the public domain. They derive from magazines, books, private collections, and pictures copyrighted by Hart Publishing Company, now released to the public for general use.

According to copyright law, all pictures printed before 1907 are now in the public domain. Pictures in this book which were initially published after 1907 derive from uncopyrighted sources, or from publications whose copyrights have been allowed to lapse through failure to renew, or from books released from copyright by Hart Publishing Company.

So as not to clutter a caption, the source of the picture is given an abbreviated designation. Full publication data may be found in the *Sources* section, in which all sources are listed in alphabetical order, with the full title of the book or magazine, the publisher, and the date of publication. The *Sources* section commences on page 379.

Captions appear beneath only those pictures which call for clear identification. For example, "mood-pictures"— depicting anger, horror, grief, etc.—are not captioned; as the Romans put it, *res ipsa loquitor,* the thing speaks for itself.

Thirty-one of the pictures are halftones, and are designated by a square symbol □ at the end of the caption. These pictures too are suitable for reproduction, but the user is alerted to rescreen such a picture or convert it into line. All other pictures can be reproduced directly in line.

This book contains a voluminous index, set forth on page 385. A picture may have several listings in the index. For example, a picture of a cathedral would be listed under the general heading of *Churches, Mosques, & Temples,* and may also be listed under the name of the town or city in which it stands, and perhaps under some special name by which it is known.

All index entries set in full caps represent one of the 96 major groupings in the book.

Hart Picture Archives

VOLUME 1
A COMPENDIUM

Aircraft

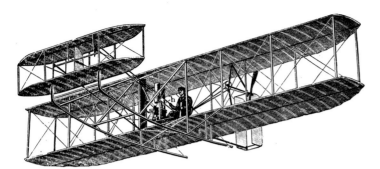

Wright Brothers' airplane, airborne, front view. *Meyers Lexikon*

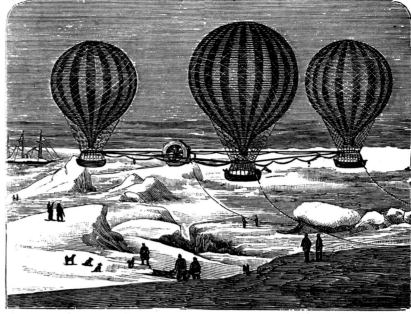

Commander Cheyne's balloons with telegraph attached. *Leslie's, Vol. 16*

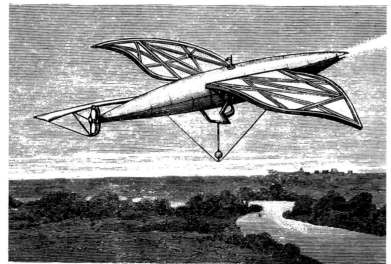

Bangartan and Baranowski's aerial navigator. *Leslie's, 1883*

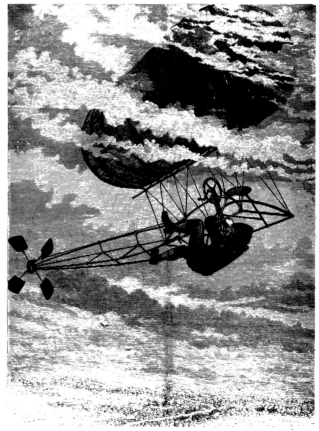

Richell's aerial machine. *Leslie's, 1883*

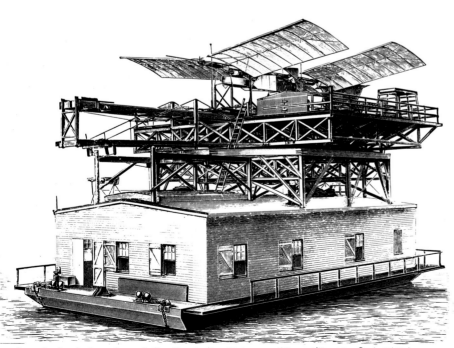

Langley's airplane launch floating in the Potomac River, Washington, D.C. *Meyers Lexikon*

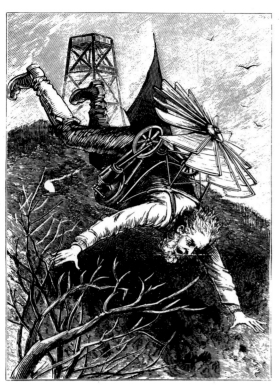

Zephaniah Phelps, a Connecticut inventor, attempting his first aerial trip. *Police Gazette*

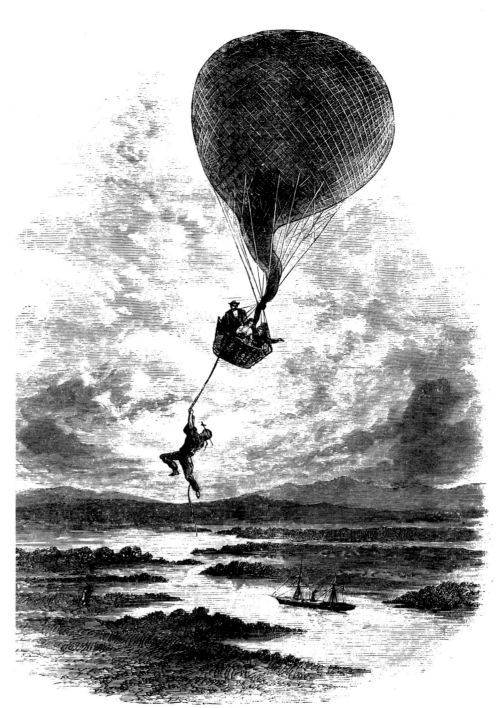

A daring ride. *Leslie's, 1884*

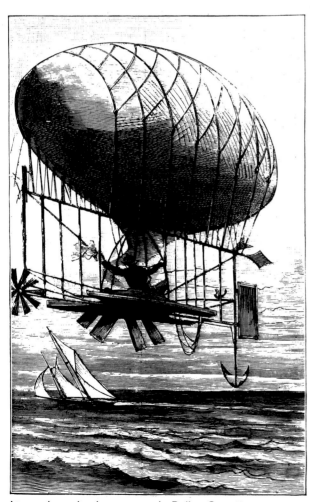

Hogan hovering heavenward. *Police Gazette*

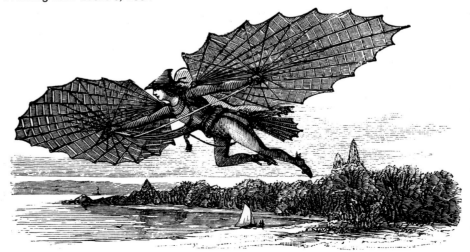

Flying machine invented by Signor Ignazio of Milan, Italy. *Leslie's, 1883*

Aircraft continued

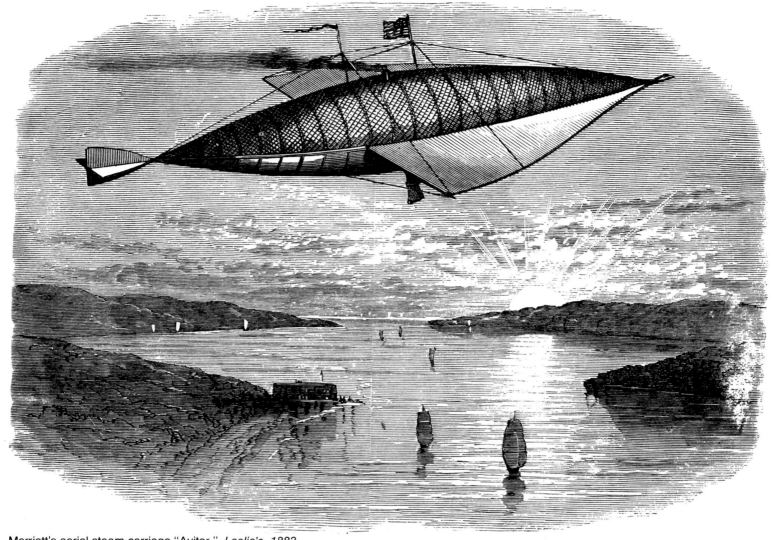

Marriott's aerial steam carriage "Avitor." *Leslie's, 1883*

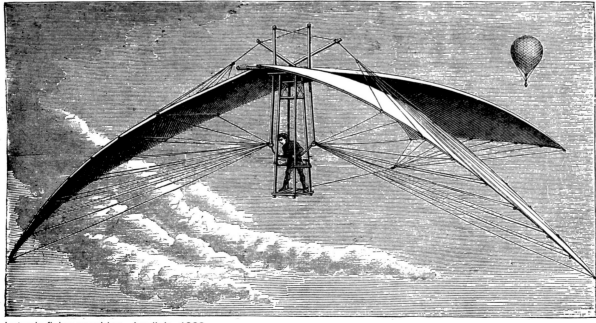

Leturr's flying-machine. *Leslie's, 1883*

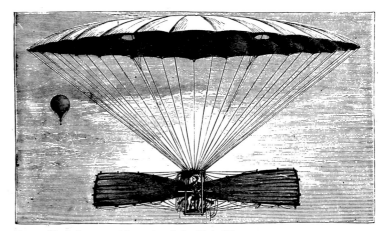

Degroff's flying-machine. *Leslie's, Vol. 17*

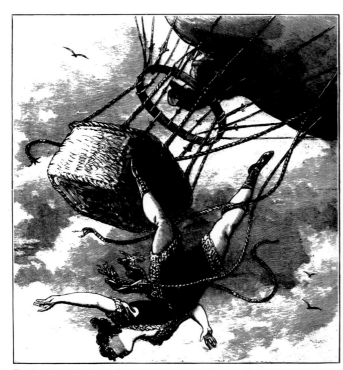

Zoelta Bentley falls from a balloon in Elyria, Ohio, to a terrible death. *Police Gazette*

W. J. Lewis' flying machine. *Leslie's, Vol. 17*

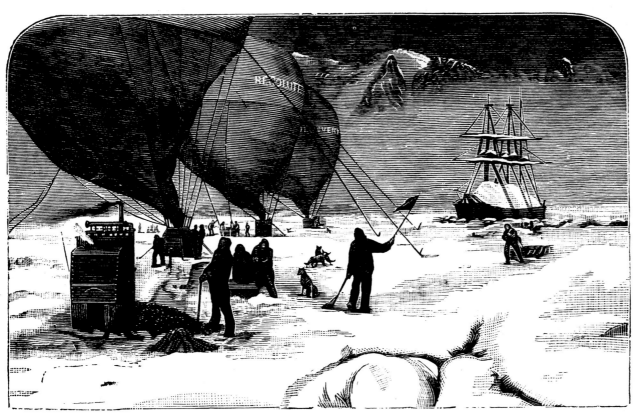

Signor Ignazio's flying-machine folded up. *Leslie's, Vol. 16*

Commander Cheyne's balloon scheme for reaching the North Pole. *Leslie's, Vol. 16*

Anger

Harper's, Vol. 44

Harper's

Leslie's

Police Gazette, 1893

Century Magazine

Police Gazette, 1892

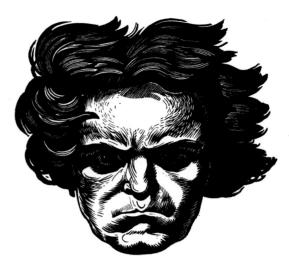

Beethoven. *Fifty Years of Soviet Art*

On a Mexican Mustang

Century Magazine

Architectural Elements

Tympan, 19th century, Cathedral of Clermont-Ferrand. *L'Art Pour Tous, Vol. 13*

Ornamented cornice with pearl beading. *Architectural Styles*

Richly ornamented Roman ovolo. *Architectural Styles*

Squinch. *Century Dictionary*

Rose-molding, 13th century,
Nôtre Dame de Paris.
Century Dictionary, Vol. 8

Quatrefoils from west portal of Amiens Cathedral, France,
13th century. *Century Dictionary, Vol. 7*

Balustrade, Villa d'Este, Tivoli,
Italy. *Century Dictionary*

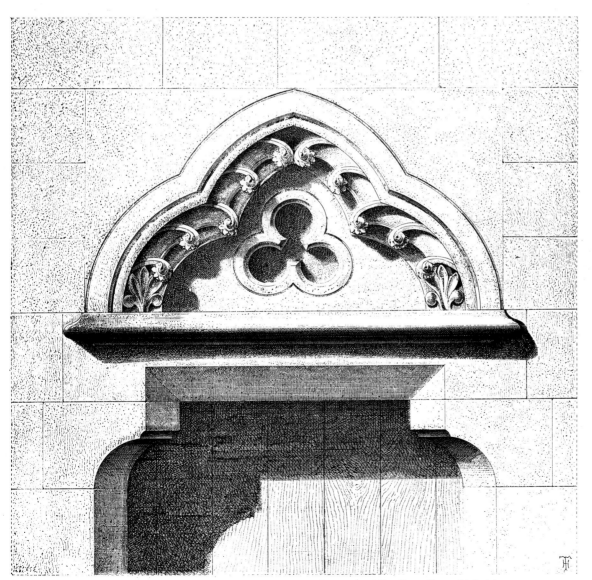

Antefixa, Propylaeum,
Athens. *Architectural Styles*

Stone-sculptured door crowning, 13th century, Cathedral of Rouen. *L'Art Pour Tous, Vol. 14*

Indian pillar, Rock-
Temple of Parasona
Rama, Ellora.
Architectural Styles

Architectural Elements continued

Panelled inner roof, St. Michael's of Coventry, 16th century.
Introduction to Gothic Architecture

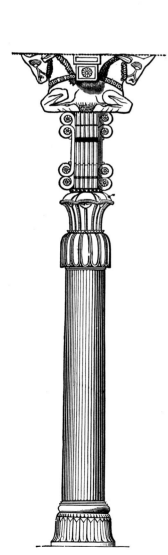

Capital (restored), from the ruins of Persepolis.
Architectural Styles

Ornamented Roman astragal. *Architectural Styles*

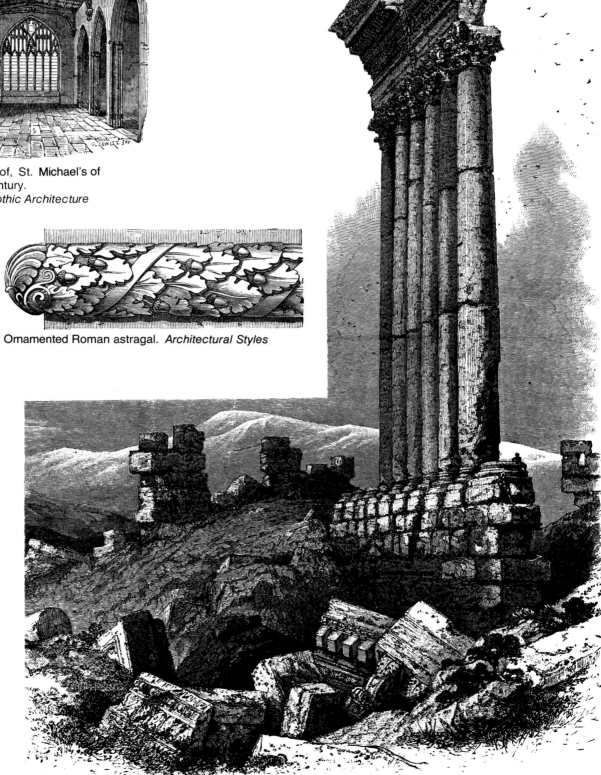

Six columns, Great Temple, Ba'albek. *Picturesque Palestine*

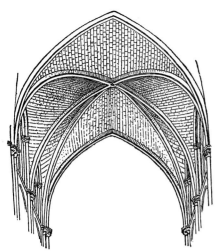

Sexpartite vaulting, nave of Bourges Cathedral, France. *Century Dictionary*

Facade of the Knight's Hall, Castle of Marienburg, Prussia. *Architectural Styles*

Minaret at Cairo. *Architectural Styles*

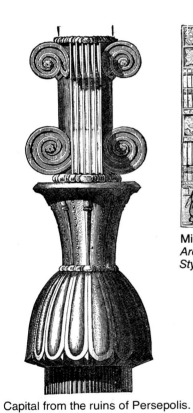

Capital from the ruins of Persepolis. *Architectural Styles*

Chinese pavilion. *Architectural Styles*

Hip-roof with superincumbent domes. *Architectural Styles*

Indian pillar. *Architectural Styles*

Sculptured ornamental border from the ruins of Nineveh. *Architectural Styles*

Part of a parapet in a house, Nuremburg. *Architectural Styles*

Architectural Elements continued

Roof-ridge ornament,
perpendicular style.
Architectural Styles

Door, Mosque of Bou-Medina.

Coved ceiling, Louvre Palace, Paris.
Century Dictionary

Penthouse. *Century Dictionary*

Capitals, 17th century, by J. Berain.
L'Art Pour Tous, Vol. 2

Rampart and arch. *Century Dictionary*

Doorway and oriel in the Penha Verde.
The Aldine

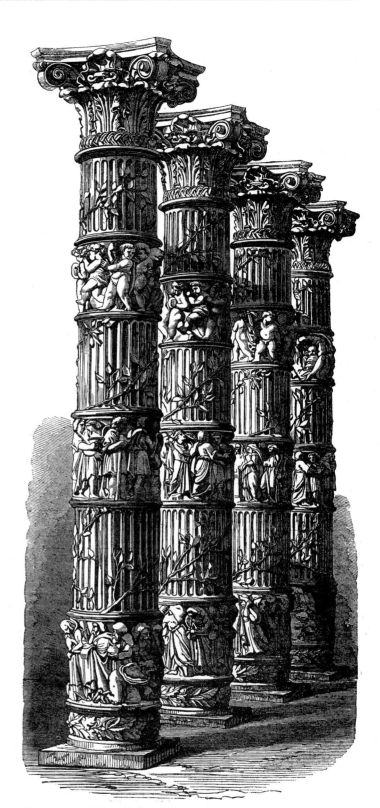

Terra-cotta pillars, S. Kensington Museum, London.
Illustrated London News

Tympanum of doorway, 1130, English. *Zell's*

Arms & Armor

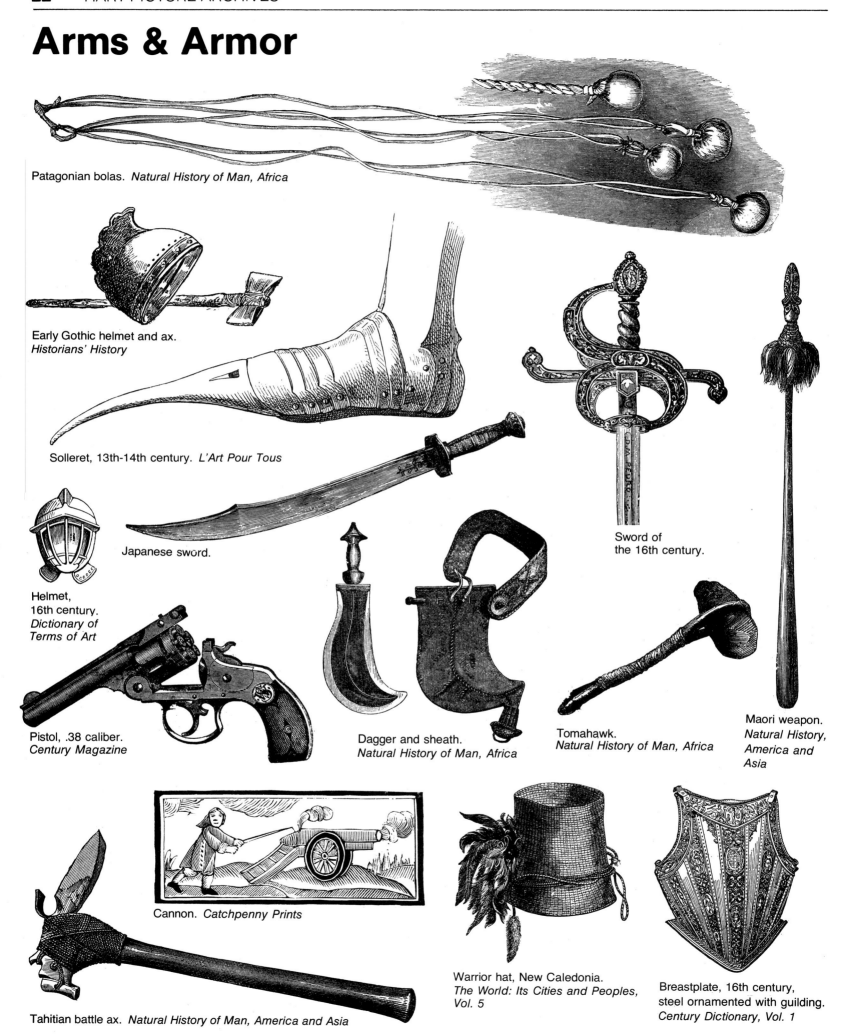

Patagonian bolas. *Natural History of Man, Africa*

Early Gothic helmet and ax. *Historians' History*

Solleret, 13th-14th century. *L'Art Pour Tous*

Japanese sword.

Helmet, 16th century. *Dictionary of Terms of Art*

Sword of the 16th century.

Pistol, .38 caliber. *Century Magazine*

Dagger and sheath. *Natural History of Man, Africa*

Tomahawk. *Natural History of Man, Africa*

Maori weapon. *Natural History, America and Asia*

Cannon. *Catchpenny Prints*

Tahitian battle ax. *Natural History of Man, America and Asia*

Warrior hat, New Caledonia. *The World: Its Cities and Peoples, Vol. 5*

Breastplate, 16th century, steel ornamented with guilding. *Century Dictionary, Vol. 1*

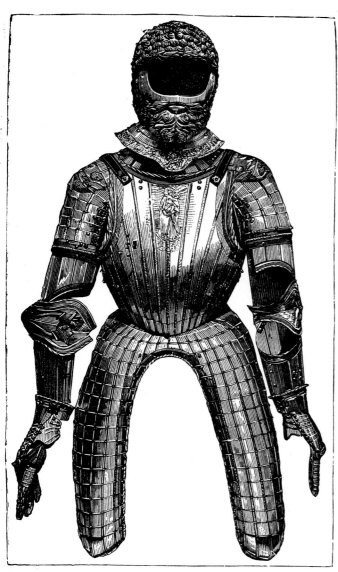

Armor worn by Charles V. *Leslie's*

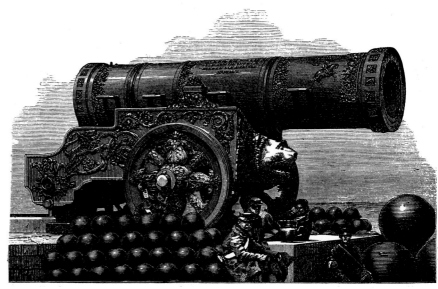

Great gun at Moscow. *Illustrated London News*

Bipennis ax with two blades.

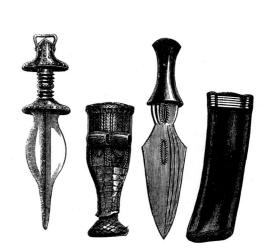

Daggers, from the Christy collection. *Natural History of Man, Africa*

Tahitian bow. *Natural History of Man, America and Asia*

Dueling pistol with sliding primer percussion locks. *Antique Firearms* □

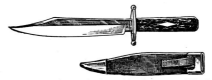

Bowie-knife and sheath. *Century Dictionary*

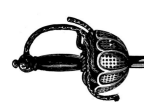

Rapier of the 16th century.

Arms & Armor continued

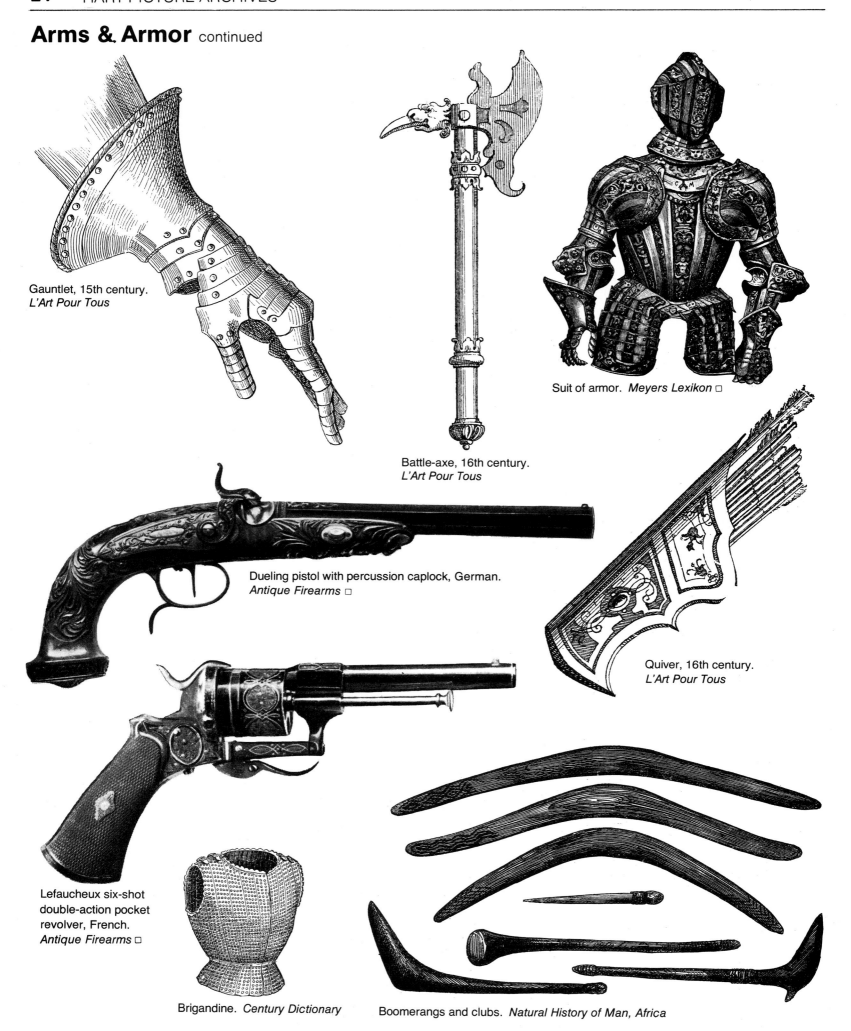

Gauntlet, 15th century.
L'Art Pour Tous

Battle-axe, 16th century.
L'Art Pour Tous

Suit of armor. *Meyers Lexikon* □

Dueling pistol with percussion caplock, German.
Antique Firearms □

Quiver, 16th century.
L'Art Pour Tous

Lefaucheux six-shot
double-action pocket
revolver, French.
Antique Firearms □

Brigandine. *Century Dictionary*

Boomerangs and clubs. *Natural History of Man, Africa*

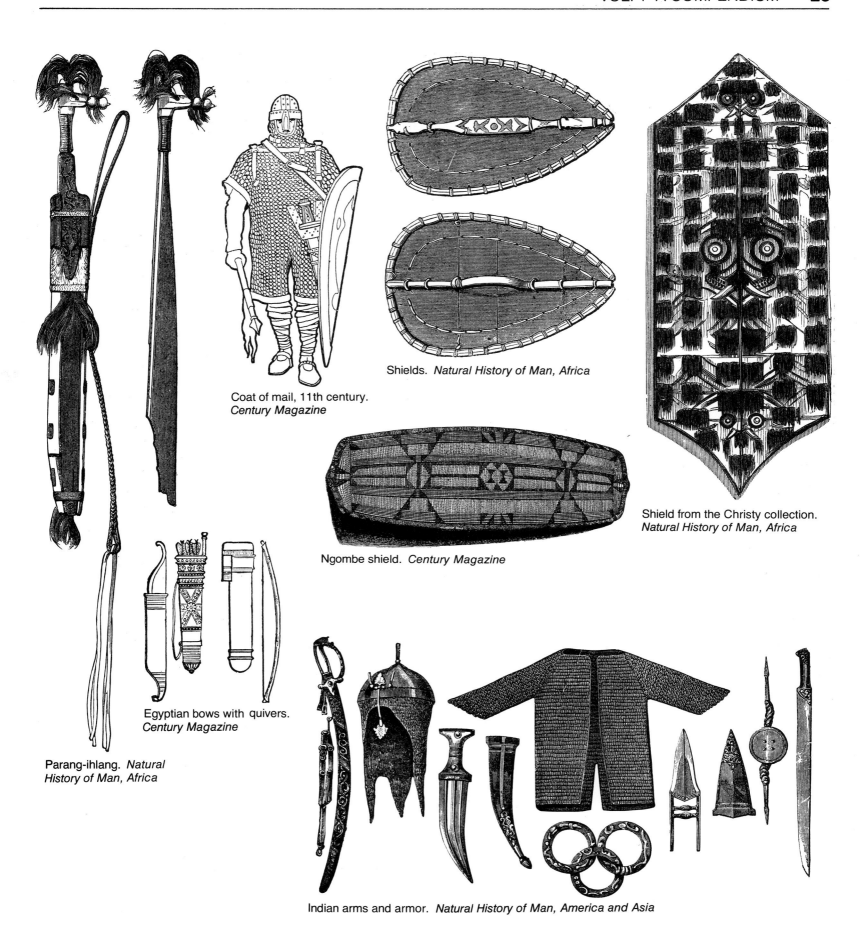

Shields. *Natural History of Man, Africa*

Coat of mail, 11th century.
Century Magazine

Shield from the Christy collection.
Natural History of Man, Africa

Ngombe shield. *Century Magazine*

Egyptian bows with quivers.
Century Magazine

Parang-ihlang. *Natural
History of Man, Africa*

Indian arms and armor. *Natural History of Man, America and Asia*

Amazonian two-stringed bow. *Natural History of Man, Africa*

Artists

Century Magazine

Harper's

Fifty Years of Soviet Art

Al'bina Makuraite

Harper's

Leslie's, Vol. 16

Aleksandr Vasin

The World: Its Cities and Peoples

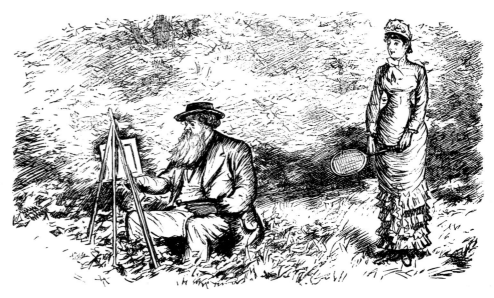

Leslie's, Vol. 23

Beauties

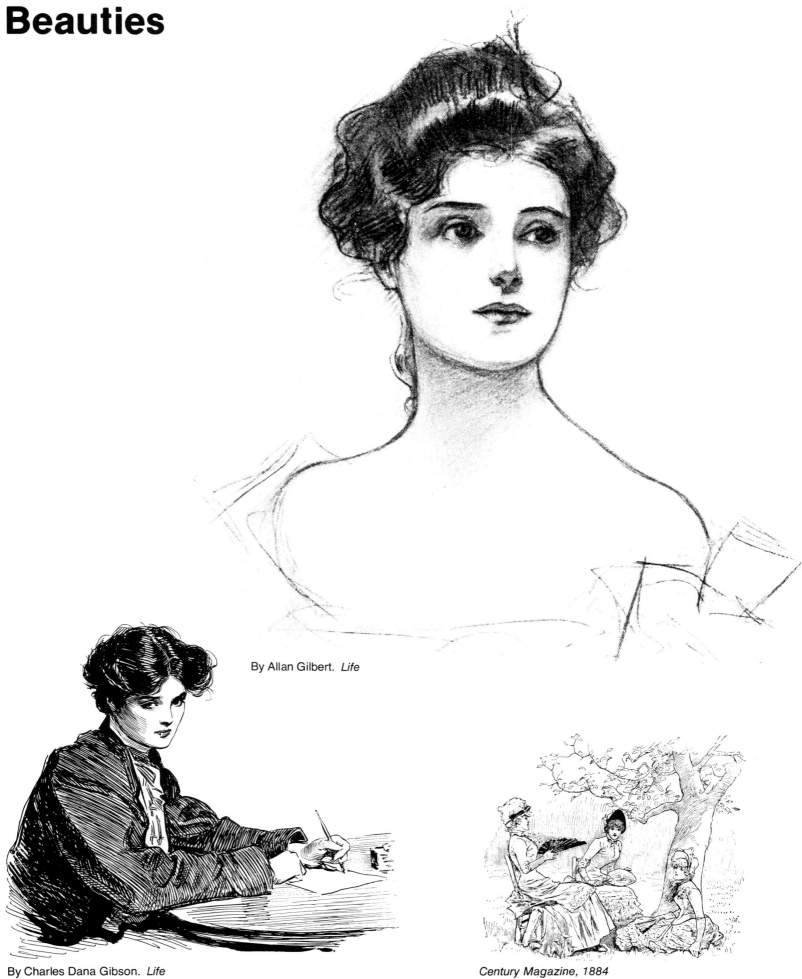

By Allan Gilbert. *Life*

By Charles Dana Gibson. *Life*

Century Magazine, 1884

Leslie's

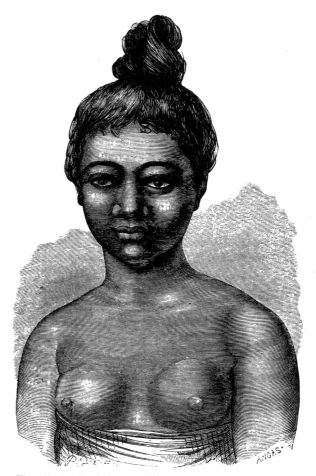

The World: Its Cities and Peoples

Leslie's

Leslie's

Beauties continued

Century Magazine

Leslie's, Vol. 16 □

Leslie's

Police Gazette, 1881

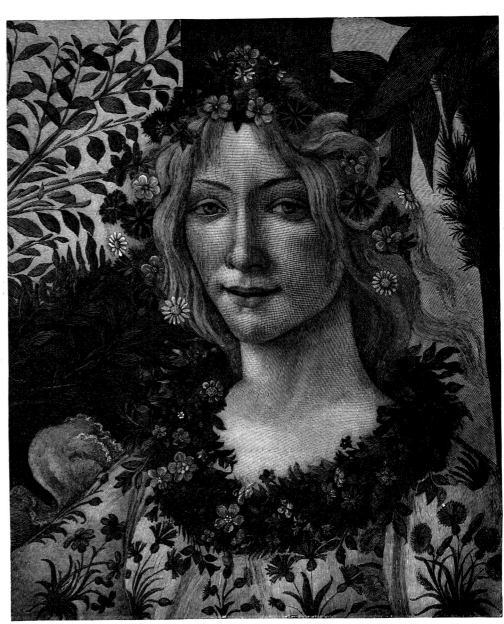

Head of "Flora," from the "Allegory of the Seasons" by Sandro Botticelli, in the Academy of Fine Arts, Florence, Italy. *Century Magazine*

Fifty Years of Soviet Art □

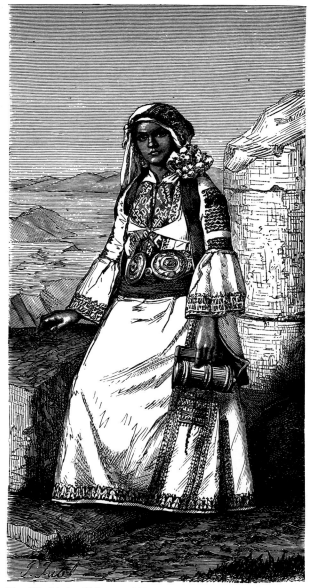

The World: Its Cities and Peoples

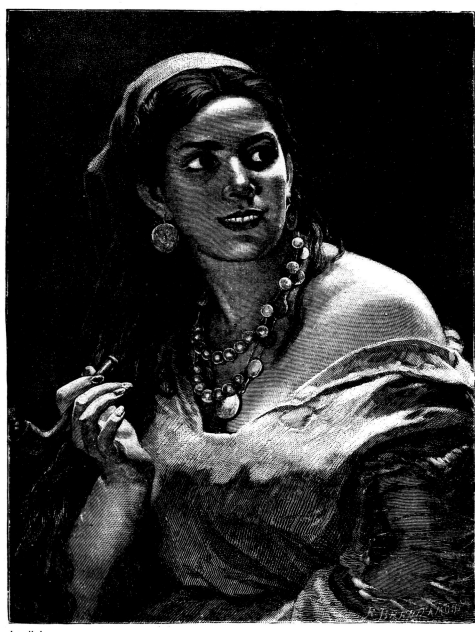

Leslie's

Harper's

Beauties continued

The World: Its Cities and Peoples

Harper's

Century Magazine □

By Frank Godart. *Century Magazine*

Fifty Years of Soviet Art

The Art of the Book

Fifty Years of Soviet Art

Leslie's

By Charles Dana Gibson. *Life*

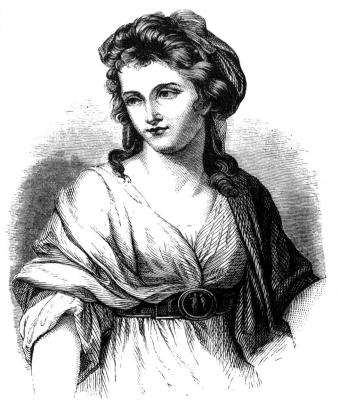

Harper's

Bicycles

Century Magazine

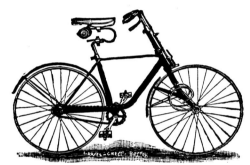

Bicycle of 1876. *Leslie's*

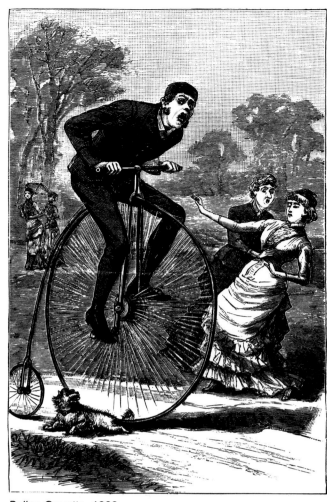

Police Gazette, 1883

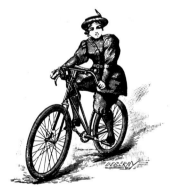

French Advertising Art

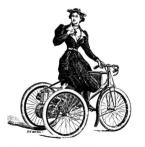

French Advertising Art

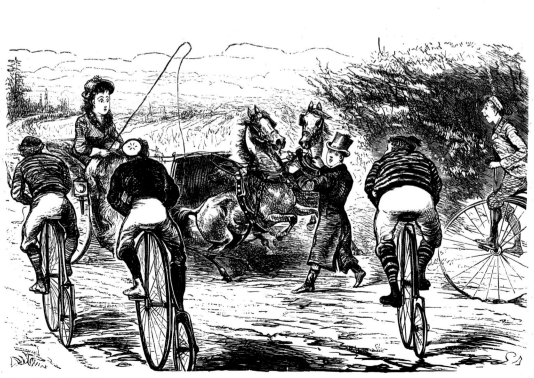

Punch, April, 1876

Life □

Century Magazine

Century Magazine

Leslie's, Vol. 23

Police Gazette, 1889

Birds

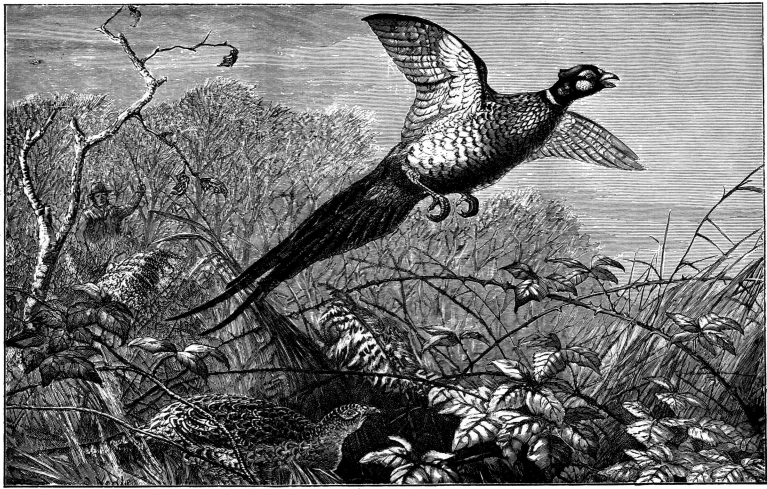

Chinese pheasants in covert.

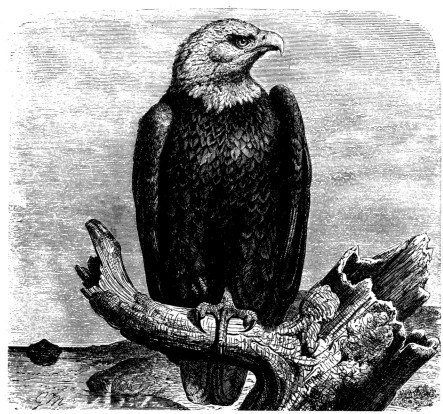

Eagle. *Lydekker*

Spotted yellow warbler.
Century Dictionary

White-bellied nuthatch.
Century Dictionary

Great blue heron. *Century Dictionary*

Topaz humming-bird.*Century Dictionary*

Swallow-tailed kite. *Century Dictionary*

Nun bird. *Century Dictionary*

European oriole. *Century Dictionary*

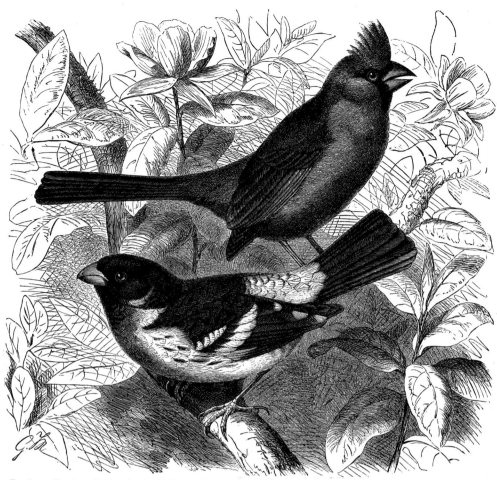

Red cardinal and rose-breasted grosbeak. *Lydekker.*

Acadian or saw-whet owl.
Century Dictionary

Snake buzzard. *Century Dictionary*

Ostrich feather. *Pen and Ink Drawing*

Birds continued

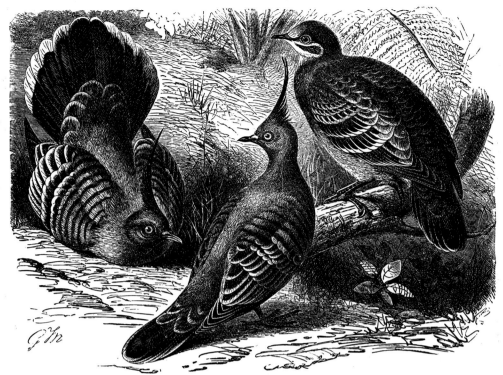

Crested and common bronze-winged doves. *Lydekker*

Savanna sparrow. *Century Dictionary*

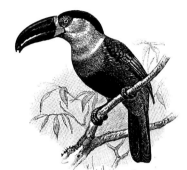

Ariel toucan. *Century Dictionary*

Foot of the royal eagle. *Harper's*

Mistlethrush. *Century Dictionary*

West African wood-stork. *Lydekker*

Wild duck. *Lydekker*

Red-headed American woodpecker. *Lydekker*

Plover. *Century Dictionary*

Solitary sandpiper.
Century Dictionary

White-throated sparrow, or
peabody-bird. *Century
Dictionary, Vol. 10*

American robin.
Century Dictionary

Pagoda starling.
Century Dictionary

Social weaver bird.
Century Dictionary

Bird feather. *Pen and Ink Drawing*

Birds continued

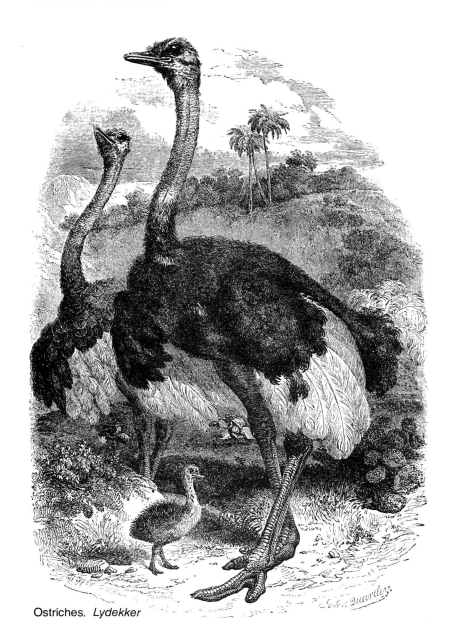

Ostriches. *Lydekker*

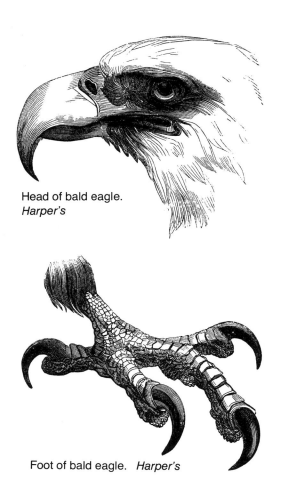

Head of bald eagle.
Harper's

Foot of bald eagle. *Harper's*

Sparrow. *Harper's*

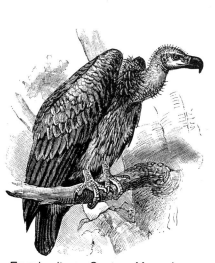

Eared vulture. *Century Magazine*

Gull's nest. *Harper's*

American partridge. *Century Dictionary*

Head of common rhea. *Lydekker, Vol. 4*

Mottled owl. *Leslie's, Vol. 23*

Peacock. *Lydekker, Vol. 4*

Great spotted cuckoo. *Lydekker, Vol. 4*

Birds continued

European white swan. *Century Dictionary*

Paradise whidah-bird.
Century Dictionary

Common whitethroat. *Century Dictionary*

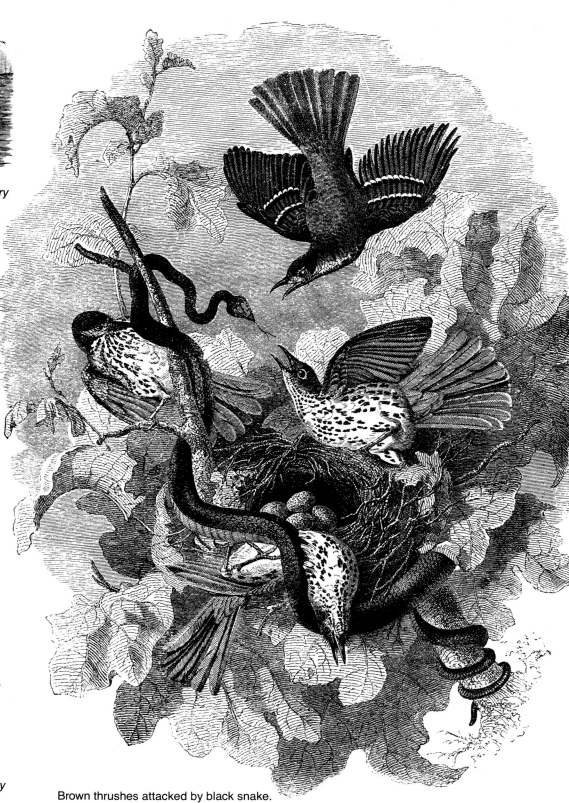

Brown thrushes attacked by black snake.

American sparrow hawk. *Century Dictionary*

Spider catcher.
Century Dictionary

Wheatear, adult male.
Century Dictionary

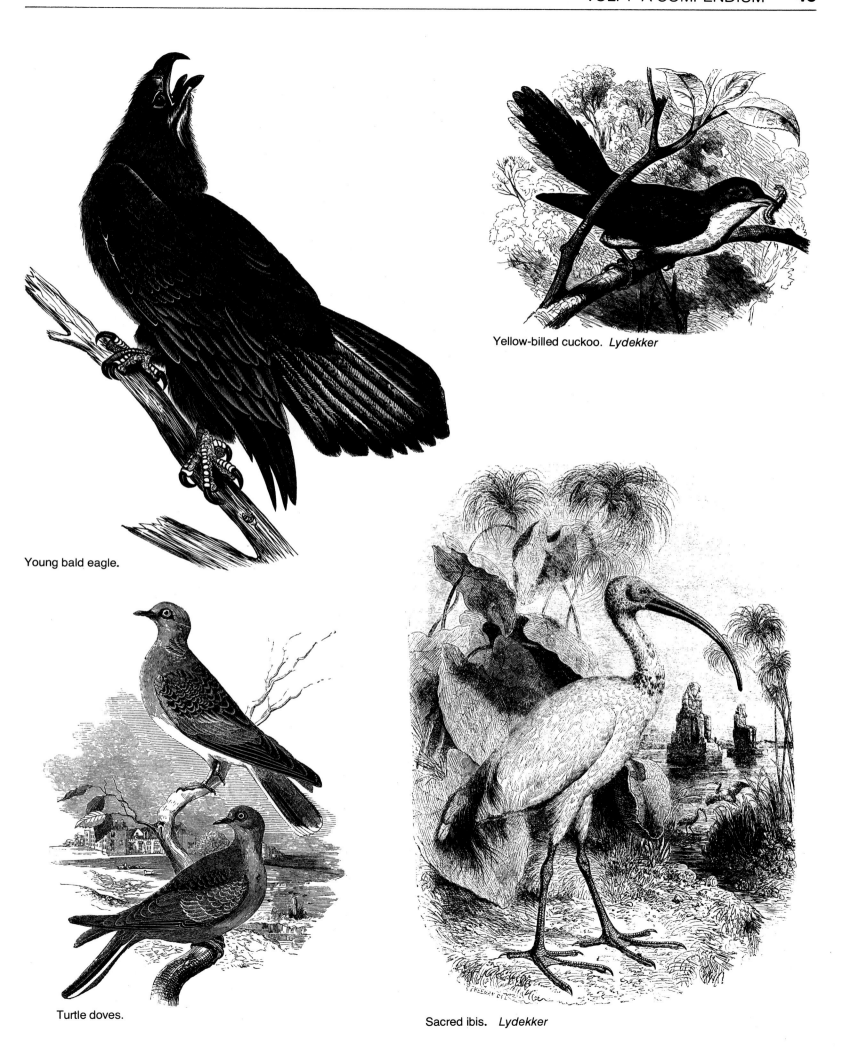

Yellow-billed cuckoo. *Lydekker*

Young bald eagle.

Turtle doves.

Sacred ibis. *Lydekker*

Borders

Deutsches Lachen

Leslie's

Harper's

The Studio

Century Magazine

Century Magazine

Borders continued

Century Magazine

Tribute Book

Fifty Years of Soviet Art

Fifty Years of Soviet Art

Harper's Roundtable

Harper's

Fifty Years of Soviet Art

Fifty Years of Soviet Art

Fifty Years of Soviet Art

Borders continued

Giants of the Republic

Century Dictionary

Century Magazine, 1896

Century Magazine

L'Art Pour Tous, Vol. 2

Century Magazine, 1901

Fifty Years of Soviet Art

The Studio

In a Fair Country

The Studio

Borders continued

Century Magazine, 1896

Century Magazine

Tribute Book

Manon Lescaut □

Harper's

Harper's

Century Magazine, 1894

Catalog of the Unusual

Century Magazine, 1896

Borders continued

Anatoly L'vovich Kaplan

The Studio

The Studio

Leslie's

The Studio

L'Art Pour Tous

Bridges

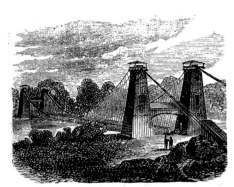

Suspension bridge across the Mississippi at Minneapolis. *Century Dictionary*

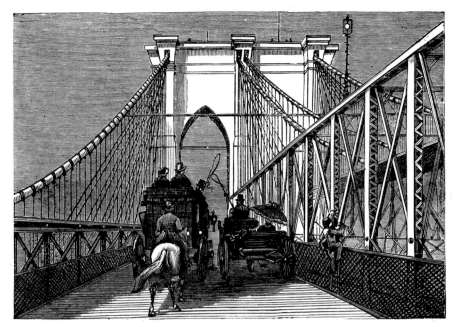

Roadway of Brooklyn Bridge, 1890. *Harper's*

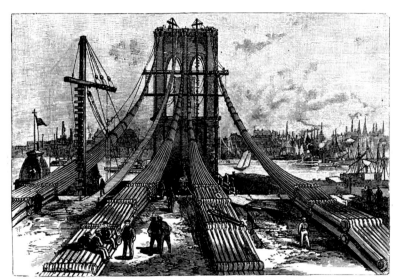

Brooklyn anchorage, 1872. *Century Magazine*

View at Chadds Ford, Pennsylvania. *Harper's*

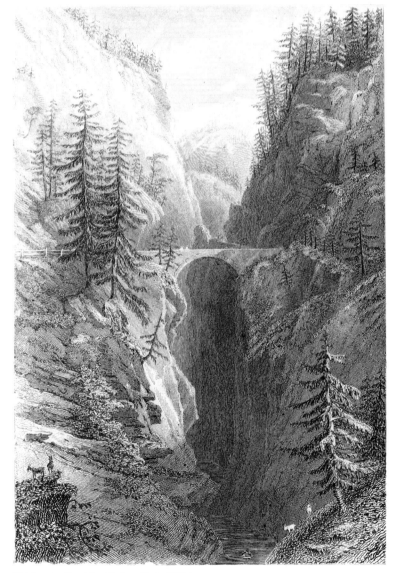

Bridge in the Via Mala. *The Aldine* □

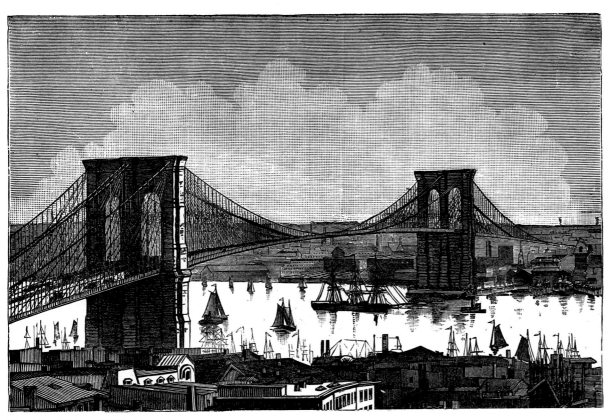

Brooklyn Bridge, 1890. *Harper's*

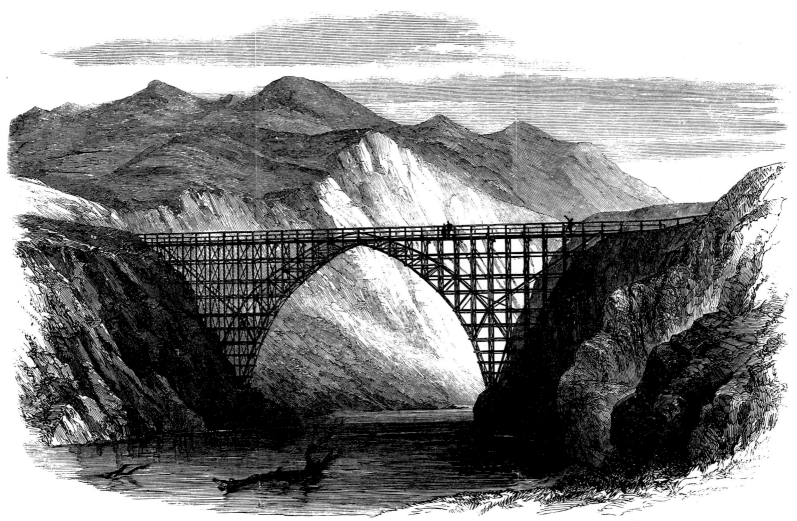

Timber Bridge over the River Wai-au-ua, Nelson Province, New Zealand. *Illustrated London News, 1866.*

Bridges continued

Native river bridge.
Century Magazine

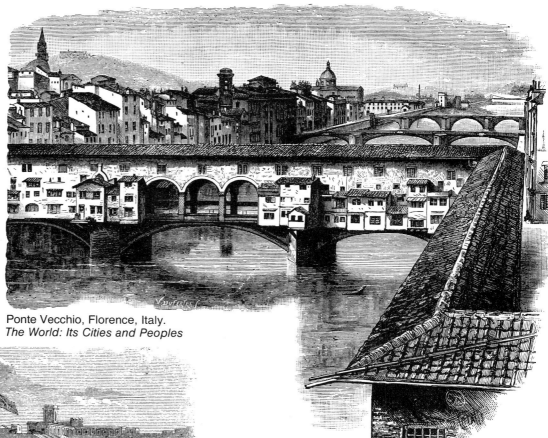

Ponte Vecchio, Florence, Italy.
The World: Its Cities and Peoples

Western entrance, Fort George. *Harper's*

Rialto, Venice, Italy. *Zell's*

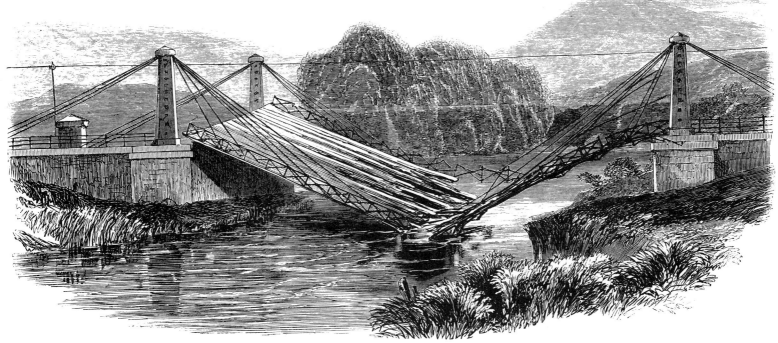

Wreck of the Victoria Bridge, Natal, South Africa. *Illustrated London News, 1866*

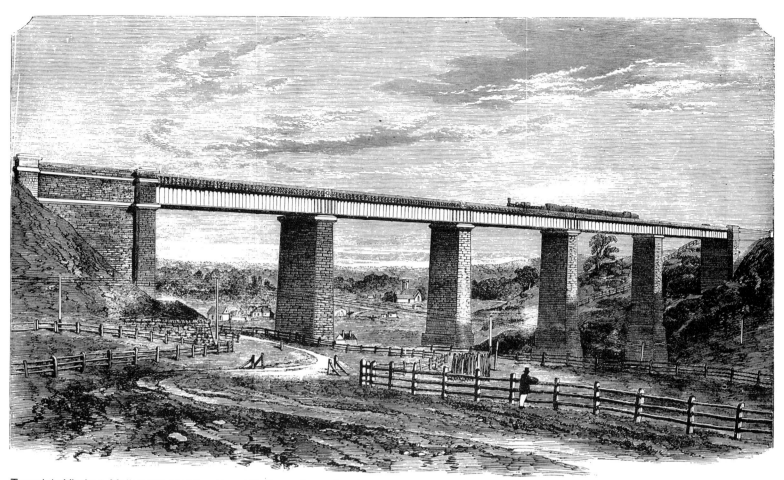

Tarradale Viaduct, Melbourne and Sandhurst Railway, Australia. *Illustrated London News*

Chinese bridge. *Chinese cutout*

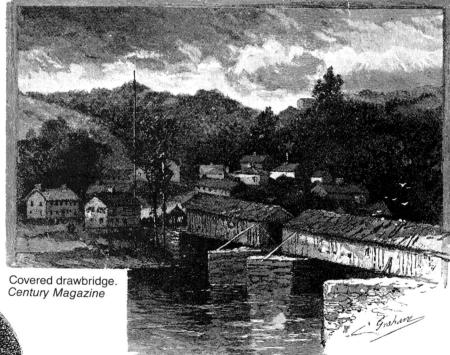

Covered drawbridge.
Century Magazine

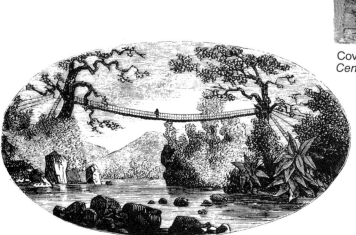

Primitive suspension bridge, Honduras, Central America. *Harper's*

Bridges continued

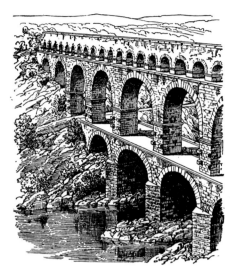

Pont du Gard, Roman aqueduct,
near Nimes, France. *Century Magazine*

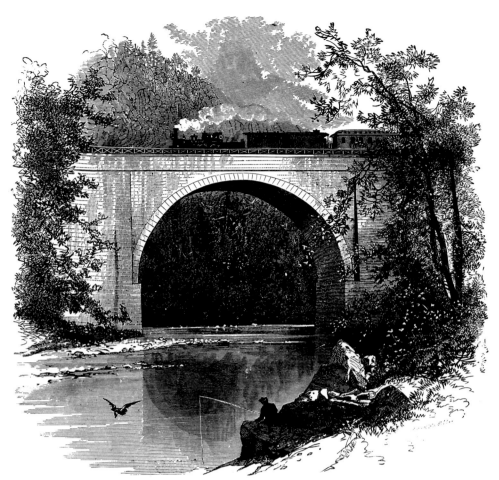

Conemaugh Viaduct, Pennsylvania Railroad. *The Aldine*

Fifty Years of Soviet Art

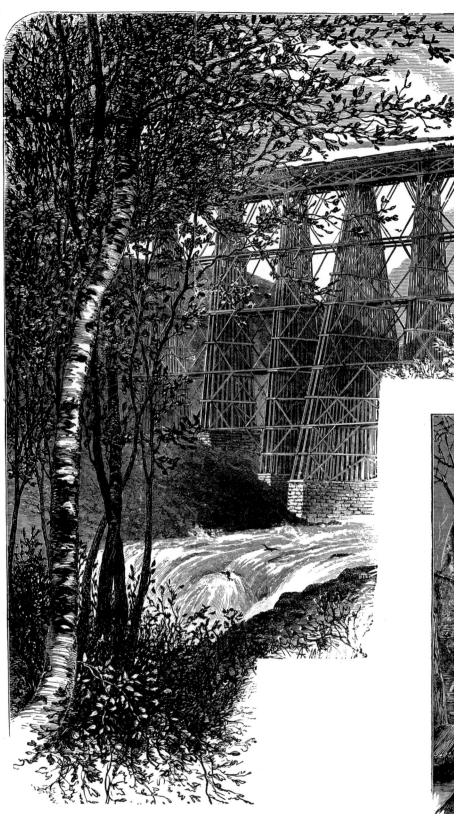

Railway bridge. *The Aldine*

A Bunch of Violets

Pont Neuf, Paris, France, 1845. *Harper's*

Buildings

Opera House, Paris. *Voyages and Travels, Vol. 1*

The Alamo, San Antonio, Texas. *On A Mexican Mustang*

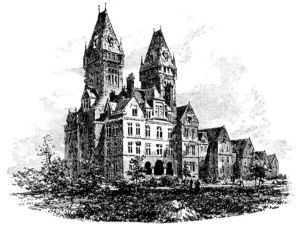

The New York State Insane Asylum at Buffalo. *Harper's*

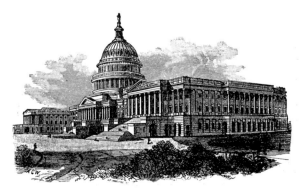

United States Capitol, Washington, D.C.
Century Dictionary

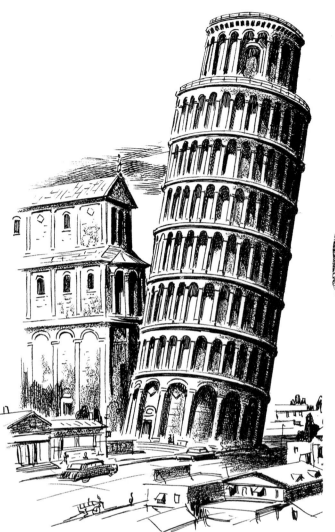

Leaning Tower of Pisa, Italy. *Incredible Structures*

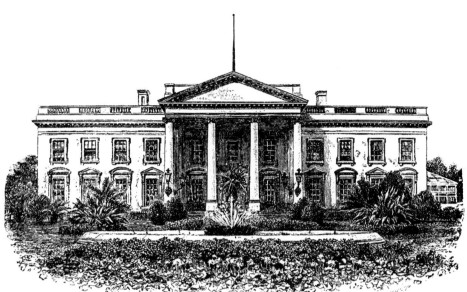

The White House, Washington, D.C. *Giants of the Republic*

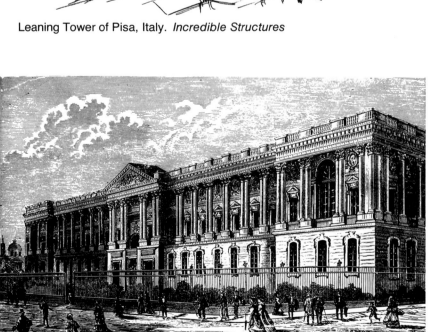

Colonnade of the Louvre, Paris

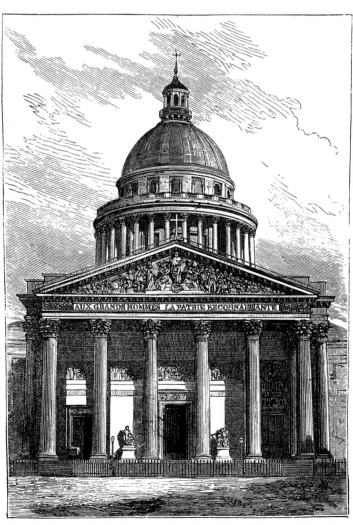

The Pantheon, Paris, France. *The World: Its Cities and Peoples*

Buildings continued

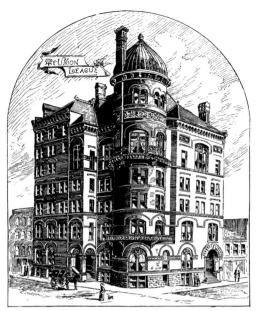

Club-house of the Union League of Chicago.
Leslie's, Vol. 29

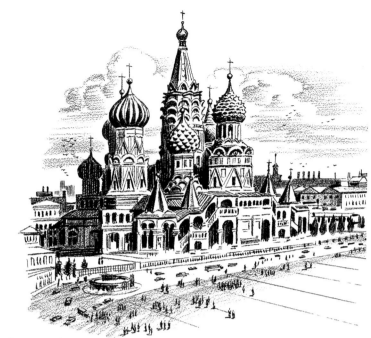

The Kremlin, Moscow. *Incredible Structures*

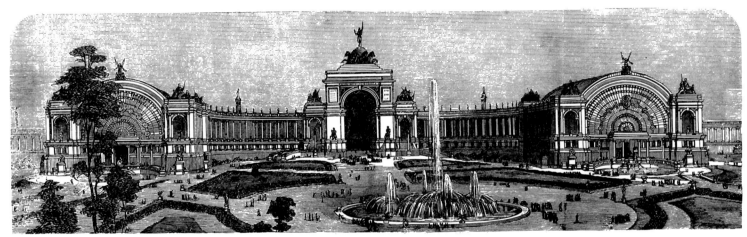

National Exhibition Building, Brussels. *Leslie's, Vol. 10*

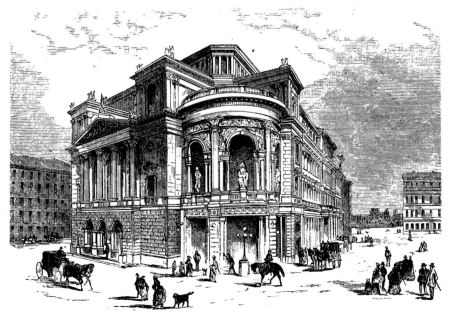

New Stadt Theatre, Vienna, Austria. *Harper's, Vol. 46*

The Chalet in the Margherita Gardens. *Leslie's, Vol. 10*

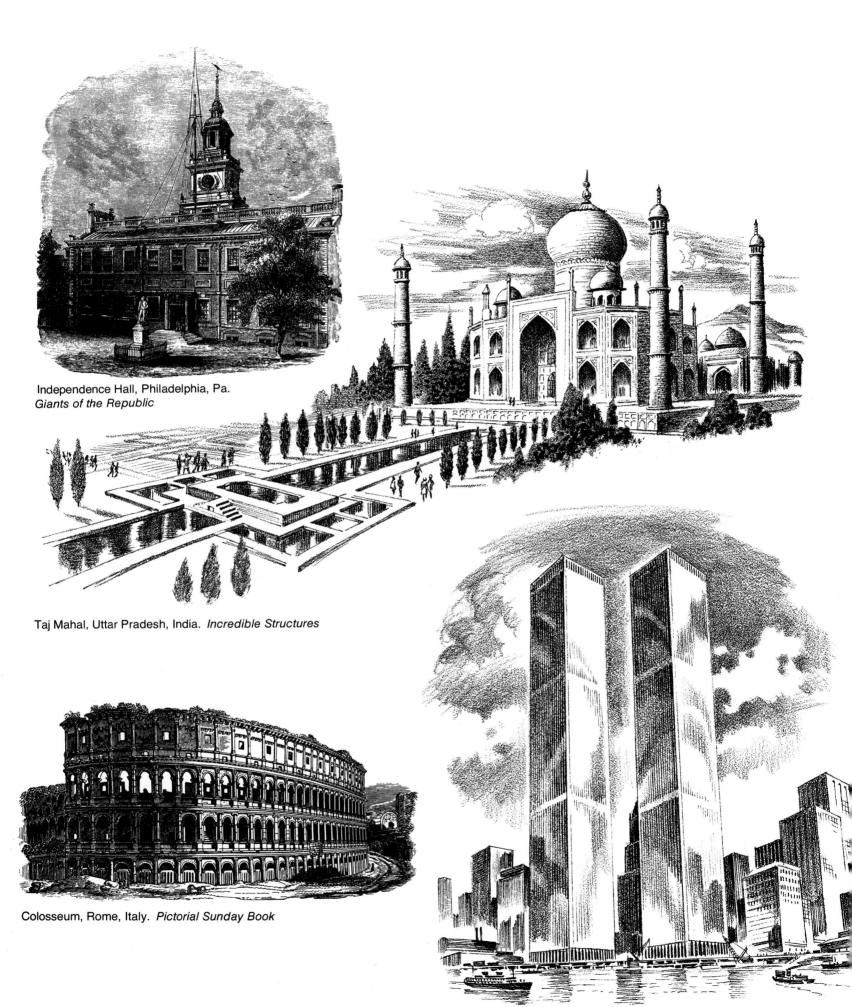

Independence Hall, Philadelphia, Pa.
Giants of the Republic

Taj Mahal, Uttar Pradesh, India. *Incredible Structures*

Colosseum, Rome, Italy. *Pictorial Sunday Book*

World Trade Center, New York City. *Incredible Structures*

Castles & Palaces

Holyrood Palace, Edinburgh, Scotland. *Harper's, Vol. 46*

Castle of Canossa—from a medieval manuscript.
Harper's

Palace of Mary Stuart. *Illustrated London News*

Castle of Coucy, Aisne, France.
Century Dictionary, Vol. 2

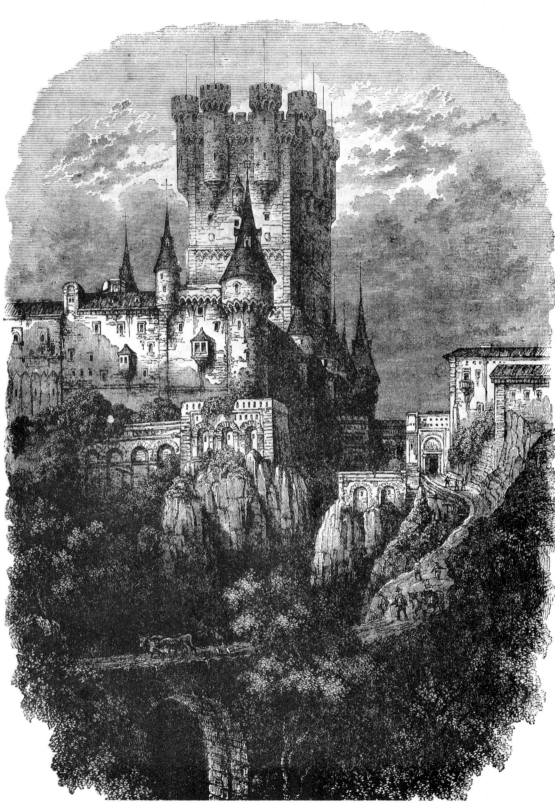

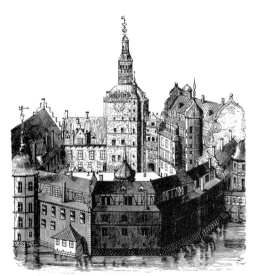

The Old Castle of Copenhagen, Denmark.
Harper's, Vol. 47

The Alcazar, Segovia, Spain. *Voyages and Travels* □

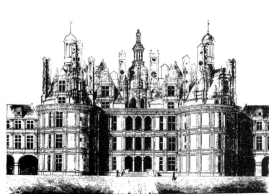

Chateau de Chambord, France.
Architectural Styles

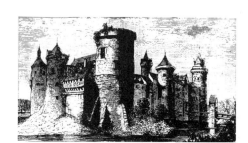

Castle in Rouen, France.

Cats

Century Magazine, 1896 □

Catalog of the Unusual

Illustrated London News, 1884

Leslie's

Mark of the printer Sessa of Venice.
Harper's, Vol. 44

Lydekker

Quaint Cuts

Siamese. *Pet Book* □

Leslie's

Century Magazine

Celebrated Persons

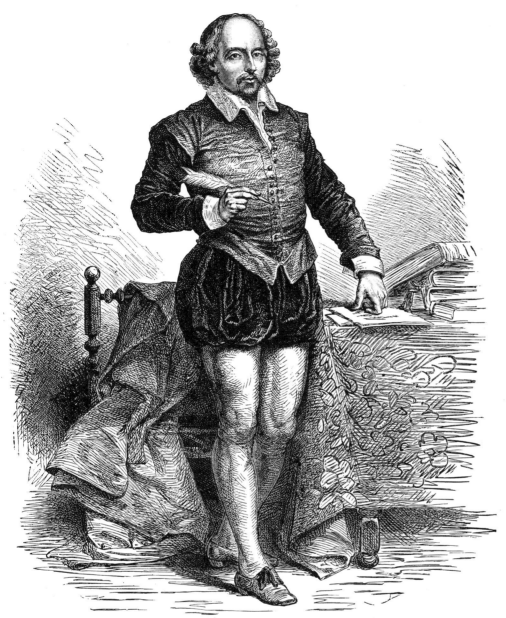

Shakespeare. *Harper's*

Queen Elizabeth. *Leslie's*

Leonardo da Vinci. *Zell's*

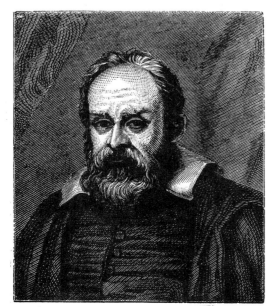

Galileo. *Harper's, Vol. 49*

William Makepeace Thackeray.
Harper's, Vol. 49

Confucius. *Harper's*

Pocahontas. *Harper's*

Tennyson. *Harper's*

Dante. *Harper's*

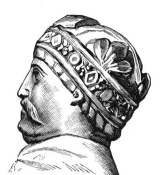

Charlemagne.
General History

Molière. *Leslie's*

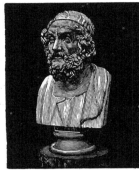

Homer. *Century Dictionary*

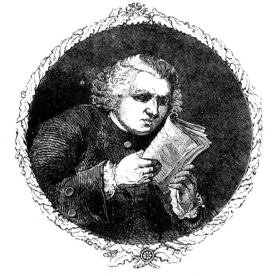

Samuel Johnson. *Harper's*

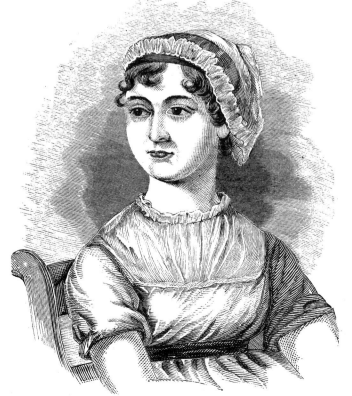

Jane Austen. *Harper's*

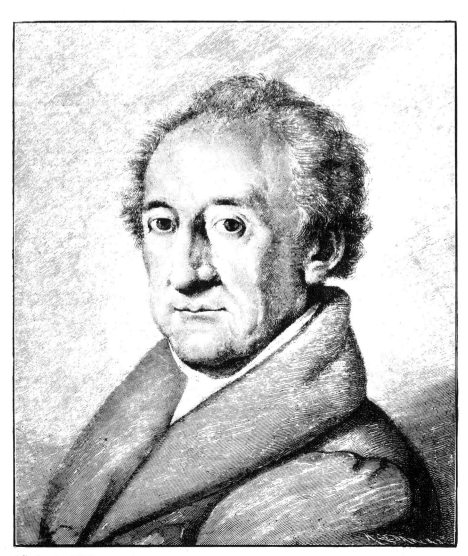

Göethe in 1829, portrait by John Joseph Schmeller. *Leslie's, Vol. 21*

Celebrated Persons continued

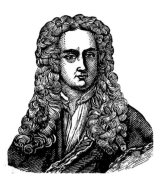

Sir Isaac Newton. *Zell's*

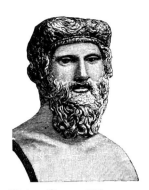

Plato. *General History*

Hendrick Hudson. *Voyages and Travels*

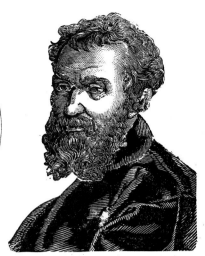

Michelangelo. *Zell's*

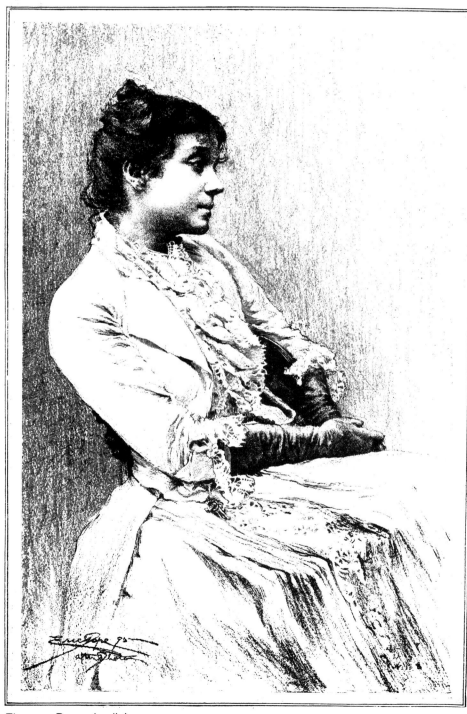

Eleonora Duse. *Leslie's*

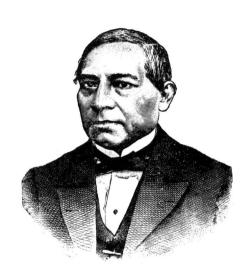

Benito Juarez. *Giants of the Republic*

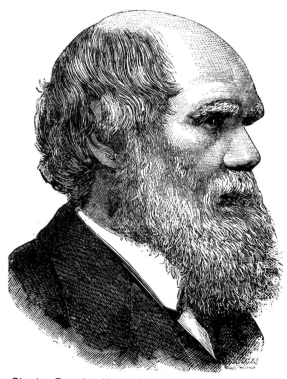

Charles Darwin. *Harper's*

Nikolai Lenin. *Fifty Years of Soviet Art*

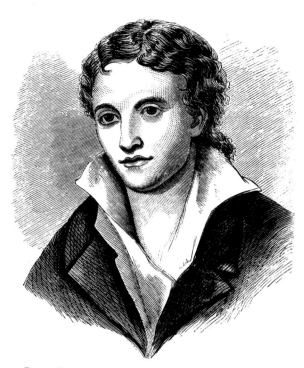

Percy Bysshe Shelley. *Harper's*

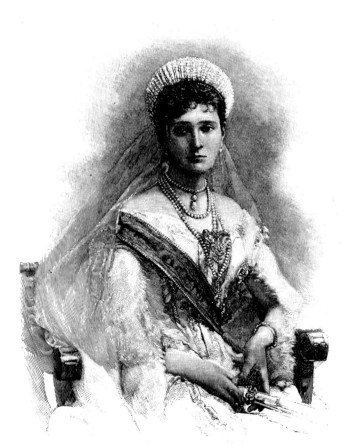

Alexandra Feodorovna, Czarina of Russia.
Century Magazine, 1896

Oliver Cromwell. *Zigzag Journeys*

Celebrated Persons continued

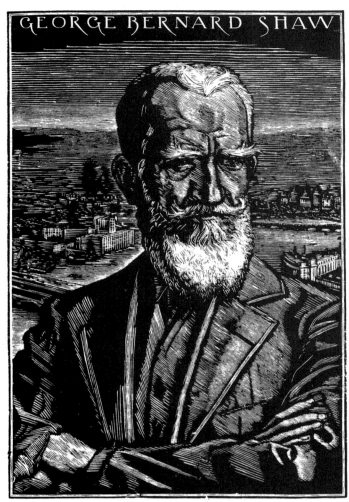

George Bernard Shaw. *The Art of the Book*

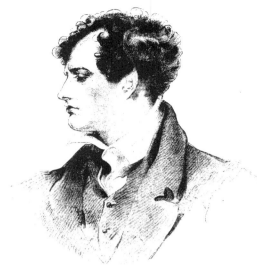

Lord Byron, from Harlow's portrait (1816). *Leslie's*

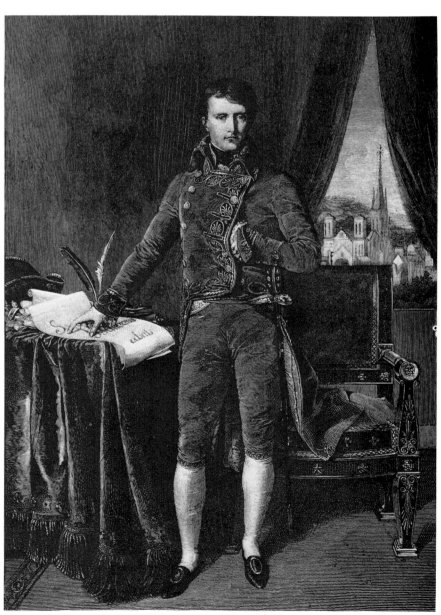

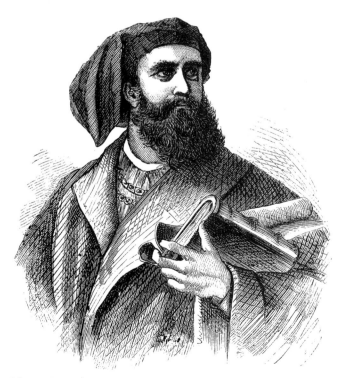

Marco Polo, from a Venetian mosaic. *Harper's, Vol. 46*

Napoleon Bonaparte, engraved by T. Johnson from the painting by Jean-Auguste Dominique Ingres in the museum at Liège, Belgium. *Century Magazine* □

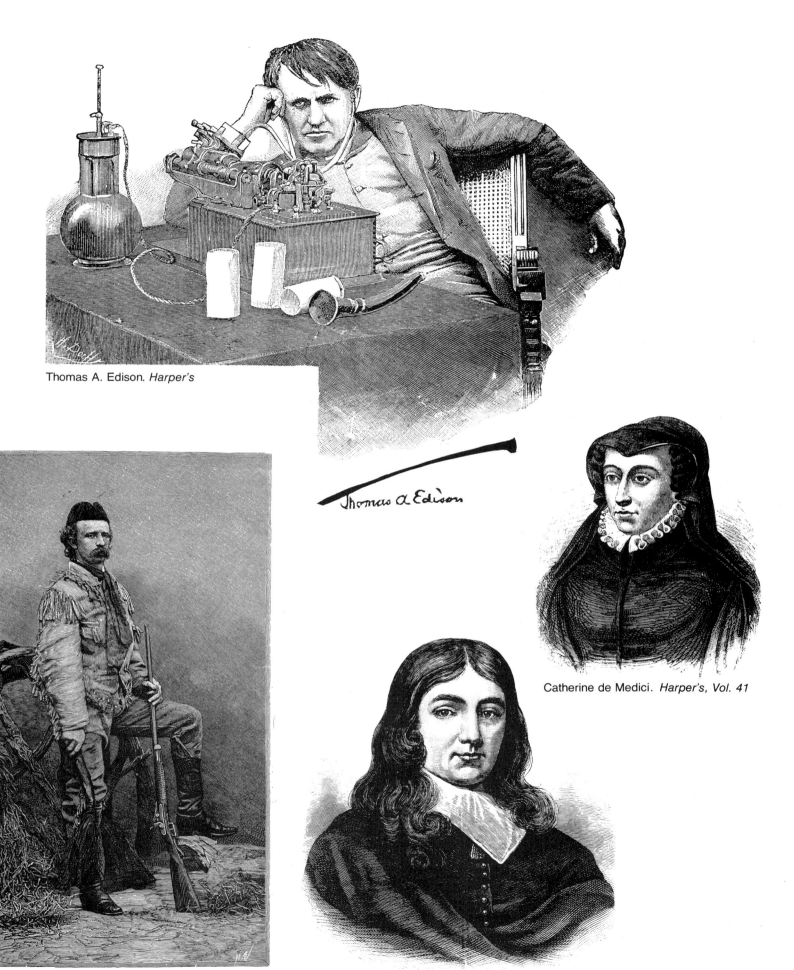

Thomas A. Edison. *Harper's*

Catherine de Medici. *Harper's, Vol. 41*

General Custer in his buckskin suit. *Harper's*

John Milton. *Leslie's*

Children

Punch

Leslie's

St. Nicholas

St. Nicholas

St. Nicholas

Al'bina Makuraite

Harper's

Drawing by Hugh Thomson. *Our Village*

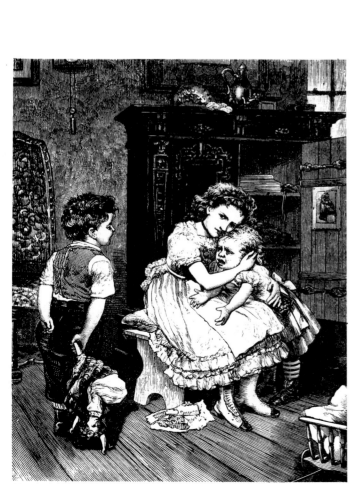

Harper's

Children continued

St. Nicholas

Life

Leslie's

Harper's

The World: Its Cities and Peoples

Harper's

Harper's

St. Nicholas

Illustration by Hugh Thomson. *Our Village*

Leslie's

Churches, Mosques, & Temples

Gothic Cathedral at Freiburg, Germany. *Voyages and Travels, Vol. 1*

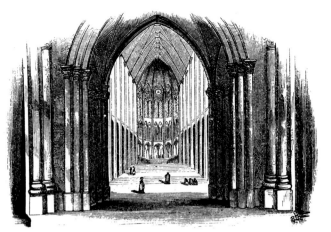

Interior of St. Dénis. *Harper's*

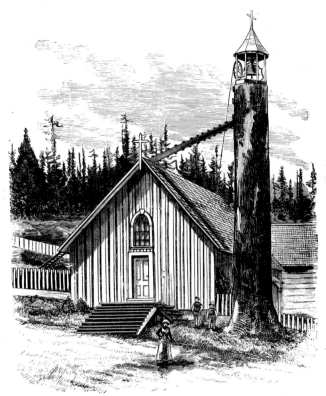

Episcopal Church, Tacoma, Washington. *Leslie's*

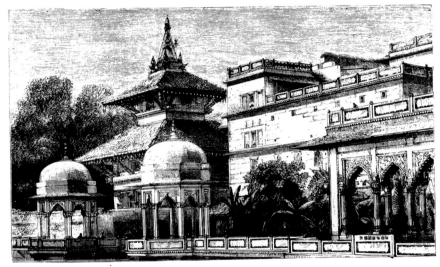

Nepalese temple. *Harper's*

Church at Jamaica,
New York.
*Field Book of the
Revolution, Vol. 2*

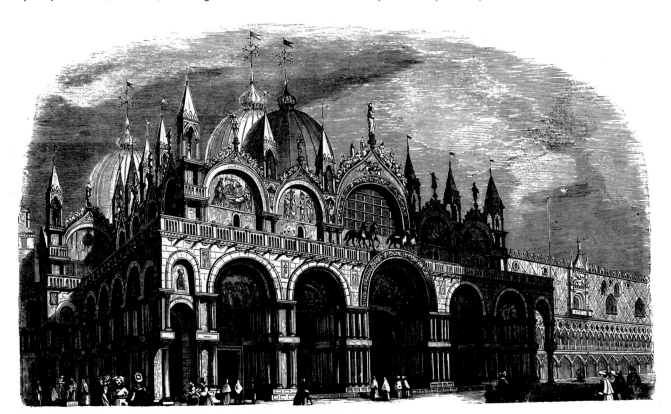

Church of St. Mark, Venice. *The World: Its Cities and Peoples*

Churches, Mosques, & Temples continued

Old Church, Orange Street, Nantucket, Massachusetts. *Leslie's*

Christ Church, Shrewsbury, New Jersey. *Leslie's*

Ancient Dutch church, New York.
Field Book of the Revolution, Vol. 1

Church, Vierlande. *Leslie's*

Vestry door, St. Peter's, Bournemouth.
Harper's, Vol. 38

Westminster Abbey, London. *Voyages and Travels, Vol. 2*

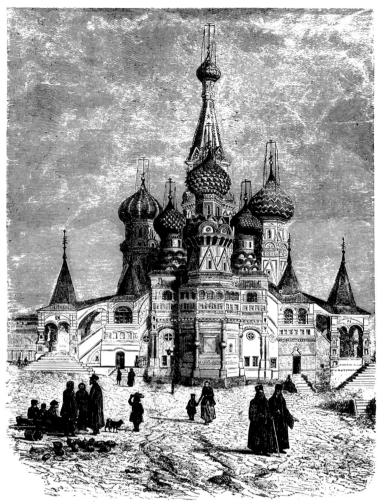

Cathedral of St. Basil, Moscow. *The World: Its Cities and Peoples*

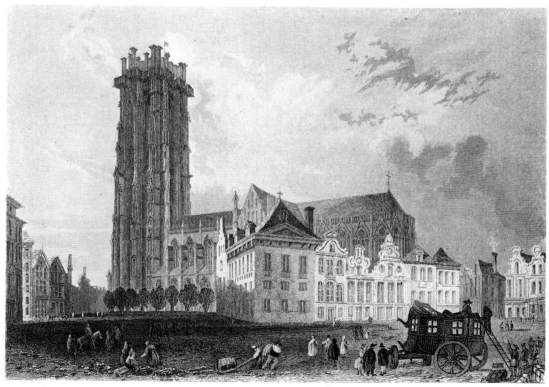

St. Rombault Church, at Malines, Belgium. *Voyages and Travels, Vol. 1* □

City Scenes

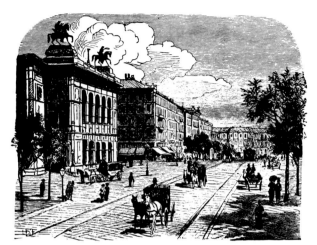

Street in Vienna. *Golden Treasury*

Facing South Church, Amsterdam.
The World: Its Cities and Peoples, Vol. 1

New York. *Life* □

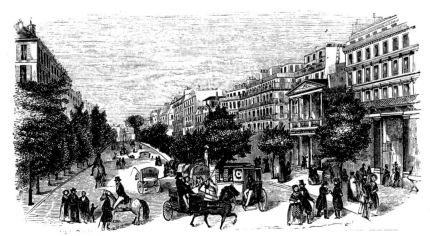

Washington, D.C. *Harper's, Vol. 5*

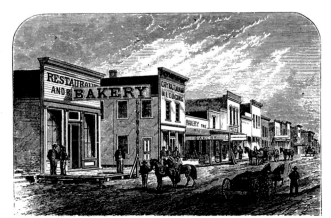

Parsons, Kansas. *Scribner's, Vol. 5*

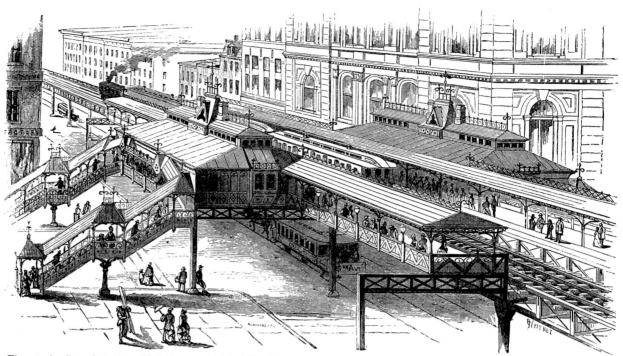

Elevated railroad station, Sixth Ave. and 23rd St., New York. *Illustrated London News*

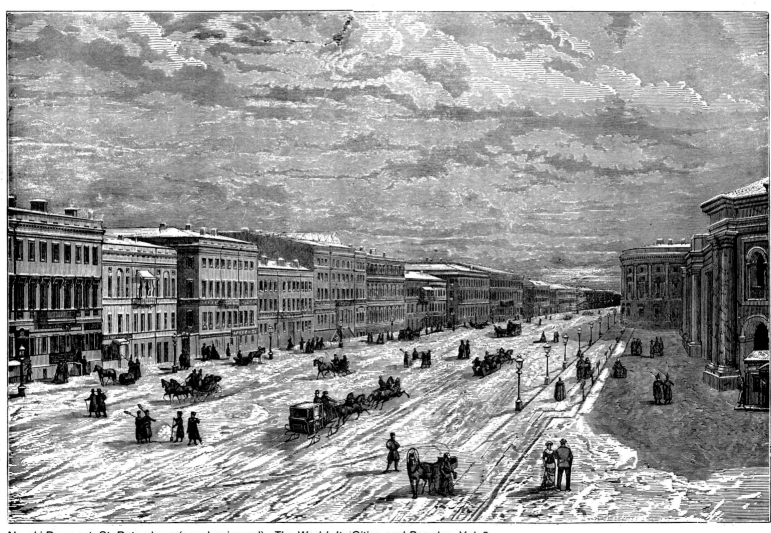

Nevski Prospect, St. Petersburg (now Leningrad). *The World: Its Cities and Peoples, Vol. 2*

City Scenes continued

St. Paul's Church in New York. *Harper's*

A narrow by-way in Damascus. *Picturesque Palestine*

Cairo. *Golden Treasury*

Bombay. *Indika*

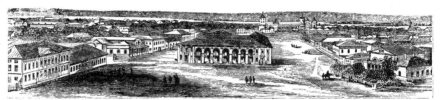

Irkutsk, Russia. *Leslie's*

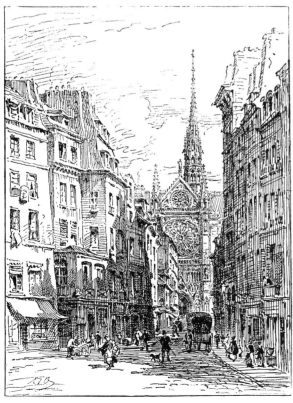

Street facing Nôtre Dame, Paris.
Paris in Old and Present Times

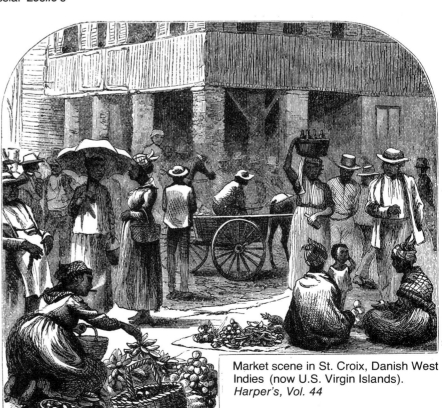

Market scene in St. Croix, Danish West
Indies (now U.S. Virgin Islands).
Harper's, Vol. 44

City Scenes continued

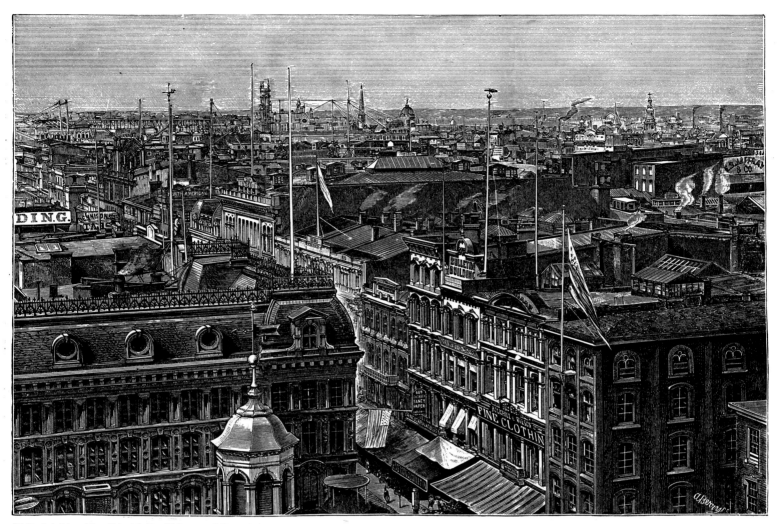

Philadelphia. *The World: Its Cities and Peoples, Vol. 3*

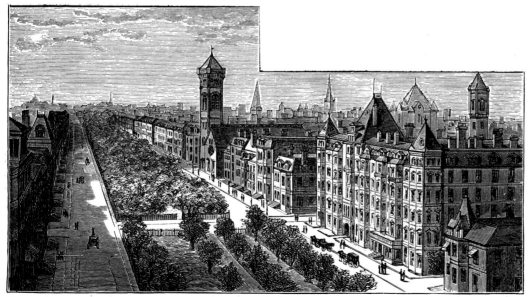

Commonwealth Avenue, Boston. *The World: Its Cities and Peoples*

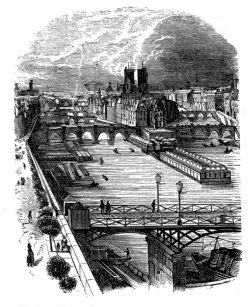

Paris. *Harper's*

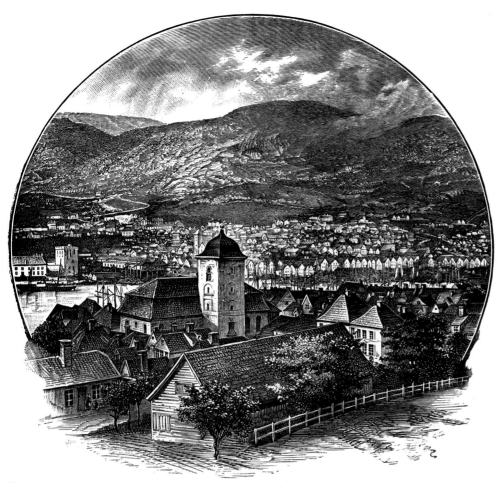

Montgomery Street, San Francisco.
The World: Its Cities and Peoples, Vol. 2

Bergen, Norway. *The World: Its Cities and Peoples, Vol. 3*

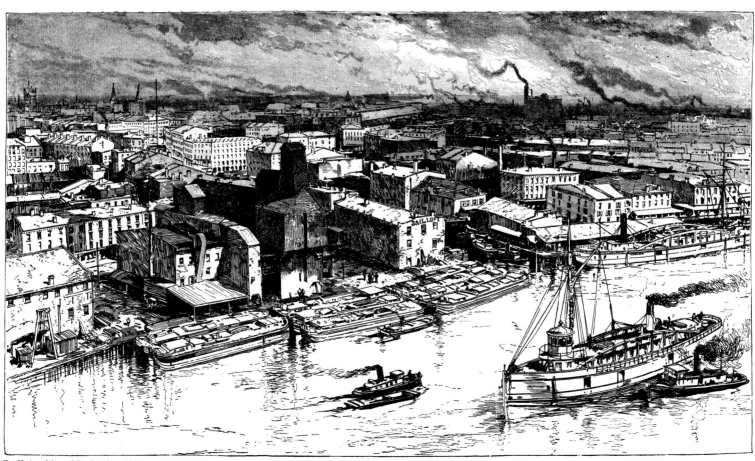

Buffalo, New York. *Leslie's*

Classic Scenes

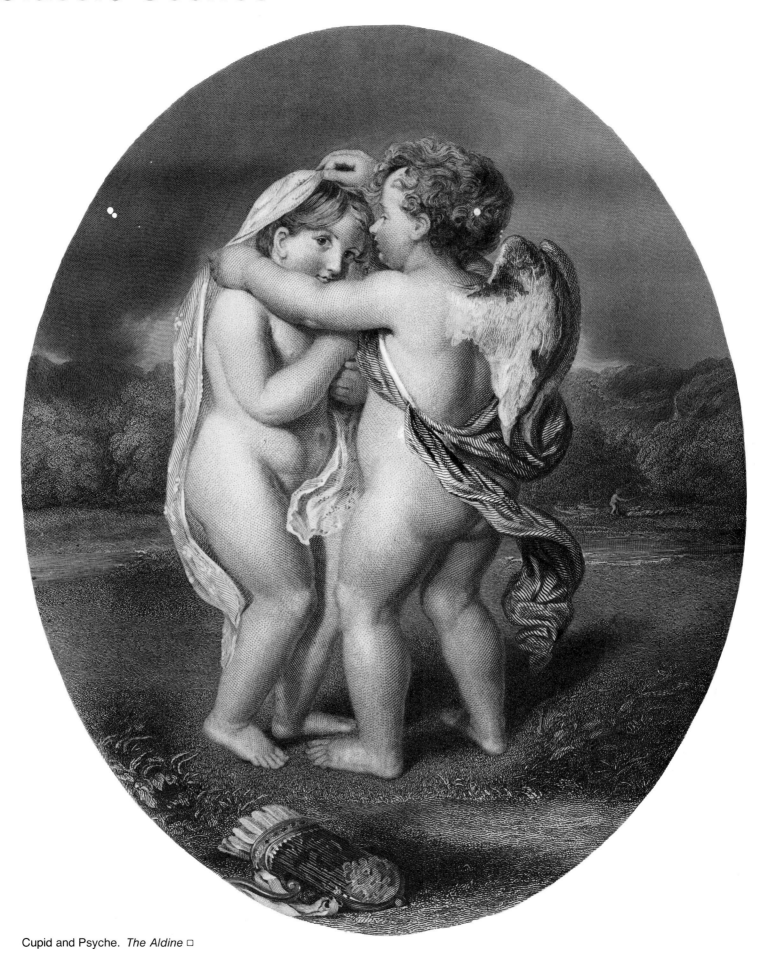

Cupid and Psyche. *The Aldine* □

The death of Adonis. *Short History of Art*

Satyr. *Short History of Art*

Greek underworld. *Short History of Art*

The death of Memnon. *St. Nicholas*

Sack of Troy. *St. Nicholas*

Eros. *Short History of Art*

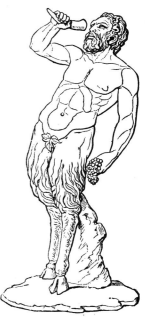

Pan. *Short History of Art*

Classic Scenes continued

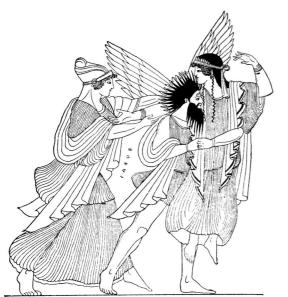

Boreas carrying off Orithyia. *Short History of Art*

Cybele and Attis, Roman relief,
3rd century. *Century Dictionary*, *Vol. 2*

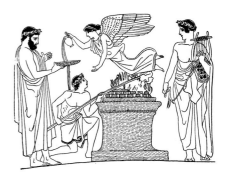

Sacrifice to Apollo. *Short History of Art*

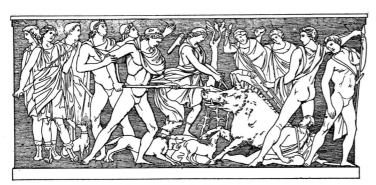

Meleager on the boar hunt. *Classic Myths*

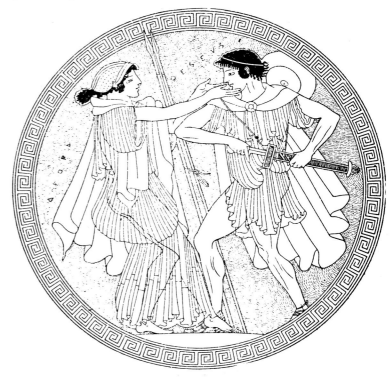

Aethra and Theseus. *Short History of Art*

The music lesson. *Short History of Art*

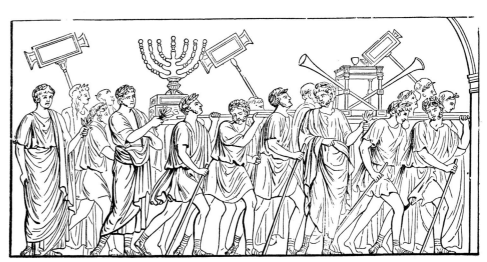

Bas-relief from the Arch of Titus. *Sunday Book*

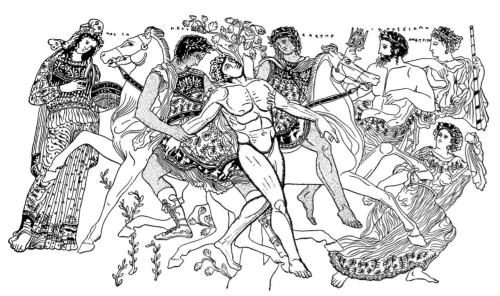

Castor and Pollux capturing the giant talus. *Short History of Art*

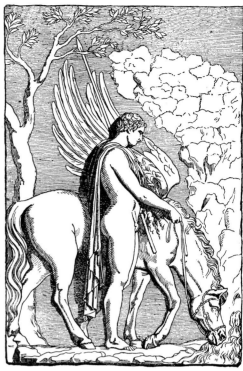

Bellerophon and Pegasus. *Short History of Art*

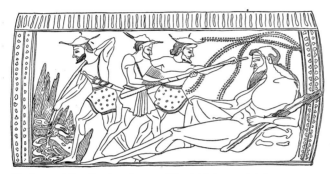

Boring out the Cyclops' eye. *Short History of Art*

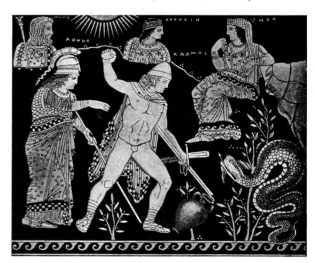

Cadmus slaying the dragon. *Short History of Art* □

A fury. *Short History of Art*

Ares (Mars). *Short History of Art*

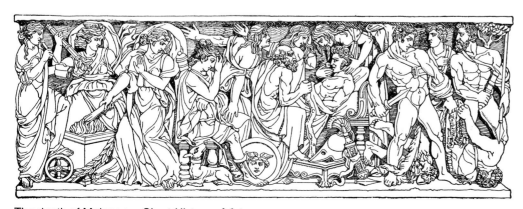

The death of Meleager. *Short History of Art*

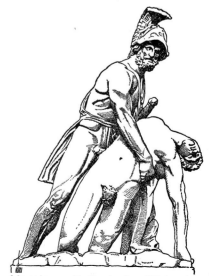

Menelaus with the body of Patroclus.
Short History of Art

Cliffs, Canyons, & Caverns

Rift in the rocks.
Marvels of the New West

Kul'at Ibn Ma'an, on the northwest side
of the Valley of Pigeons. *Picturesque Palestine*

Defile in Idumea, in the road from Palestine to Egypt.

Cave town near the San Juan. *Marvels of the New West*

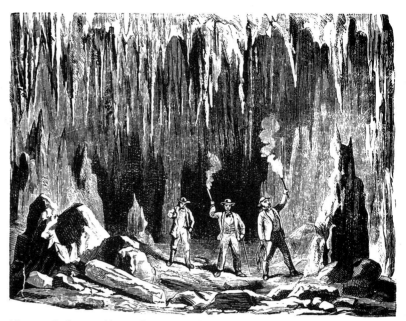

Mammoth Caves, Kentucky. *Harper's*

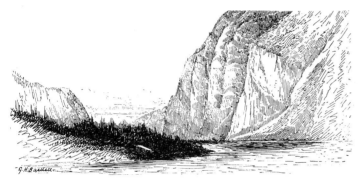

Grand Manan Island, off New Brunswick, Canada, by G.H.Bartlett. *Pen and Ink Drawing.*

Palestine.
Picturesque Palestine □

Clothing

Bonnet. *Harper's*

Casual dress. *Harper's*

Top hat and coat.
Illustrated London News

Children's clothing. *Illustrated London News*

Female attire.
Century Magazine

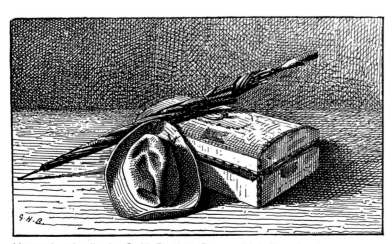

Hat and umbrella, by G. H. Bartlett. *Pen and Ink Drawing*

Carriage costume. *Harper's, Vol. 3*

Autumn cloak. *Harper's*

Dress coat.
Century Magazine

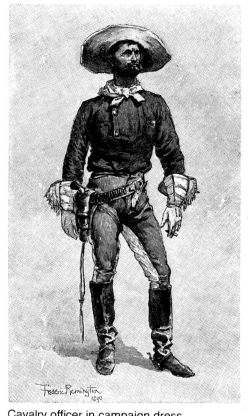

Cavalry officer in campaign dress,
by Frederic Remington.
Century Magazine, 1890

Sock and garter.
Illustrated London News

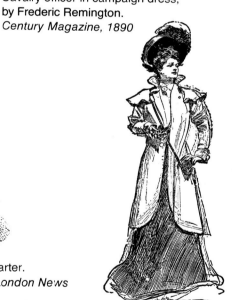

Female attire, circa 1900.
Life

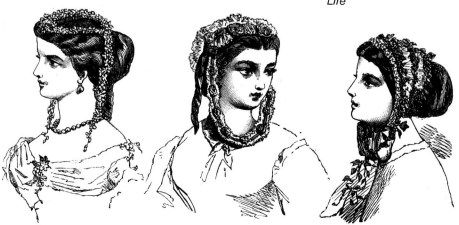

Paris fashions. *Illustrated London News*

Clothing continued

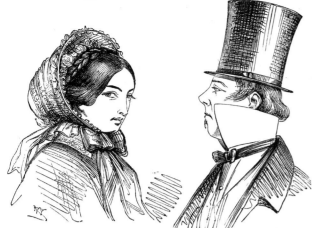

Bonnet and top hat. *Harper's*

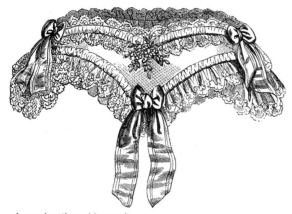

Lace berthe. *Harper's*

Corset. *Sears Catalogue*

Spanish lady at the bullfight, Madrid. *The World: Its Cities and Peoples*

Bathing suit. *Police Gazette, 1883*

Gentlemen's street attire. *Punch*

Fischer Russe cape. *Harper's*

Fichu. *Illustrated London News*

Skirt supporter. *Harper's*

Lace-trimmed cuff. *Harper's*

Gentlemen's attire. *Harper's*

Round bonnet. *Harper's*

Bathing dress. *Harper's*

Under-sleeve. *Harper's*

Lace basquine. *Harper's*

Coins

Virginia penny.

Ancient Greek coin showing image of Artemis.

Shilling of Henry VIII.

Coin of Antiochus III.

Thaler of Luneburg, 1547.

Ancient coin of Tyre.

Newark Siege-piece.

Japanese coins.

Hebrew shekel.

Melkart, the Tyrian Hercules.

Ancient Chinese pu.

Farthing of Charles II, 1672.

Coin of Vespasian.

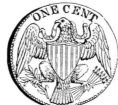

Batz of St. Gall, Switzerland.

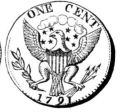

Tetradrachm of Alexander the Great.

Chalchihuitls, Mexican stones.

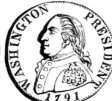

Washington cent, 1791, reverse large eagle, and reverse small eagle.

Peso duro of Mexico.

Broad of James I.

Macedonian coin.

Cloth money.

Rupie, German East Africa.

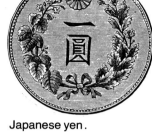

Japanese yen.

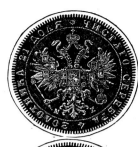

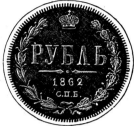

Ruble, 1862.

Mark, Germany

Krone, Austria.

Fourpenny piece of Queen Victoria.

Coin of Nero.

George-noble of Henry VIII.

American dollar.

Russian ruble.

Solidus of Constantine the Great.

First money coined by the U. S.

Pataca of John V, 1749.

Washington half-dollar.

Bezant (Solidus) of Romanus III.

Japanese 10-yen piece.

Comic Figures

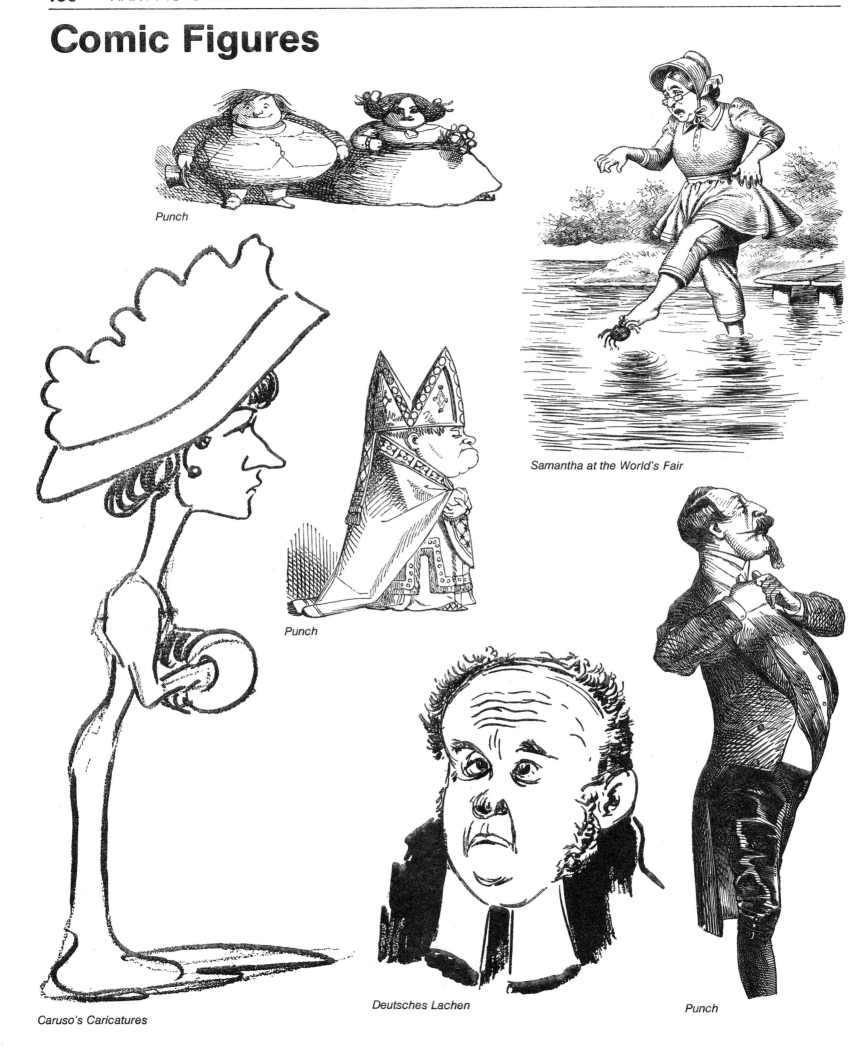

Punch

Samantha at the World's Fair

Punch

Caruso's Caricatures

Deutsches Lachen

Punch

Drawing by Aubrey Beardsley. *The Early Work*

Punch

Punch

Punch

The Art of the Book

Punch

Comic Figures continued

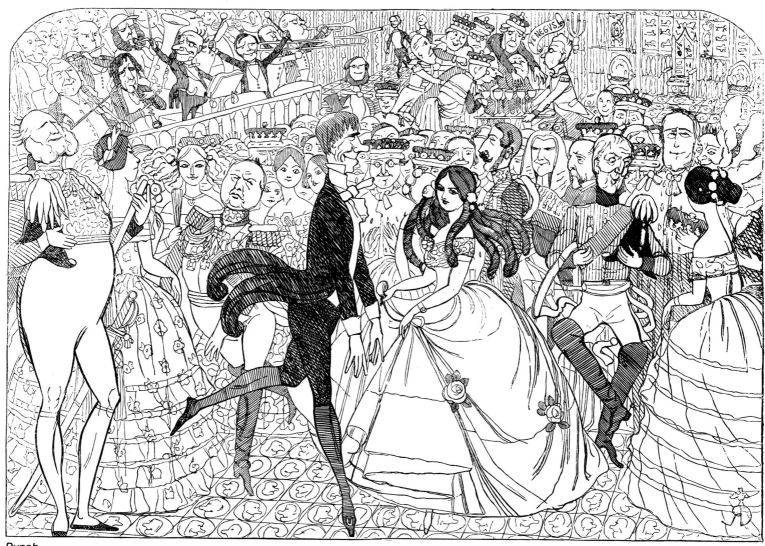

Punch

Deutsches Lachen

Harper's, Vol. 103

Punch

Deutsches Lachen

Punch

Punch

Punch

Caruso's Caricatures

Punch

Death & Grieving

Fifty Years of Soviet Art □

Leslie's

Harper's

Harper's

Leslie's, Vol. 15

Nikolai Ivanovich Piskarev

Death & Grieving continued

Fifty Years of Soviet Art

Leslie's

Leslie's

Graphic Arts of Lvov □

Leslie's

Harper's

Leslie's

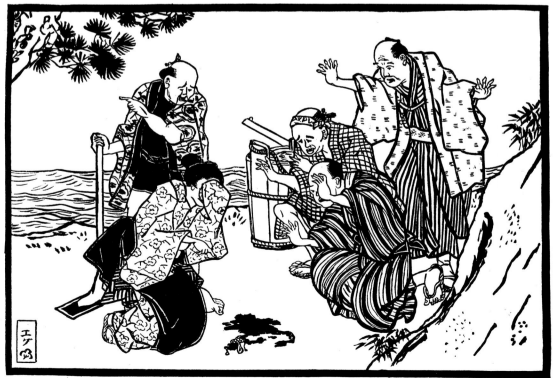

Nikolai Ivanovich Piskarev

Leslie's

Decorative Objects

Cut crystal pitcher. *Illustrated London News*

Grenzhausen mug, 18th century.
Century Dictionary, Vol. 9

Sculptured silver dish. *Meyers Lexikon*

The Dodwell Vase, from Moses.
Scribner's Magazine, Vol. 3

Siegburg Cannette, 1589.
Century Dictionary, Vol. 9

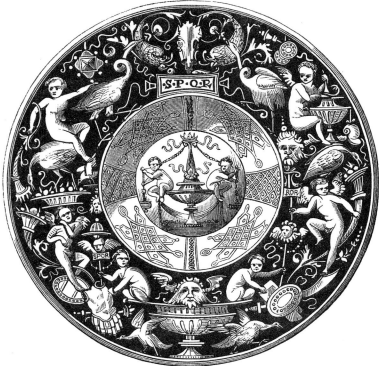

Faenza fruit dish, ornamented with "Amorini" trophies
and arabesques. *Harper's, Vol. 48*

Painted vase from Tenampua.
Leslie's, Vol. 15

Whistling jar. *Zell's*

Water vessel, copper-tinned,
old Kashmir ware. *Indika*

Plate. *Meyers Lexikon*

Kreussen drug-jar, 1657.
Century Dictionary, Vol. 9

Water jug. *Crystal Palace*

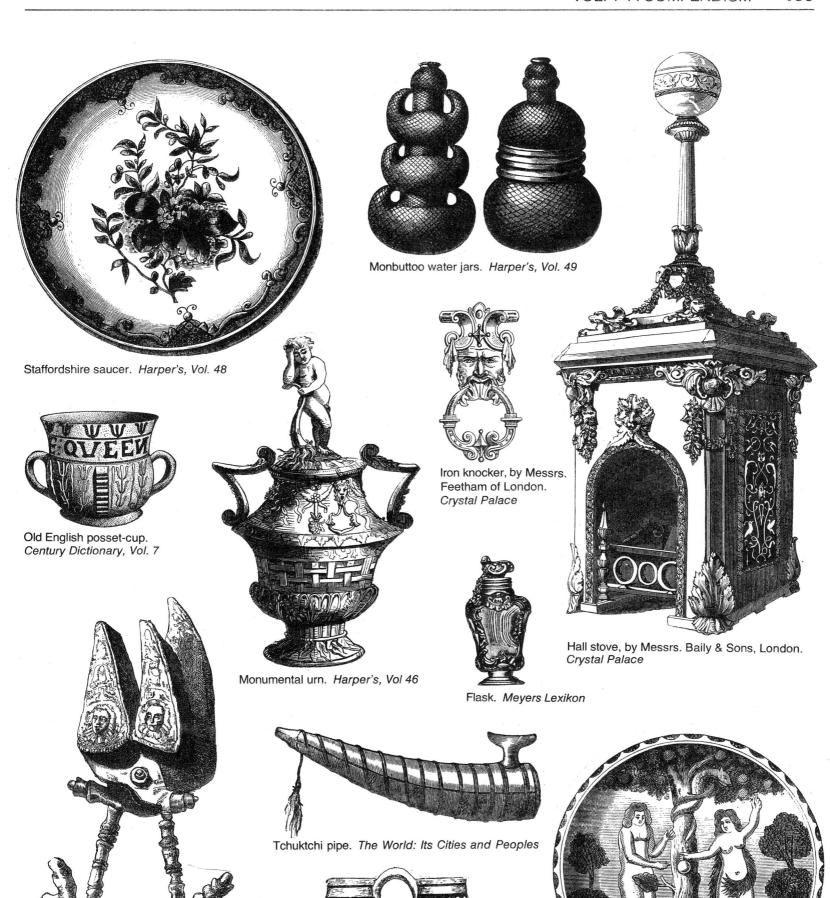

Staffordshire saucer. *Harper's, Vol. 48*

Monbuttoo water jars. *Harper's, Vol. 49*

Old English posset-cup.
Century Dictionary, Vol. 7

Iron knocker, by Messrs.
Feetham of London.
Crystal Palace

Monumental urn. *Harper's, Vol 46*

Flask. *Meyers Lexikon*

Hall stove, by Messrs. Baily & Sons, London.
Crystal Palace

Tchuktchi pipe. *The World: Its Cities and Peoples*

Snuffers dug up at Dorchester. *Harper's*

Mochaware, English double water jug,
about 1800. *Century Dictionary*

Staffordshire ware, about 1650. *Harper's, Vol. 48*

Decorative Objects continued

Basket, South Australia. *Natural History, America and Asia*

Antique clock, designed by Woodington. *Crystal Palace*

Grenzhausen mug, 18th century. *Century Dictionary, Vol. 9*

Corinthian vase. *Harper's*

Aftaba (water vessel), copper-tinned, from Peshawur. *Indika*

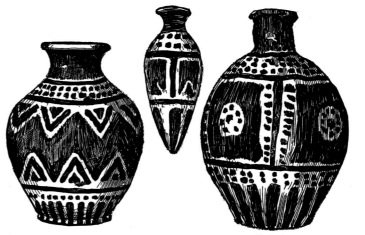

Greek bottles, from the Museum of Napoleon III. *Historians' History*

Base of a salt-cellar, Limoges, 16th century.

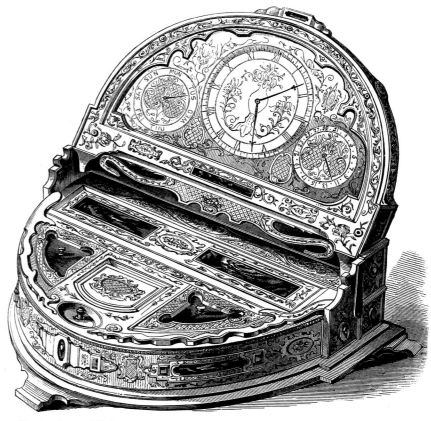

Clock. *Crystal Palace*

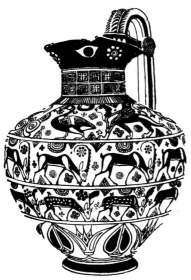

Greek jug. *Historians' History*

Staffordshire ware, about 1650. *Harper's, Vol. 48*

Teapot. *Illustrated London News*

Mexican stirrups. *Natural History, America and Asia*

Washington pitcher, Liverpool, England, 1800. *Zell's*

Decorative Objects continued

Drinking vessels. *Harper's*

Metal bell pulls. *Crystal Palace*

Infant's cradle. *Harper's, Vol. 21*

Victoria Regia cot, designed by J. Bell. *Crystal Palace*

Raeren jug, 1597.
*Century Dictionary,
Vol. 9*

Biberon of orion ware. *Leslie's*

German drinking jug, 17th century.
Zell's, Vol. 2

American dinner ware. *Illustrated London News*

Haviland china. *Illustrated London News*

Delft ware, 17th century. *Zell's*

Gourd snuff box.

Greek jug. *Historians' History*

Vase. *Illustrated London News*

Iron cup by M. Falloise, of Liège. *Crystal Palace*

Saxon jar. *Harper's, Vol. 48*

Early German pitcher. *Leslie's*

Leather jewelry box.
Catalog of the Unusual

Berry dish. *Illustrated London News*

Ornament for edifice. *Crystal Palace*

Designs & Patterns

Pattern from a cotton-printer's block, 19th century, Indian. *Pattern Design*

Top of Henri II salt-cellar.
Harper's, Vol. 51

Design of French origin.
Harper's

Japanese stencil of umbrellas with characters and crests of owners.
Japanese Stencil Designs

Interlaced ornament, Russian, Middle Ages.
Designs and Patterns

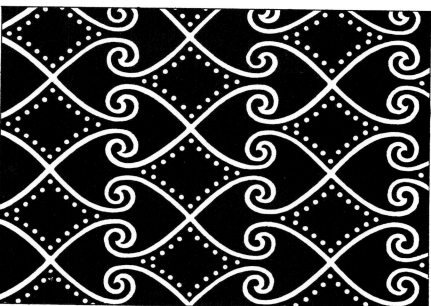

Diaper ornament, Egyptian. *Designs and Patterns*

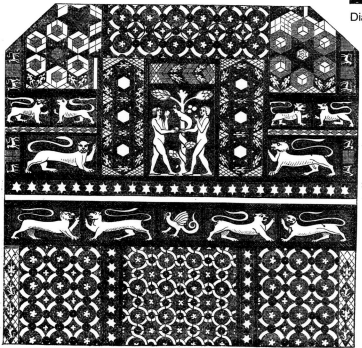

Tile decoration from Cruden's Chapel, Saracenic origin, copied by the English. *Harper's, Vol. 48*

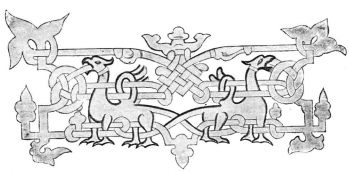

American, 19th century. *St. Nicholas* □

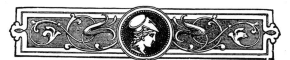

Victorian. *England Under Victoria*

American. *Leslie's*

Victorian. *England Under Victoria*

Fret diaper ornamentation, Japanese.
Designs and Patterns

Modern French conventional foliage from the paintings of the chapels of Nôtre Dame, Paris, France. *Designs and Patterns*

Designs & Patterns continued

Japanese conventional foliage.
Designs and Patterns

Century Magazine

Historians' History

Ornamentation. *Arabian Nights*

Arabesque counterchange pattern.
Architectural Styles

Book decoration, 16th century. *Harper's*

Thomas Hood

Enamelled earthenware tile, Turkish, 17th century, from the
Victoria and Albert Museum, London, England. *Pattern Design*

Niello, from top of snuff-box. *Century Dictionary, Vol. 6*

Mural decoration at the Alhambra, Granada.

Historians' History

Silver engraved tazza, by R. Attenborough of London. *Crystal Palace*

Fret ornament, Middle Ages, wall painting in the Church of Tournus, Saone-et-Loire. *Designs and Patterns*

Cylindrical stamp found in Piedras Negras, Veracruz, serpent (Coatl) design. *Design Motifs of Ancient Mexico*

Grolier scroll, from a book cover design. *Century Dictionary*

Harper's, Vol. 103

England Under Victoria

Designs & Patterns continued

Decorative woodwork. *Century Magazine, June, 1890*

Mikhail Ivanovich Pikov

Design from a seal cylinder, Assyrian.
Pattern Design

Palmette embroidered on the border of a vestment, Sicilian,
12th century, Imperial Treasury, Vienna. *Pattern Design*

Century Magazine

England Under Victoria

Diaper ornament, German Middle Ages, gold and green counter-changed, red
beaks and feet. *Designs and Patterns*

Diaper ornament, Egyptian.
Designs and Patterns

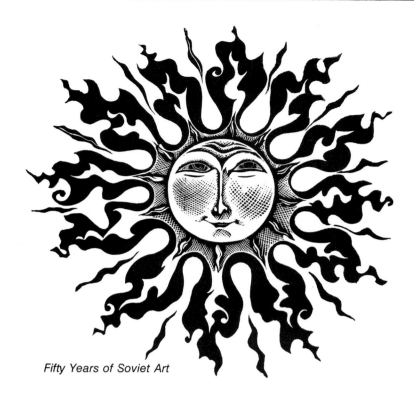

Fifty Years of Soviet Art

Tile from the Malvern Abbey.
Harper's, Vol. 48

Floral pattern. *Japanese Stencil Design*

Conventional foliage, Greek.
Designs and Patterns

Enamelled wall tiles, diaper ornament, Persian.
Designs and Patterns.

Dogs

Flat stamp using dog's head (Itzcuintli), Veracruz, Mexico. *Design Motifs of Ancient Mexico*

Pointer.
The Dog Lover's Reader

Begging, by Hugh Thomson. *Our Village*

Skye terrier. *Harper's*

Dachshunds. *The Dog Lover's Reader* □

A flirtation, by Hugh Thomson. *Our Village*

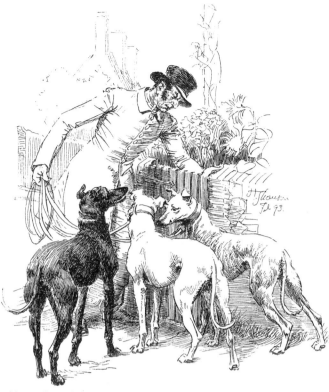

Home from their walk, by Hugh Thomson. *Our Village*

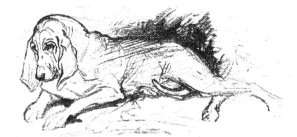

Bloodhound. *Leslie's*

Dog trained by owner, a fishmonger in Peckham, England to carry messages between home and shop. *Leslie's, Vol. 21*

Saint Bernard. *Harper's*

Dignity and impudence. *Harper's, Vol. 10*

Exhortation

Leslie's

Leslie's

Samantha at the World's Fair

Nikolai Ivanovich Piskarev

Fifty Years of Soviet Art □

Fabric Designs

German brocade. *L'Art Pour Tous*

Blanket pattern. *Harper's*

Pattern of a silk damask, Spanish, 15th
15th century, at the Victoria and Albert
Museum, London.

Queyu, or bead apron. *Natural History of Man, Africa*

Detail from a woven silk fabric, Venetian,
15th century. *Pattern Design*

Cotton shroud. *Leslie's*

Handmade all lace
Renaissance tidy.
Sears Catalogue

Handmade linen doily
with Renaissance lace
edge. *Sears Catalogue*

Canzou, or lady's cape of
embroidered needle-work.
Crystal Palace

German cross-stitch, 16th century. *L'Art Pour Tous*

Unit of a textile pattern represented in
a picture by Giotto, Italian, early 14th
century. *Pattern Design*

Design from a woven silk fabric, Byzantine, 12th century.
Pattern Design

Border design, 16th century. *L'Art Pour Tous*

Faces

Leslie's

Girl of Makhana, Upper Senegal, Africa.
The World: Its Cities and Peoples

Nikolai Ivanovich Piskarev

Life

Fifty Years of Soviet Art

Harper's

Nikolai Ivanovich Piskarev

Leslie's

Faces continued

Harper's

Leslie's

Aleksandr Vasin □

Nikolai Ivanovich Piskarev

Harper's, Vol. 46

Century Magazine

Essays on Polish Graphic Arts

Century Magazine

Polar and Tropical Worlds

Faces continued

Southwestern landowner. *Scribner's*

Nikolai Ivanovich Piskarev

Nadir Abdurakhmanov

The World: Its Cities and Peoples

Drawing by G.H. Bartlett. *Pen and Ink Drawing*

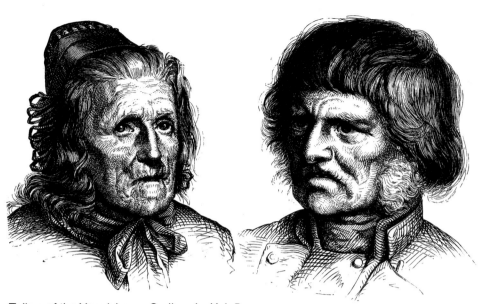

Toilers of the Vogelsberg. *Scribner's, Vol. 5*

Essays on Polish Graphic Arts □

Leslie's

Leslie's

London Illustrated News

Faces continued

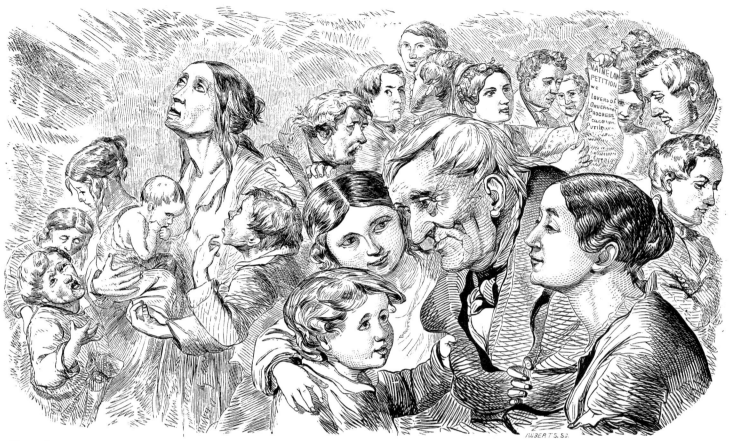

Harper's

Century Magazine

The World: Its Cities and Peoples

Essays on Polish Graphic Arts

Illustrated London News

Through Asia, Vol. 1 □

Essays on Polish Graphic Arts □

Natural History of Africa

Factories & Mills

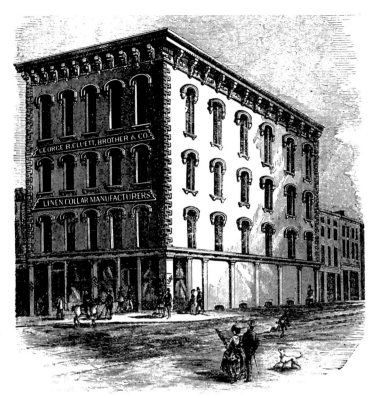

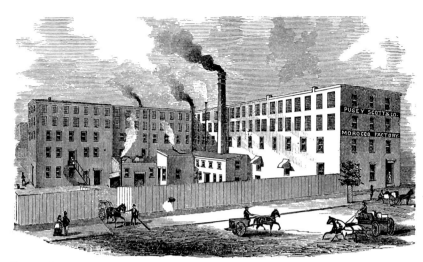

Pusey Scott & Co., Morocco factory. *Leslie's*

George B. Cluett, Brother & Co.'s linen collar factory, Troy, New York. *Great Industries*

Sugar mill. *Century Dictionary*

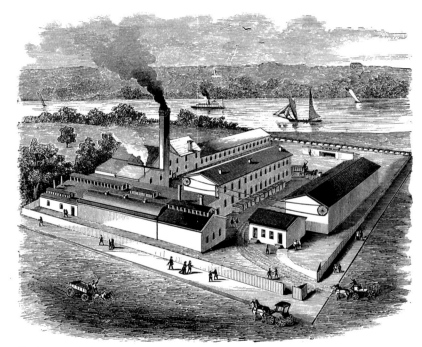

Parlor-match factory. *Leslie's*

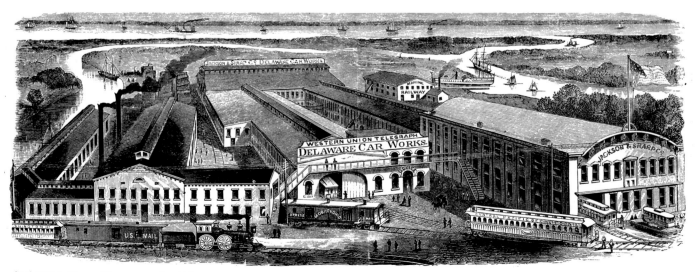

Jackson & Sharp Co. car works, Wilmington, Delaware. *Great Industries*

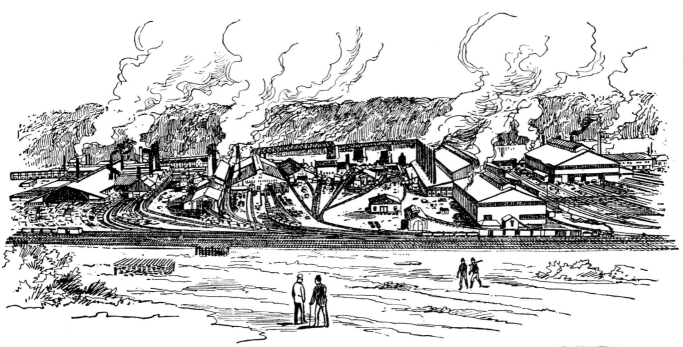

Carnegie Works, Homestead, Pa. *Police Gazette, 1892*

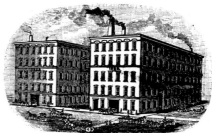

Screen factories.
Century Magazine, 1891

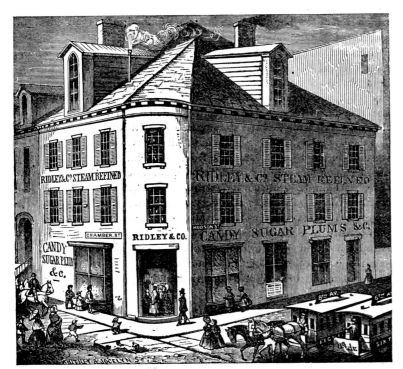

Ridley & Co. candy factory, Hudson Street, New York City. *Harper's*

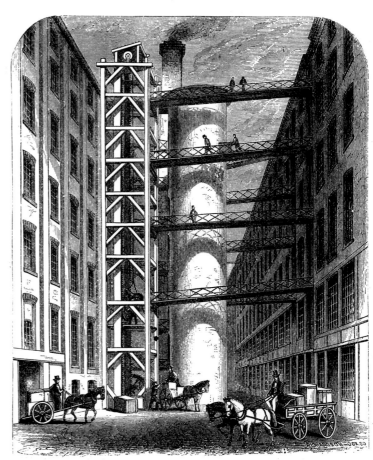

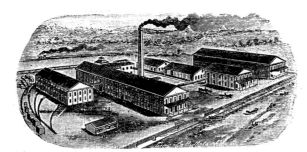

Century Magazine

Courtyard of Harper and Brothers, publishers, New York City.
Harper's, Vol. 31

Families

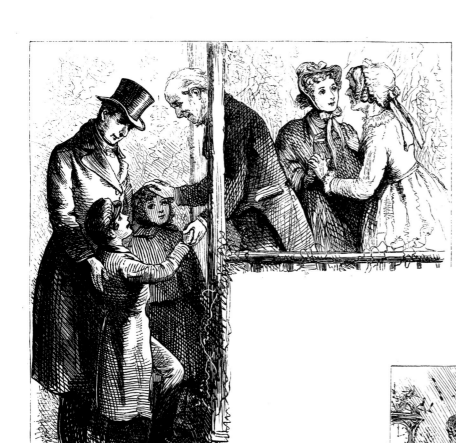

Harper's

Munsey's

Harper's

St. Nicholas

Art of the Book

Drawing by Hugh Thomson. *Our Village*

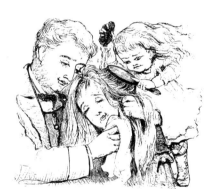

Art of the Book

Harper's

Harper's

Families continued

Harper's

Harper's, Vol. 47

Leslie's

Art of the Silhouette

Nikolai Ivanovich Piskarev

Leslie's

Punch

Harper's

St. Nicholas

Fantasies

Manticore. *Curious Woodcuts of Fanciful and Real Beasts*

Punch

Fifty Years of Soviet Art □

Plumed snake, ancient Pueblo pottery pictography, Shongopovi, Arizona. *Southwestern Indian Art*

Horseshoeing a duck.

Fifty Years of Soviet Art □

Ancient Pueblo pottery design, Mimbres, New Mexico. *Southwestern Indian Art*

Punch

Punch

Harper's

Art of the Book

Harper's

Punch

Drawing by George Cruikshank. *Comic Almanack*

Ancient Shongopovi picture writing, Pueblo pottery design. *Design Motifs of Ancient Mexico*

Art of the Book

Punch

Drawing by George Cruikshank. *Comic Almanack*

Punch

Punch

Fantasies continued

Fifty Years of Soviet Art

Punch

Southwestern Indian Art

Deutsches Lachen

Mythological group from a Chimu vase. *Harper's*

Life

The Art of the Book

Harper's

Nikolai Ivanovich Piskarev

Punch

Century Magazine

Fifty Years of Soviet Art

Farms & Farmyard Animals

Masked Japanese pig. *Lydekker*

Sheep. *Standard Horse and Stock*

Sow and pigs. *Catchpenny Prints*

Ox prepared for casting. *Standard Horse and Stock*

A Dakota wheat farm. *Marvels of the New West*

Carriage horses. *Harper's* ▫

Safety band for supporting cattle in rough sea.
Leslie's

Dogs chasing sheep. *Our Village*

Bronze turkey. *Harper's*

The Morningside Barn Chapel, Ozark Mountains.

Farms & Farmyard Animals continued

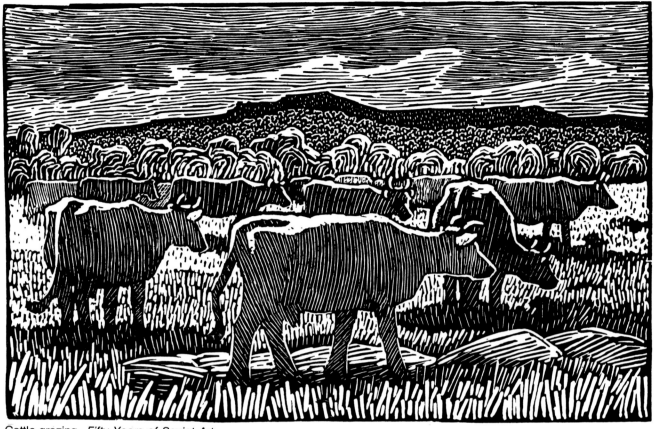

Cattle grazing. *Fifty Years of Soviet Art*

Mule. *Century Magazine*

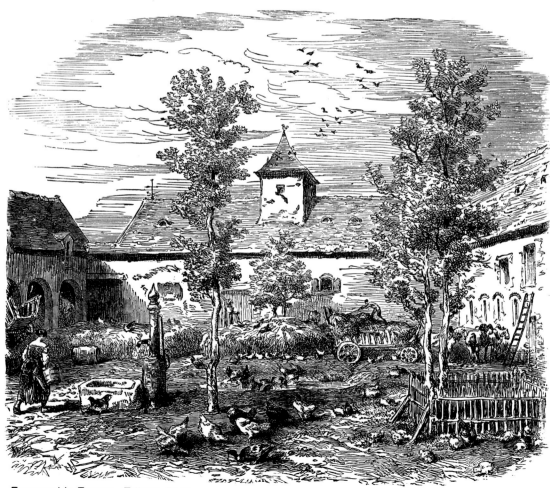

Farmyard in France. *Tribute Book*

Rooster.
French Advertising Art

Gayal. *Century Dictionary*

Barnyard. *Harper's*

Ram. *Century Dictionary*

Ancient shepherd with black-headed sheep. *Lydekker*

Barred Plymouth Rock female. *Standard of Perfection*

Farms & Farmyard Animals continued

Geese on the road. *Century Magazine*

The pup's affair with the gander, by Hugh Thomson. *Our Village*

Goat with collar. *Standard Horse and Stock*

Dwarf Chinese pigs. *Lydekker*

Sheep heads, by G.H. Bartlett. *Pen and Ink Drawing*

Four-horned ram. *Zell's*

Ox-cart, by G.H. Bartlett. *Pen and Ink Drawing*

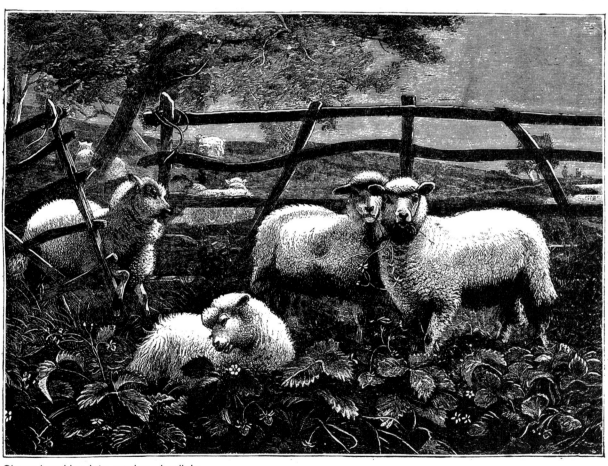

Sheep breaking into garden. *Leslie's*

Tail wagon. *Standard Horse and Stock*

Farmhouse site of Civil War battle of Groveton Corners, Virginia, August, 1862. *Century War Book*

Fish

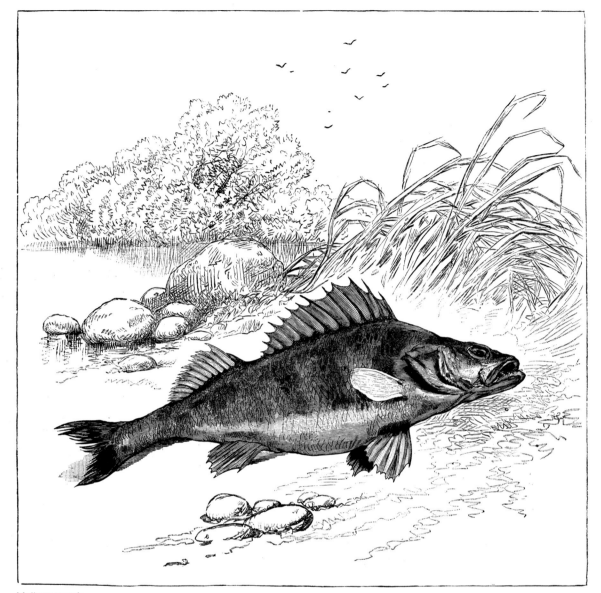

Yellow perch.

Butterfish. *Century Dictionary*

A wing-shell or stromb.
Century Dictionary

Boar-fish. *Century Dictionary*

Sun-fish. *Zell's*

European sole. *Century Dictionary*

Black bass. *Harper's*

Venus' girdle. *Lydekker*

Barracuda and fishing-frog. *Lydekker*

American sole or hogchoker.
Century Dictionary

Black grunt. *Century Dictionary*

Sea anemone, open and closed.
Century Dictionary

Sheat-fish. *Century Dictionary*

River crawfish. *Century Dictionary*

Common lamprey. *Zell's*

Indo-Pacific basking shark. *Lydekker*

Fish continued

River mussel, North Carolina.
Century Dictionary

Shrimp. *Basics of Fishing*

Minnow. *Basics of Fishing*

Bowfin, or mudfish. *Century Dictionary, Vol. 1*

Trout egg magnified. *Harper's*

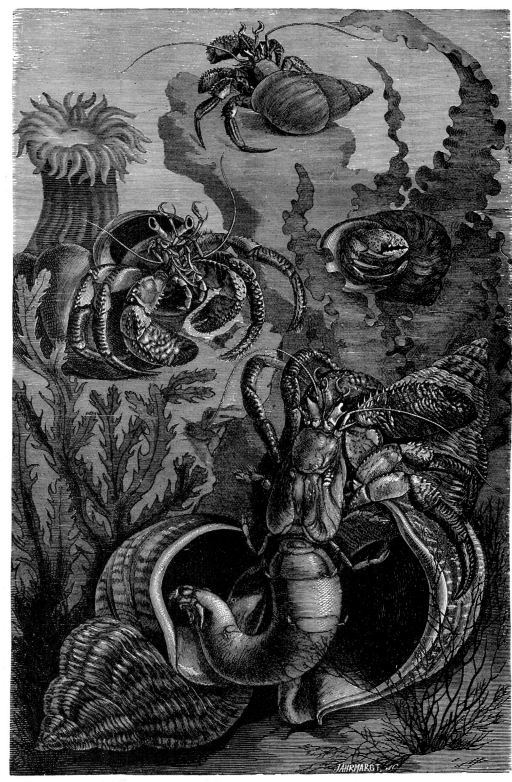

Hermit crabs. *Lydekker*

Myristica melongena.
Century Dictionary

Eel. *Leslie's, Vol. 21*

Chain pickerel. *Basics of Fishing*

Halibut. *Harper's, 1852*

Shells of the Infusoria. *Harper's*

Rainbow trout. *Basics of Fishing*

Common pike. *Lydekker*

Young edible crab. *Lydekker*

Poison-fish. *Century Dictionary*

Herring. *Harper's, 1852*

Lesser spotted dog-fish and its eggs. *Lydekker*

Fishermen & Sailors

Dutch boatman.
The World: Its Cities and Peoples

Russian boatman. *Nadir Abdurakhmanov*

Century Magazine

Century Magazine

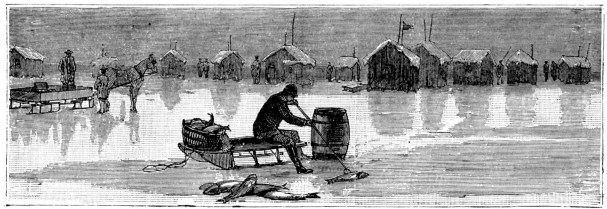

Village of Fishtown during the business season. *Leslie's*

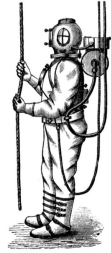

Deep water
diver's suit.
Meyers Lexikon

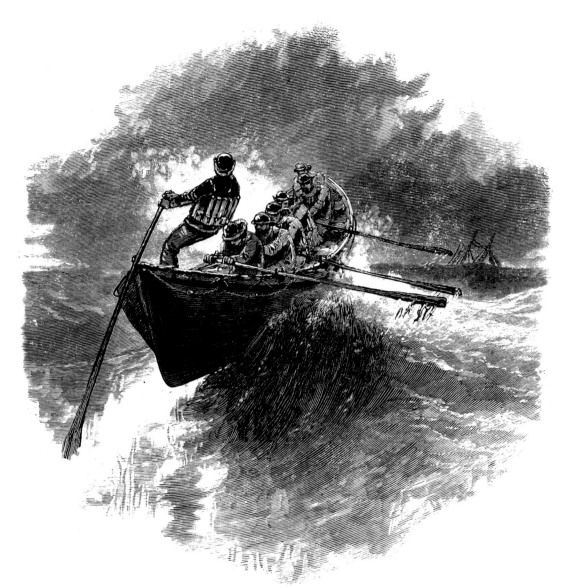

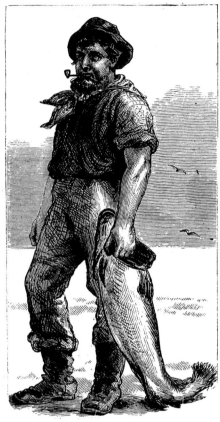

Harper's

The life-saving service on the Great Lakes. *Leslie's*

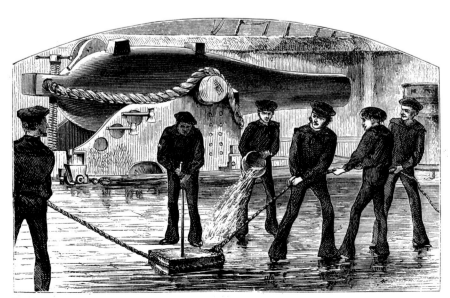

Swabbing the deck. *Illustrated London News*

Stormy weather. *Century Magazine*

Food & Drink

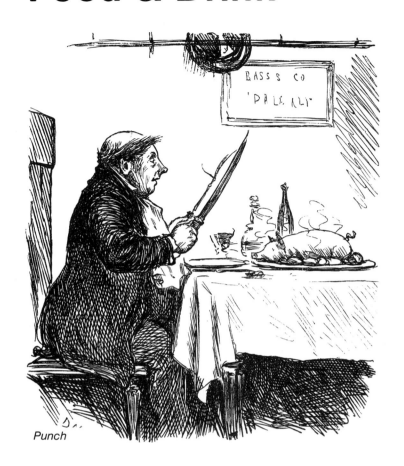

Punch

Century Dictionary

Harper's

Harper's

Harper's

The Art of the Book

Harper's

Punch

Harper's

Harper's

Harper's

Illustrated London News

The Art of the Book □

St. Nicholas

Food & Drink continued

Century Magazine, 1891

Punch

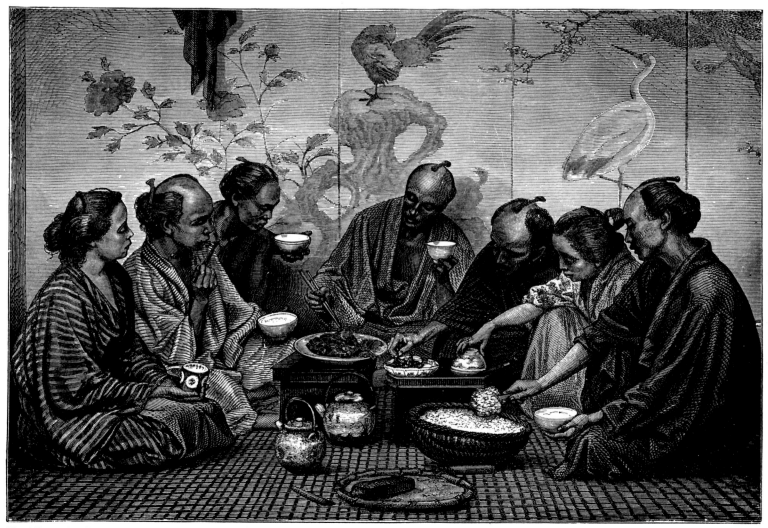

The World: Its Cities and Peoples

Harper's

Harper's

Anatoly L'vovich Kaplan □

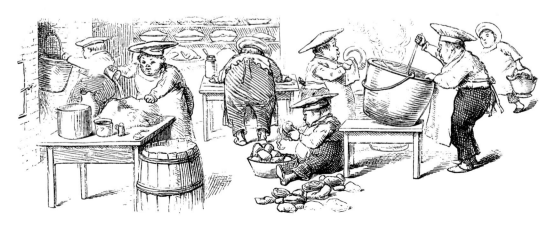

Harper's

Menu ornament, 19th century.

Fountains

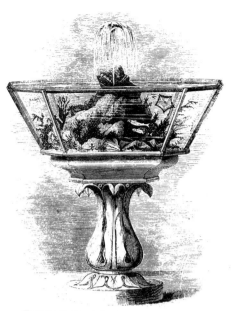

Fountain aquarium.
Illustrated London News

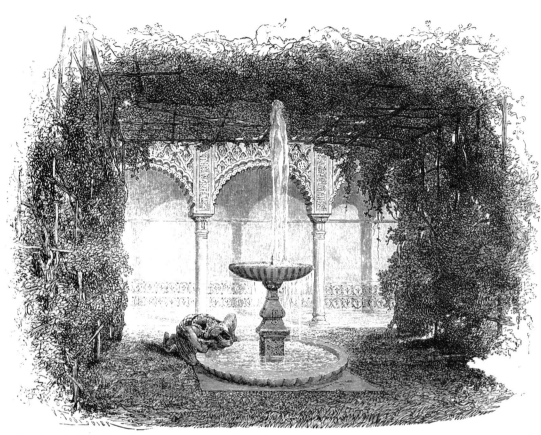

Fountain in the Alhambra. *Voyages and Travels*

Holy water stoup, Church
of San Miniato, Florence.
Century Dictionary

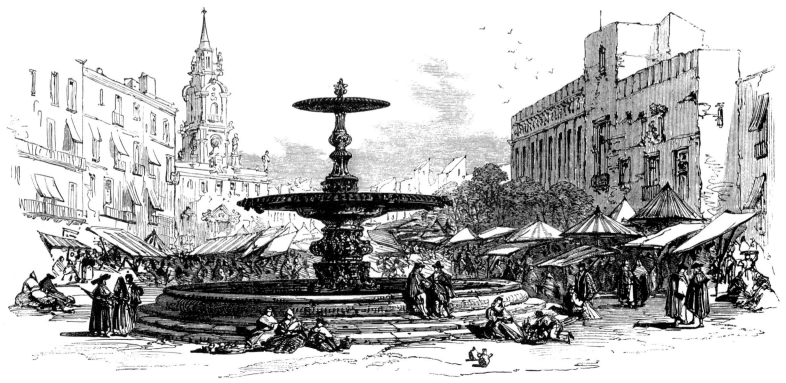

Fountain in a Mexican market place. *Illustrated London News*

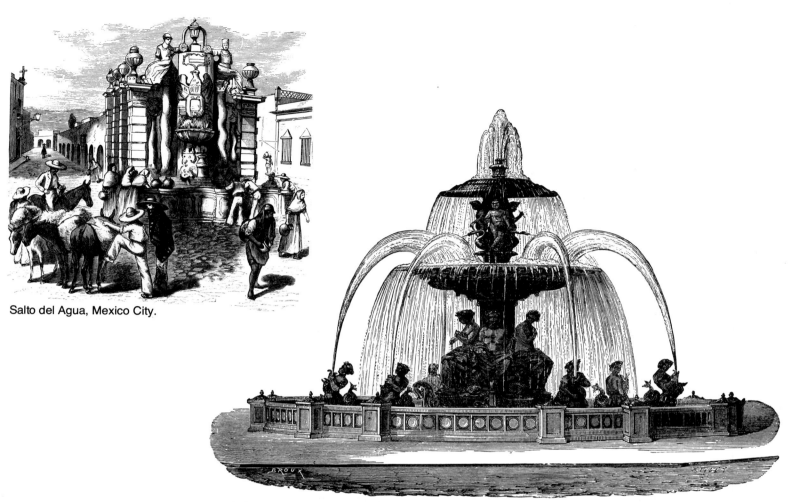

Salto del Agua, Mexico City.

Fountain in the Place de la Concorde, Paris. *The World: Its Cities and Peoples*

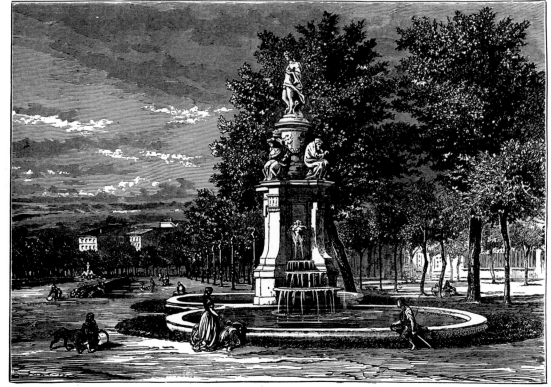

Fountain of the Four Seasons, The Prado, Madrid. *Voyages and Travels*

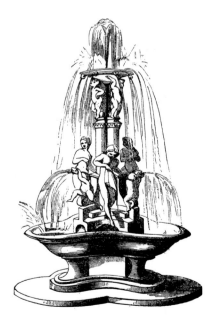

Bronze model of a fountain by Gasser of Vienna. *Crystal Palace*

Furniture

Armchair by Thierichens, Berlin. *Meyers Lexikon*

French dressing table by Ch. Plumet, Paris. *Meyers Lexikon*

Night table by L. Sorel, Paris. *Meyers Lexikon*

Tea table by H. Sauvage, Paris. *Meyers Lexikon*

Sofa with two settees, 18th century. *Century Dictionary*

Bench by R. Riemerschmid. *Meyers Lexikon*

American sofa, circa 1900. *Sears Catalogue*

Scandinavian table by Hirschler, Berlin. *Meyers Lexikon*

Armchair by B. Pankok, Munich. *Meyers Lexikon*

Chair by L. Sorel, Paris. *Meyers Lexikon*

Cromwellian music table, by G.H. Bartlett. *Pen and Ink Drawing*

Cabinet by A. Petrasch, Munich, Germany.
Meyers Lexikon

Chair by Stil von Dittmar,
Berlin, Germany.
Meyers Lexikon

Snap table.
Century Dictionary

Chair by R. Riemerschmid,
Munich, Germany.
Meyers Lexikon

American oak cupboard,
circa 1900.
Sears Catalogue

Sheraton card table,
by G.H. Bartlett.
Pen and Ink Drawing

Chair by F. Hanel, Berlin,
Germany. *Meyers Lexikon*

Open cabinet and chair by L. Majorelle,
Nancy, France. *Meyers Lexikon*

Oak rolltop
desk.
*Century
Magazine*

Urn stand.
*Century Dictionary,
Vol. 10*

Wrought iron bed. *Sears Catalogue*

Japanese fire screen.

Table and chair by L. Majorelle, Nancy, France.
Meyers Lexikon

Furniture continued

Chair by Thierichens, Berlin. *Meyers Lexikon*

German table. *Meyers Lexikon*

Oak bookcase and desk. *Sears Catalogue*

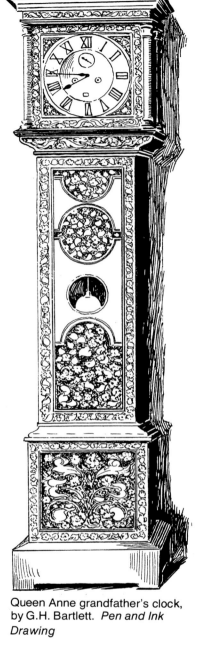

Queen Anne grandfather's clock, by G.H. Bartlett. *Pen and Ink Drawing*

Tambour writing table. *Century Dictionary*

Darby and Joan seat. *Century Dictionary*

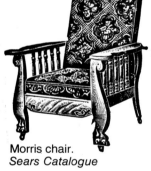

Morris chair. *Sears Catalogue*

Folding stool. *Meyers Lexikon*

Scandinavian armchair by W. Leistikow, Berlin. *Meyers Lexikon*

Oak rocker. *Sears Catalogue,*

Italian chest. *Meyers Lexikon*

French table. *Meyers Lexikon*

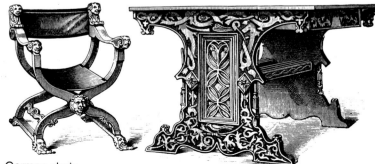

German chair. *Meyers Lexikon*

German table. *Meyers Lexikon*

Oak desk and chest. *Sears Catalogue*

Ancient chair at Moor Park, England.
Leslie's

Music chair. *Crystal Palace*

Pedestal.
Century Magazine

Picture frame.

Ladies' desk.
Sears Catalogue,

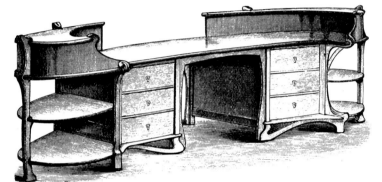

Writing table, by H. van de Velde,
Brussels, Belgium. *Meyers Lexikon*

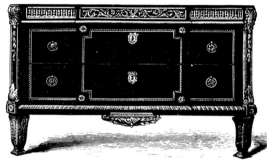

Commode. *Meyers Lexikon*

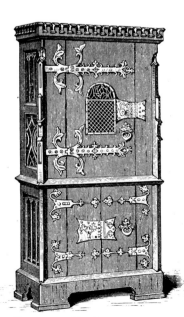

German cabinet.
Meyers Lexikon

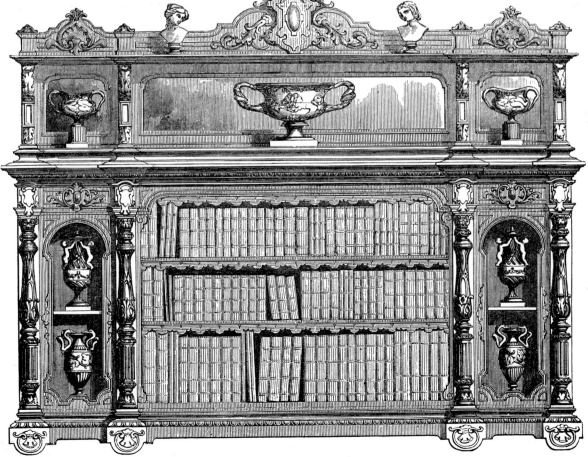

French bookcase. *Crystal Palace*

Furniture continued

Rosewood and walnut table, by Michael Thonet, of Vienna. *Crystal Palace*

Antique ornamental table used by Washington. *Harper's, Vol. 18*

German choir chair. *Meyers Lexikon*

Smokers' cabinet, open. *Century Magazine, 1901*

Oak rolltop desk. *Sears Catalogue*

Chippendale chair, after a design by Thomas Chippendale. *Century Dictionary, Vol. 2*

Oak pedestal table. *Sears Catalogue*

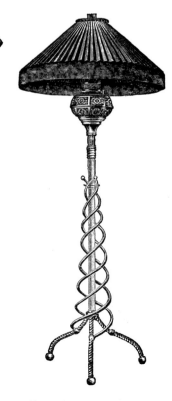

Brass lamp. *Century Magazine, 1890*

Brass bedstead. *Illustrated London News*

Communion table. *Field Book of the Revolution*

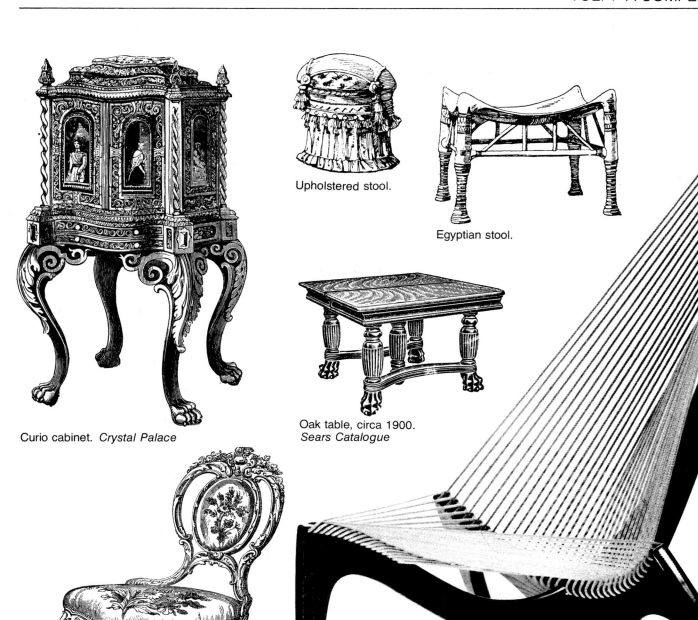

Curio cabinet. *Crystal Palace*

Upholstered stool.

Egyptian stool.

Oak table, circa 1900.
Sears Catalogue

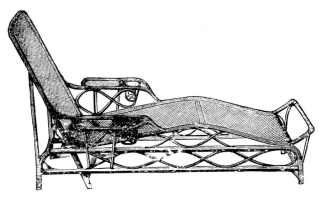

Danish rope chair. *Catalog of the Unusual* □

Upholstered chair, by Jackson &
Graham of London. *Crystal Palace*

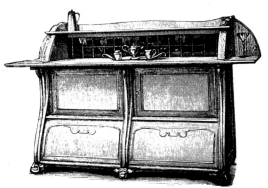

Buffet, by H. van de Velde, Brussels,
Belgium. *Meyers Lexikon*

Cane lounge. *Illustrated London News*

Walnut early English
dining-room chair.
Illustrated London News

Glassware

Crystal decanter. *Crystal Palace*

Venetian wine-glass, 16th century. *Harper's, Vol. 42*

Theban glass-makers. *Harper's, Vol. 42*

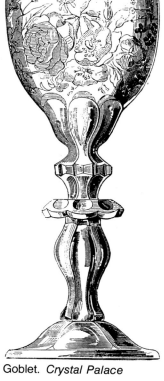

Goblet. *Crystal Palace*

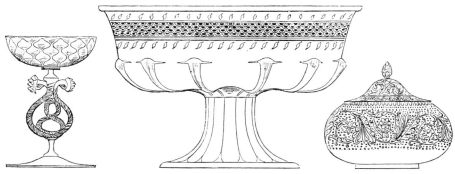

Venetian glassware. *L'Art Pour Tous*

Flagon. *Harper's*

Cut glass vase. *Crystal Palace*

Engraved flagon, Clichy glass-works. *Harper's, Vol. 42*

German glasses. *L'Art Pour Tous*

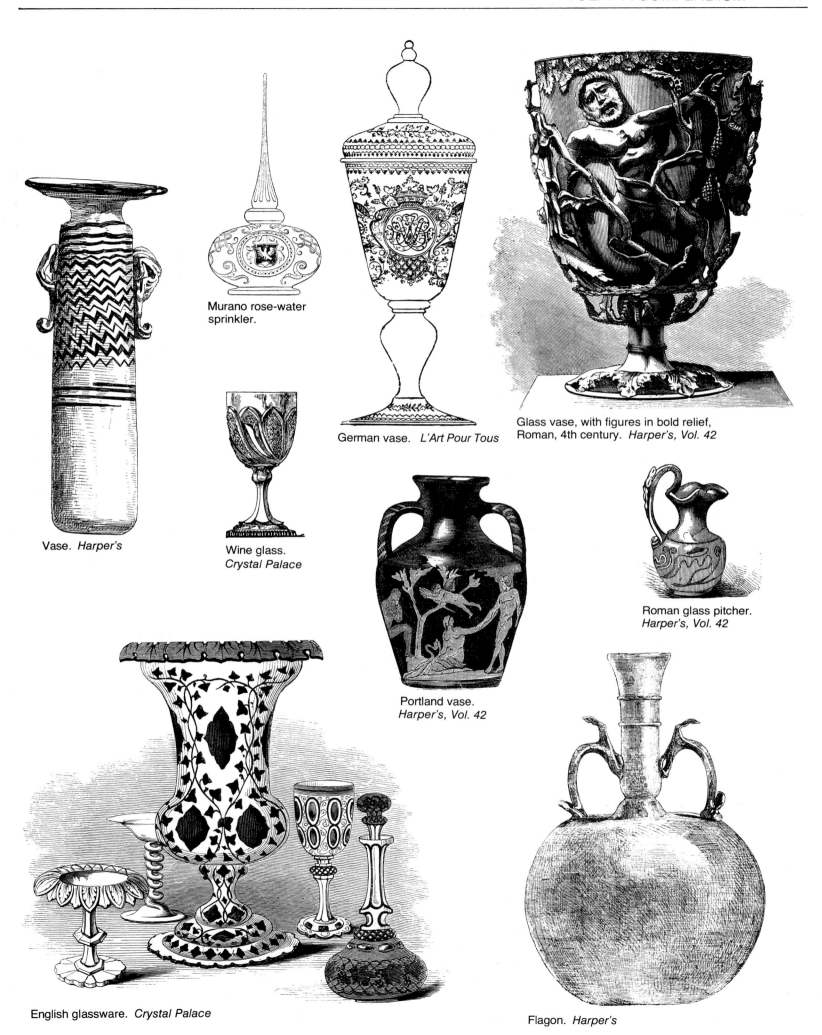

Vase. *Harper's*

Murano rose-water sprinkler.

German vase. *L'Art Pour Tous*

Wine glass.
Crystal Palace

Glass vase, with figures in bold relief,
Roman, 4th century. *Harper's, Vol. 42*

Portland vase.
Harper's, Vol. 42

Roman glass pitcher.
Harper's, Vol. 42

English glassware. *Crystal Palace*

Flagon. *Harper's*

Gods & Goddesses

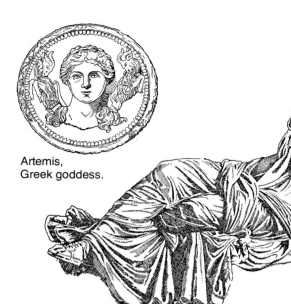

Artemis,
Greek goddess.

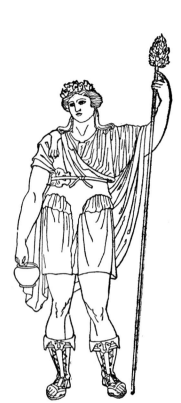

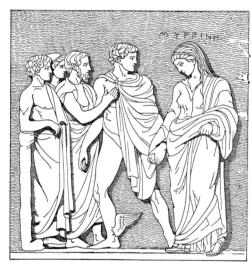

Palantine Apollo, Greek god.
Century Magazine

Sleeping Ariadne, Greek goddess. *Century Magazine*

Bacchus, Roman god.

Hermes, Greek god.

Siva, Hindu god.
Century Magazine

Apis, calf-god of Egypt.

Kali, Hindu god.

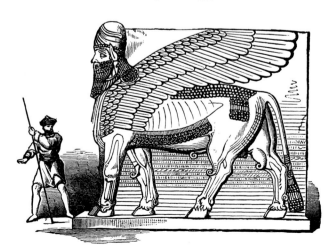

Pan, Greek god.

Poseidon, Greek god.

Winged bull from Nimroud, Assyria.

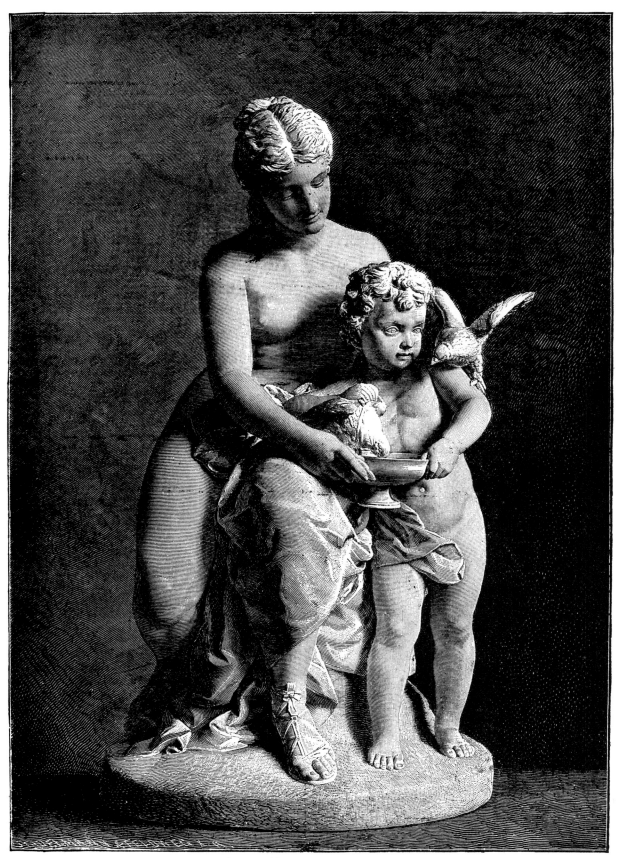

Hebe and Cupid feeding Venus' doves. *Century Magazine*

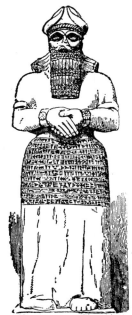

Nebo, Babylonian god of knowledge, literature, and agriculture.

Baal, Canaanite god.

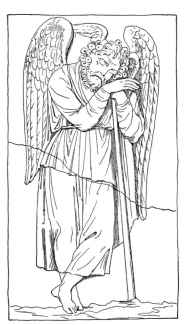

God of Sleep

Goods

Washington's liquor chest.
Harper's, Vol. 18

Elersware teapot. *Illustrated London News*

Ohio lamp.
Century Magazine

Pen nib. *Sears Catalogue*

Bible and iron specs. *Harper's*

Cocoa.
Century Magazine, 1890

Hand truck. *French
Advertising Art*

Tub. *French
Advertising Art*

Soda siphon.
*French
Advertising Art*

Scales. *French Advertising Art*

Lawn mower.
Century Magazine

Comb. *Sears Catalogue*

Mustache comb. *Catalog of the Unusual*

Opera glasses. *Sears Catalogue*

Hose. *French
Advertising Art*

Bowl and pitcher. *Crystal Palace*

National cash register. *Century Magazine*

Steamer trunk. *Sears
Catalogue*

German letter opener. *Meyers Lexikon*

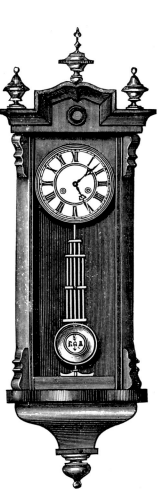

Clock. *French Advertising Art*

Ice cream freezer.
Century Magazine

Pocket knife. *Century Magazine*

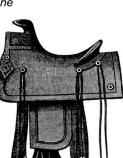

Magnifying glass.
Sears Catalogue

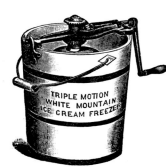

Saddle. *Meyers Lexikon*

Wedgwood basket. *Harper's*

Spools of thread. *Century Magazine*

Travel case for pets.
French Advertising Art

Kerosene lamp.
Sears Catalogue

Old French Stove.
French Advertising Art

Sterling silver lady's hat brush.
Sears Catalogue

Horse's hood.
Sears Catalogue

Thimble. *Sears
Catalogue*

Kennel. *French
Advertising Art*

Lady's tricycle.
French Advertising Art

Safety pin. *Sears Catalogue*

Yale key. *Century Magazine*

Bottles. *Harper's*

Fountain pen. *Century Magazine*

Harbors & Wharves

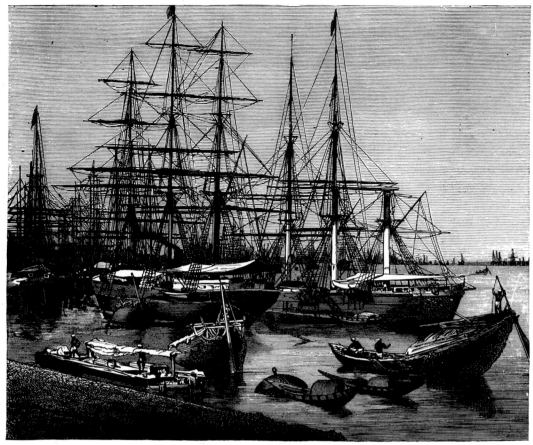

Calcutta, India.

Portland, Oregon. *Zell's,Vol. 2*

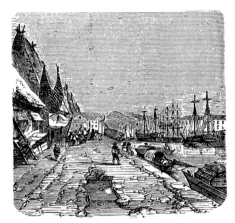

Manila Harbor.

The Mayflower in Plymouth Harbor. *History of the U.S.*

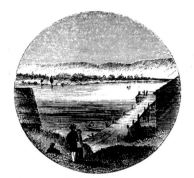

Chimney Point Landing, Vermont. *Harper's*

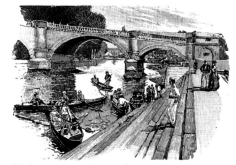

Richmond, Virginia. *Century Magazine*

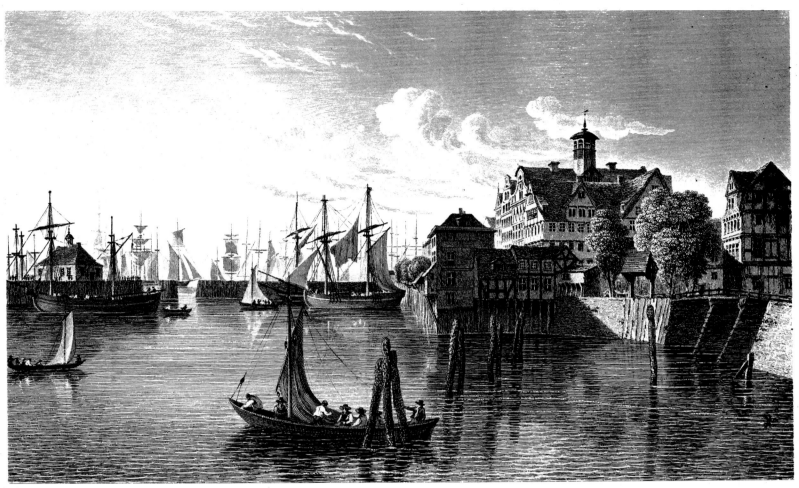

Hamburg, Germany □

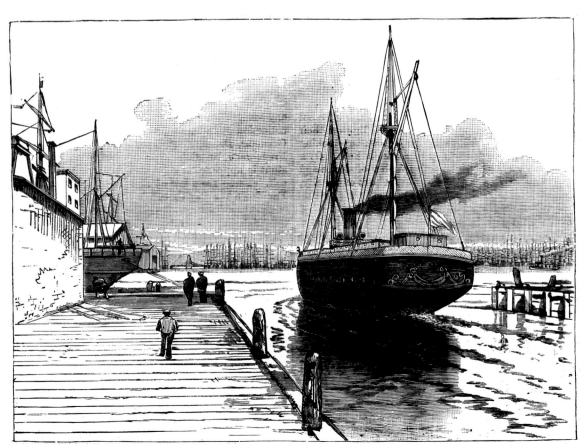

Entrance to the Erie Basin. *Leslie's*

Namur, Belgium. *Zell's*

Harbors & Wharves continued

Wittenham Clump, from
Day's Lock.
Century Magazine

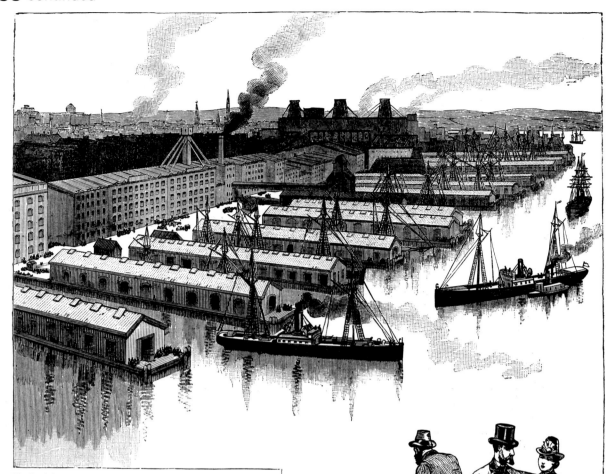

Fruit ships arriving in Brooklyn, New York. *Leslie's*

Ship to shore. *Samantha at the World's Fair*

Souris and Colville Bay, Canada. *Century Magazine*

Art of the Book □

Acapulco. *Zell's*

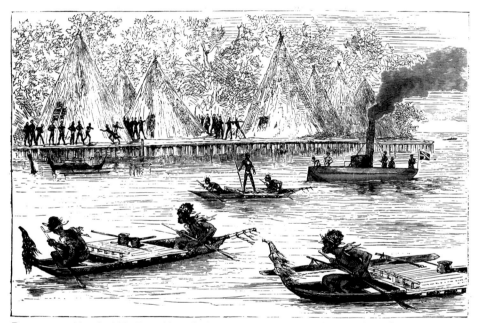

The Art of the Book

Papuans at Humboldt's Bay, New Guinea, alarmed by the arrival of the Challenger.
Century Magazine

Freighter. *Harper's*

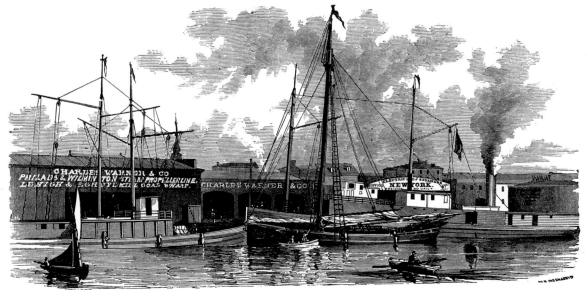

Wilmington, Delaware. *Illustrated London News*

Headpieces & Tailpieces

Century Magazine

Tribute Book

Life of the Greeks and Romans

Punch

Century Magazine

Punch

Tribute Book

By George Wharton Edwards. Century Magazine

Punch

By Irene Jerome. *In a Fair Country*

Century Magazine

Tribute Book

Punch

Century Magazine

Punch

Headpieces & Tailpieces continued

Century Magazine, 1895

Drawing by Hugh Thomson. *Our Village*

Punch

A Bunch of Violets

Century Magazine

Punch

Punch

Punch

Harper's

Tribute Book

Century Magazine

By Alfred Brennan. *Life*

Headpieces & Tailpieces continued

St. Nicholas

Harper's

Drawing by H.R. Millar. *Century Magazine, 1895*

Century Magazine

Punch, Vol. 24

Century Magazine

Century Magazine

Century Magazine

Tribute Book

In A Fair Country

Century Magazine

Drawing by Hugh Thomson. *Our Village*

Heraldic Devices

Cross quartered

Bend azure

Argent (Fesse embattled gules)

Scarp

Cross moline

Fusil

Heraldic fret

Rustre

Barry of six

Per pale gules and argent three roundels counterchanged.

Cross portate

Lion statant gardant

Chevron fracted

Lion salient.

Saltier

Hart at gaze

Fleur-de-lis

Arms of Berlin

Arms of Rome

Arms of Moscow

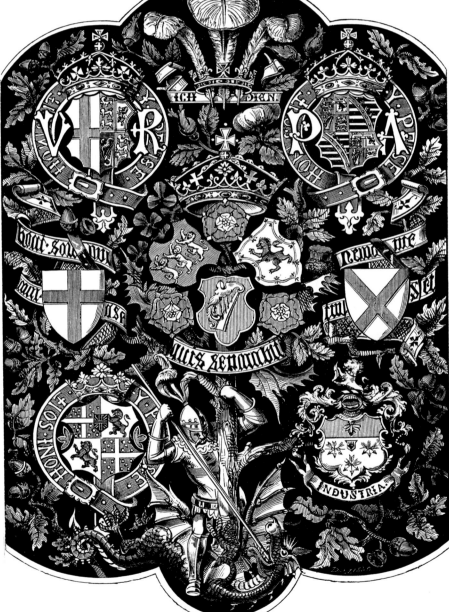
Tapestry worked in heraldic patterns, by Bifield, of Islington. *Crystal Palace*

Arms of the Rothschild Family

Three lions passant gardant, England, 13th century

State coat of arms of Rio de Janeiro, 1866. *Meyers Lexikon*

Arms of Rottweil, 1814. *Meyers Lexikon*

Panther emblazoned arms of Steiermark, 1887. *Meyers Lexikon*

Arms of Saalfeld, 1870. *Meyers Lexikon*

Arms of Hall (Tyrol), 1880. *Meyers Lexikon*

Arms of Olmütz, 1881. *Meyers Lexikon*

Arms of Antwerp.

Arms of Mährisch-Ostrau, 1886. *Meyers Lexikon*

Arms of Görlitz, 1898. *Meyers Lexikon*

Arms of Ols, 1896. *Meyers Lexikon*

Arms and Crown of H. M. THE QUEEN.

Escutcheon of Elizabeth, Queen of Henry VII.

Arms of Brussels.

Arms of Philadelphia.

Arms of Copenhagen.

Smith's arms. *Harper's, Vol. 21*

Blazon emblem of Turkish Empire. *Meyers Lexikon*

Arms of Geneva.

Arms of Chicago. *The World: Its Cities and Peoples*

Arms of Toronto. *The World: Its Cities and Peoples*

Historic Scenes

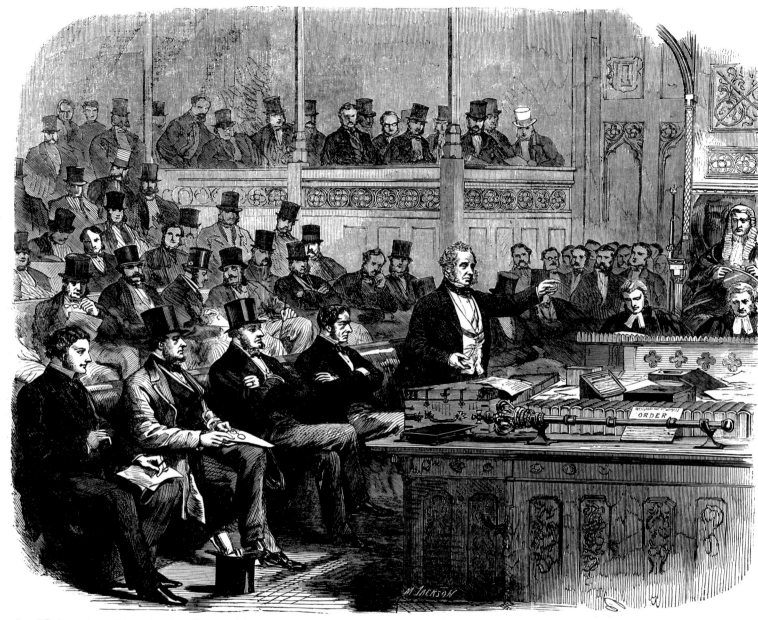

Lord Palmerston addressing the House of Commons.
Illustrated London News

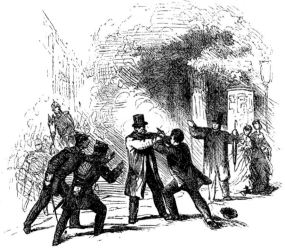

The attempt to assassinate Count Bismarck.
Harper's, Vol. 40

Ovation to Garibaldi at Genoa. *Leslie's*

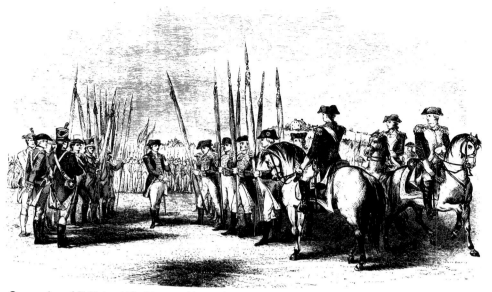

Surrender of British at Yorktown. *Harper's*

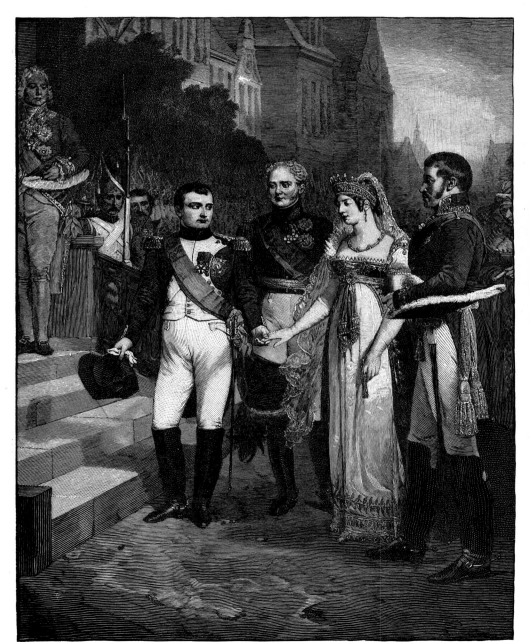

Napoleon receiving the Queen of Prussia at Tilsit. *Century Magazine*

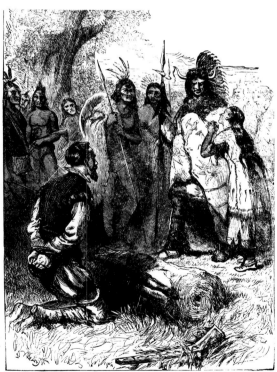

Pocahontas interceding for Captain John Smith. *Harper's*

Historic Scenes continued

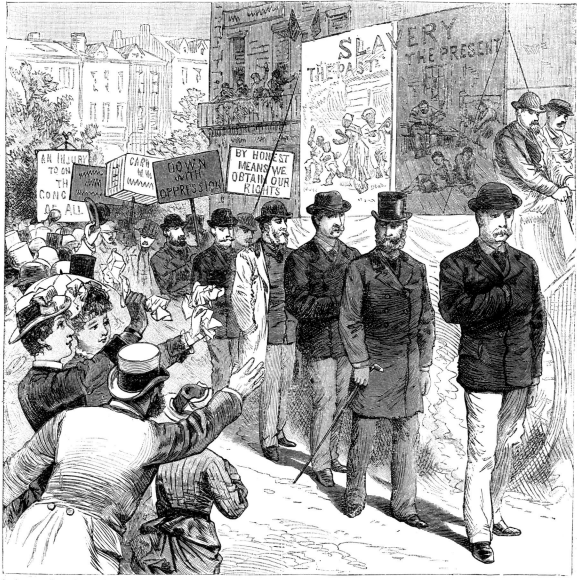

Labor strike. *Leslie's*

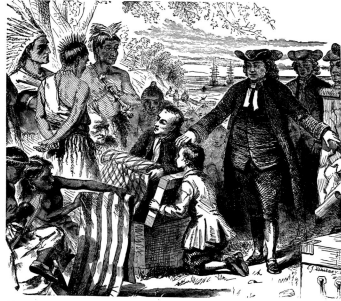

Penn's treaty with the Indians. *Harper's*

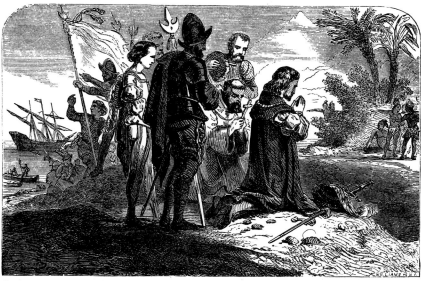

Columbus after landing. *Harper's*

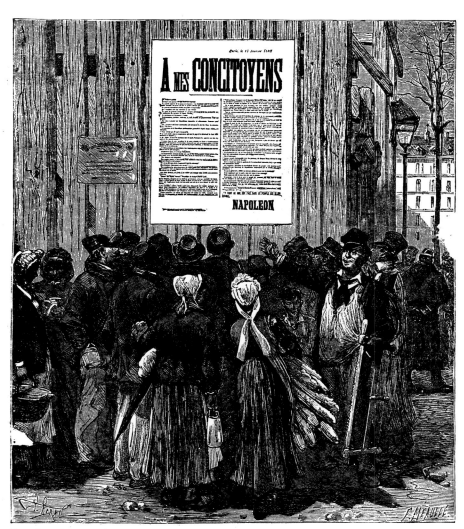

Reading the manifesto of Prince Napoleon. *Harper's*

Joseph relating his dreams to his brethren. *Sunday Book*

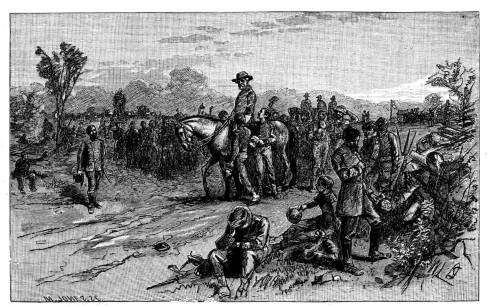

General Lee's return after surrender. *Century Magazine*

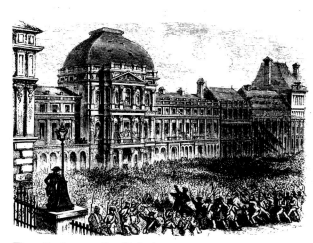

The attack upon the Tuileries. *Illustrated London News*

Homes

Home of Mozart,
Salzburg, Germany.
Century Dictionary

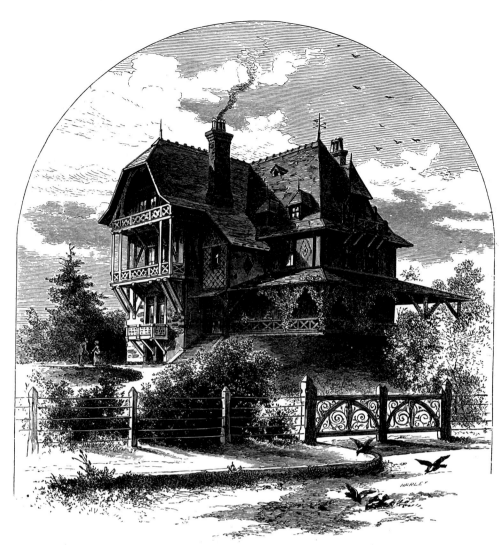

Home of Thomas G. Appleton, Newport, Rhode Island. *Homes of America*

House in the country. *Harper's*

Tangut tent at Dulan-Yung. *Through Asia* □

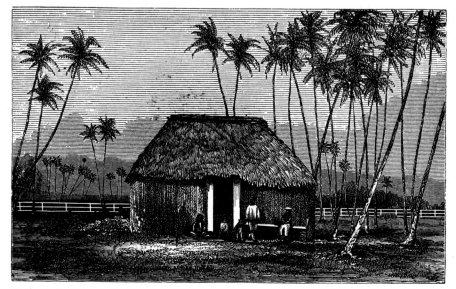

Grass hut, Africa. *Harper's*

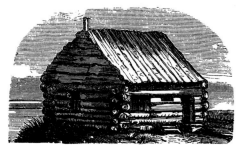

Log cabin on Mount Kineo, Maine.
Harper's, Vol. 51

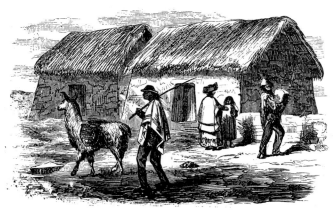

Indian huts, Quito. *Harper's*

Vicarage where John Cotton lived. *Leslie's*

Guy Park.

Milton's house, York Street,
Westminster, London.
Leslie's, Vol. 15

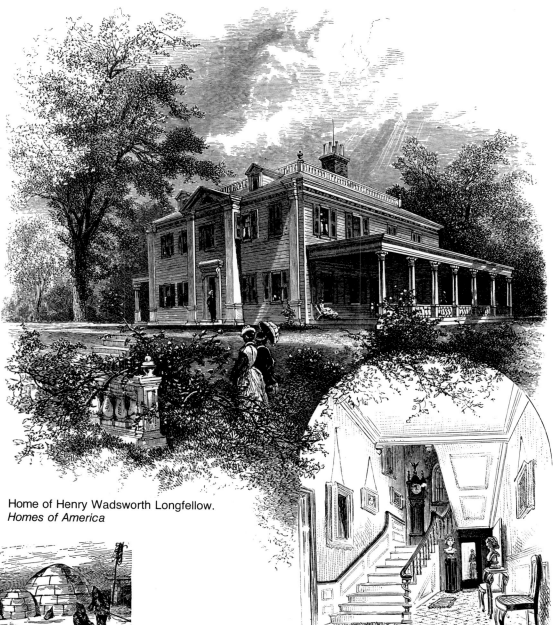

Home of Henry Wadsworth Longfellow.
Homes of America

Snow hut. *Century Dictionary*

Homes continued

House of Hans Sachs. *Zig Zag Journeys* □

The Woodhull house.
Field Book of the Revolution

Townsend's house.
Field Book of the Revolution

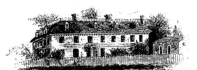

Phillipse manor house.
Field Book of the Revolution

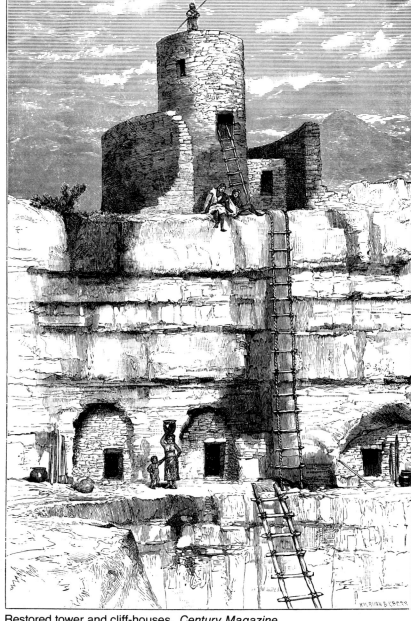

Restored tower and cliff-houses. *Century Magazine*

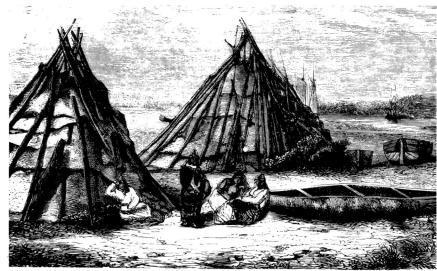

Movable homes of the Micmac Indians. *Leslie's*

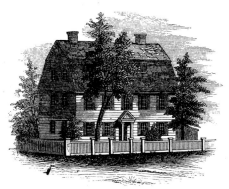

The Webb house.
Field Book of the Revolution

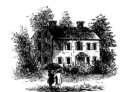

Howe's quarters.
Field Book of the Revolution

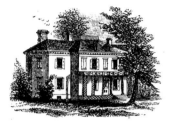

Jones' mansion.
Field Book of the Revolution

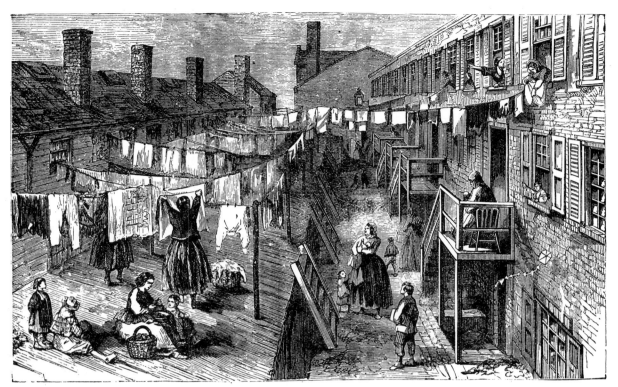

Homes of the poor. *Leslie's*

The Birdsall house.
Field Book of the Revolution

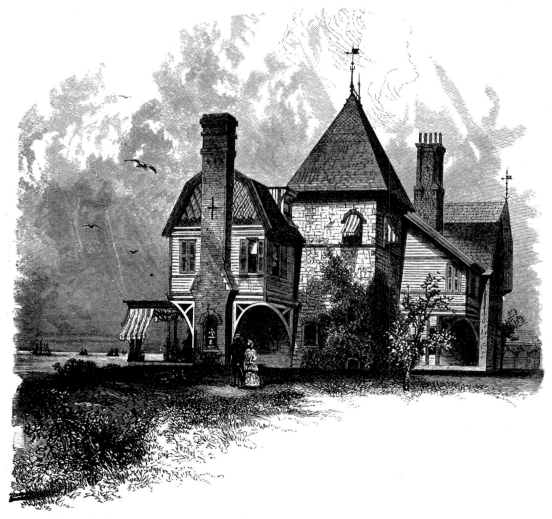

Home of John Quincy Adams. *Homes of America*

The Verplanck house.
Field Book of the Revolution

Horror

Leslie's, Vol. 21

St. Nicholas, 1889 □

Leslie's □

Masterpieces of Horror □

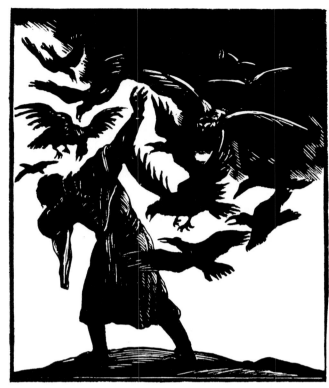

Nikolai Ivanovich Piskarev

Leslie's

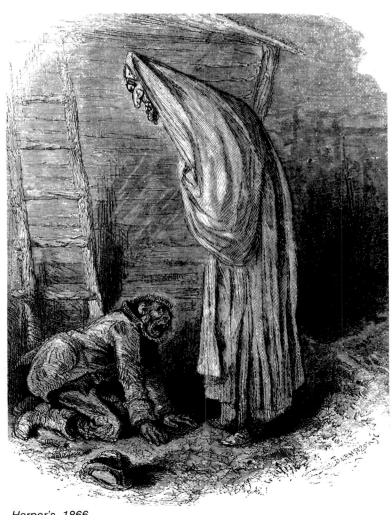

Harper's, 1866

Horses

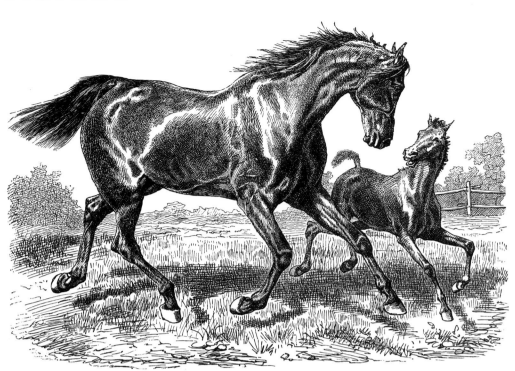

London Illustrated News

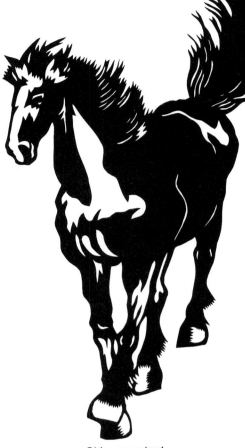

 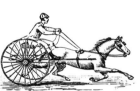

Carriage race. *French Advertising Art*

Chinese cutout.

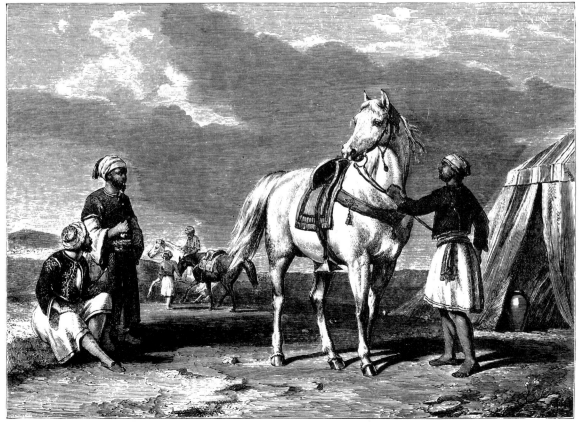

The pride of the desert. *Illustrated London News*

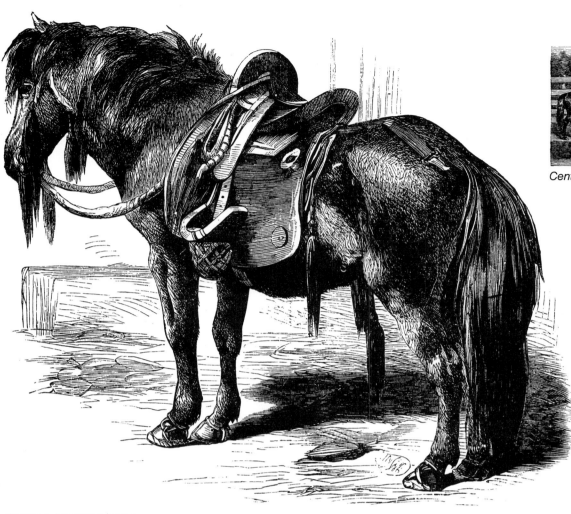

Saddled Japanese horse.
Leslie's

Century Magazine

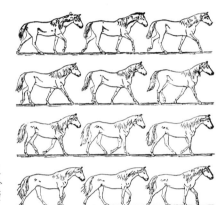

Consecutive walking positions.
Century Dictionary

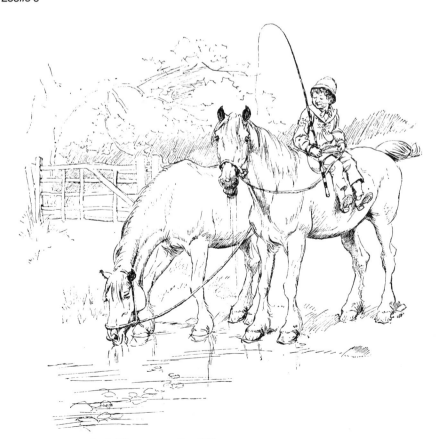

Drawing by Hugh Thomson. *Our Village*

Drawing by G.H. Bartlett. *Pen and Ink Drawing*

Initials

Initials continued

Initials continued

Insects & Worms

Periphylia. *Lydekker*

Corkscrew sea-fan.
Lydekker

Humbug. *Harper's*

Promethean silkworm.
Century Dictionary

Fruit fly.
Century Dictionary

Syrian locust. *Sunday Book*

Reading by means of the Elater Noctilucus. *Leslie's*

Spiny-headed thread worm. *Lydekker*

Ant. *Fifty Years of Soviet Art*

Limapontia capitata. *Lydekker*

Fungus beetle.
Century Dictionary

Butterfly. *Meyers Lexikon*

Privot hawk moth. *Zell's*

Common flesh fly. *Riverside Natural History*

Katydid. *Riverside Natural History*

Fringe-legged mosquito.
Century Dictionary

Laborers

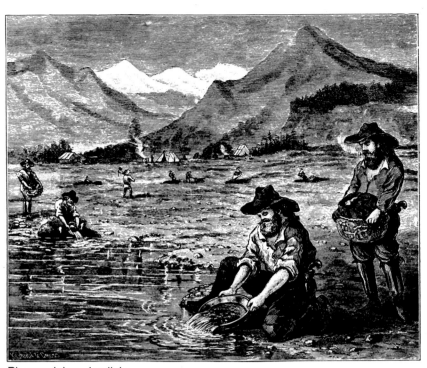

Placer mining. *Leslie's*

Washing. *Century Magazine*

Husking corn.

Gathering grapes. *Harper's*

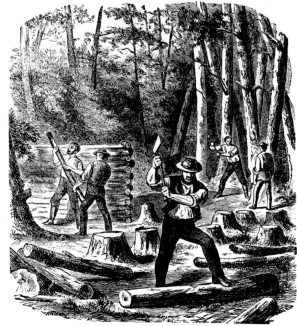

Felling trees in Jamestown. *Harper's*

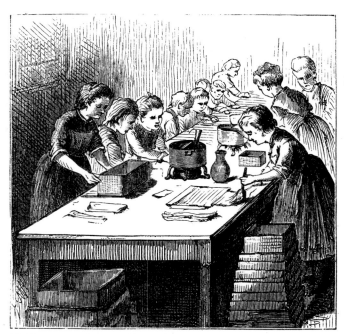

Making paper boxes. *Harper's*

Harvesting. *Nikolai Ivanovich Piskarev*

Riveting a column. *Harper's*

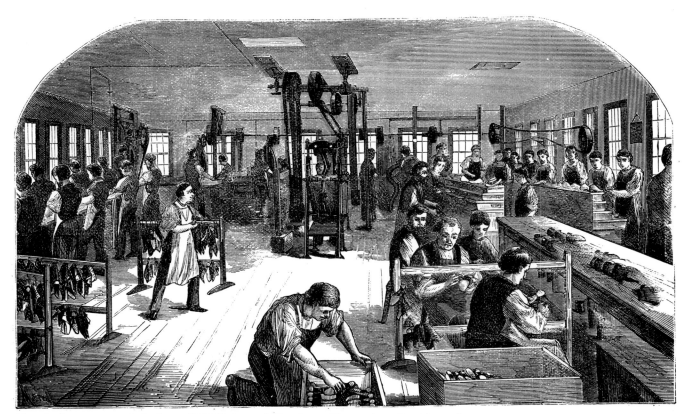

Shoe-bottoming room in factory of B.F. Spinney & Co., Lynn, Massachusetts. *Harper's*

Laborers continued

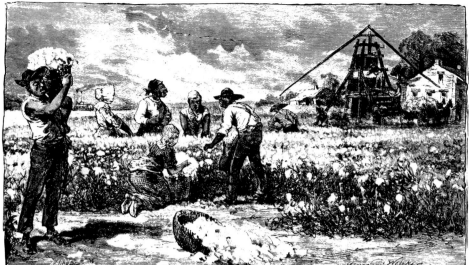

Picking cotton. *Leslie's*

Filling casks. *Harper's*

Field hand. *Art of the Book* □

Tea pickers in Ceylon. *Century Magazine*

Irrigating an orchard. *Marvels of the New West*

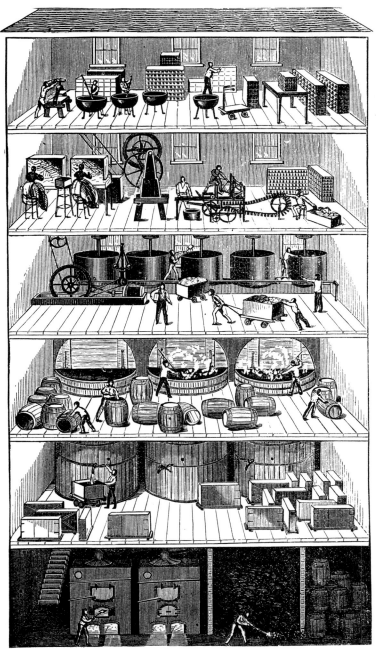

Soap manufactory of E. Morgan's Sons. *Harper's*

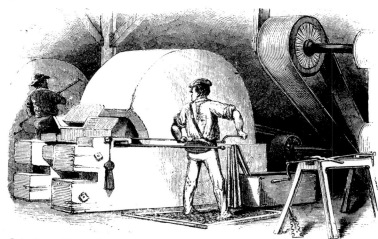

Grinding. *Harper's*

Volga boatmen. *Nikolai Ivanovich Piskarev*

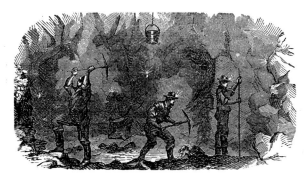

Mining. *Harper's, 1857*

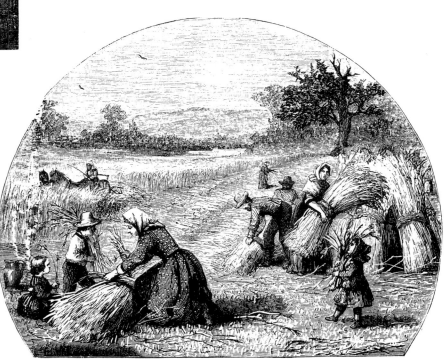

Field workers. *Leslie's*

Landscapes

Harper's

In a Fair Country

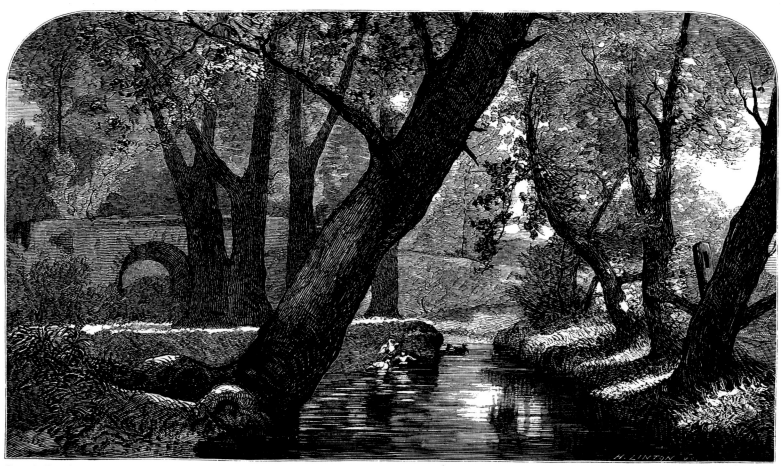

Bonnie Brook near Rahway, New Jersey. *The Aldine*

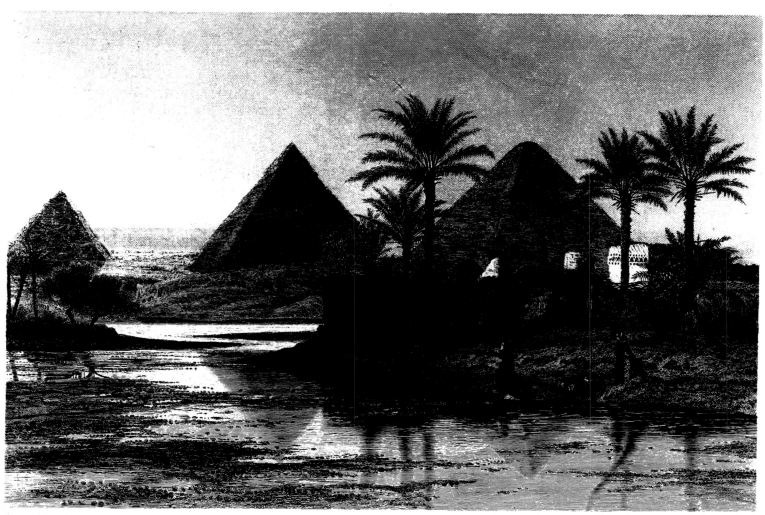

Pyramids. *Picturesque Palestine* □

Arles (France) and the Rhone. *Zig Zag Journeys*

James River at Richmond. *Harper's*

Landscapes continued

Harper's

Near Toby's Eddy. *Harper's*

Virginia water. *Voyages and Travels*

Nelson's Ferry. *Harper's*

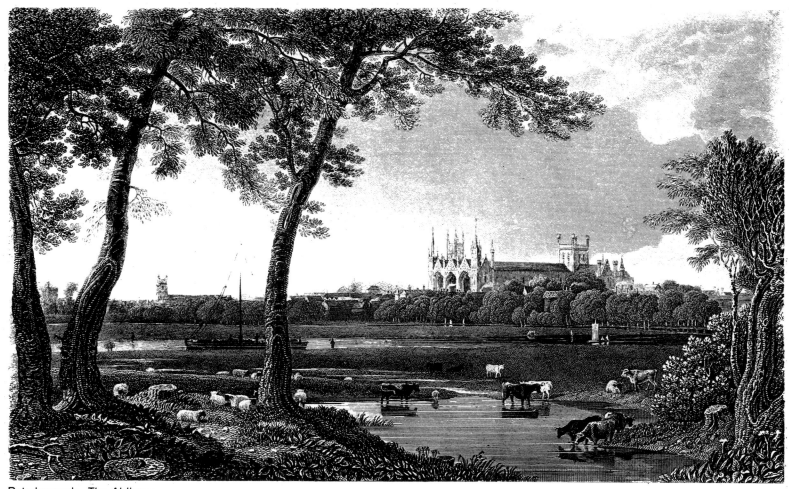

Peterborough. *The Aldine* □

Cherokee Ford. *Harper's*

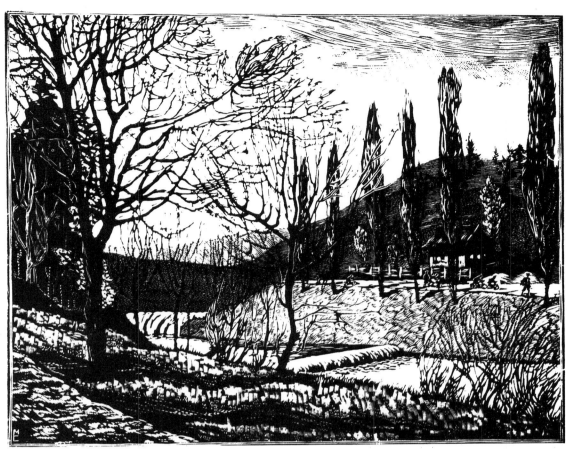

Aleksandr Postel'

Deer Island on the Merrimac,
Massachusetts. *Harper's*

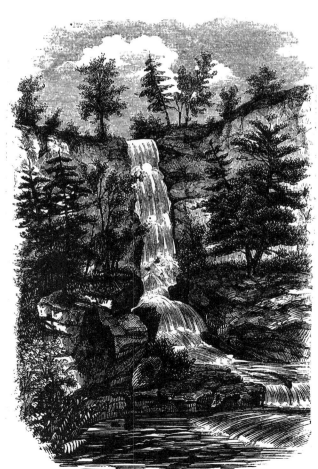

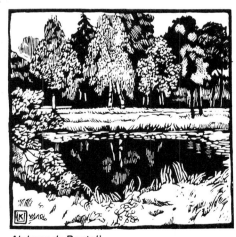

Aleksandr Postel'

Tuckesege Ford, North Carolina. *Harper's*

Harper's

Landscapes continued

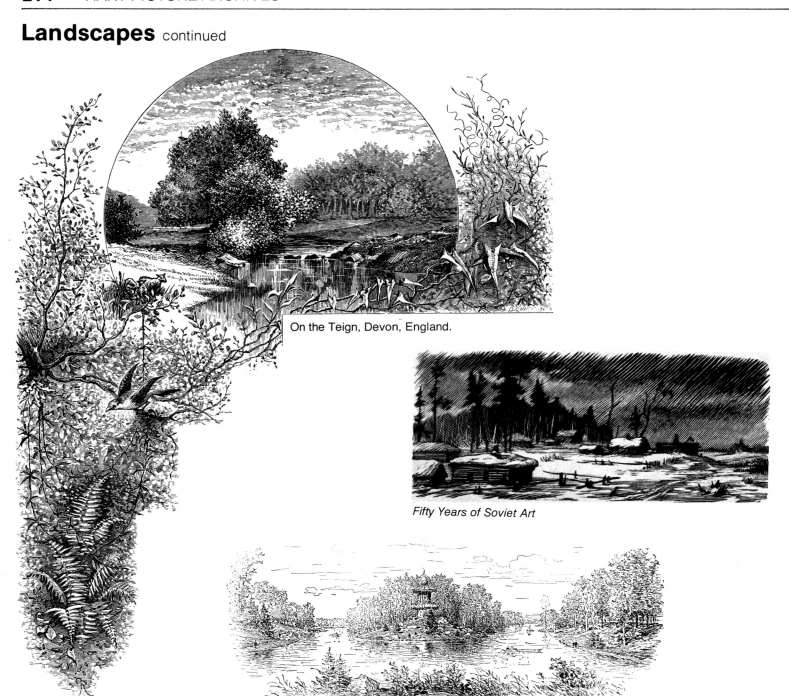

On the Teign, Devon, England.

Fifty Years of Soviet Art

Lake in the forest of Boulogne, Paris. *Paris in Old and Present Times*

View of Lake Drummond in Dismal Swamp, Virginia. *Leslie's*

Coastline, by G.H. Bartlett. *Pen and Ink Drawing*

The Liebthaler Glen. *Voyages and Travels*

Leslie's

Eutaw Springs. *Harper's, Vol. 17*

Lighthouses

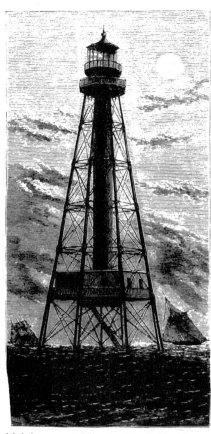

Lighthouse at Alligator Reef, Florida.
Harper's

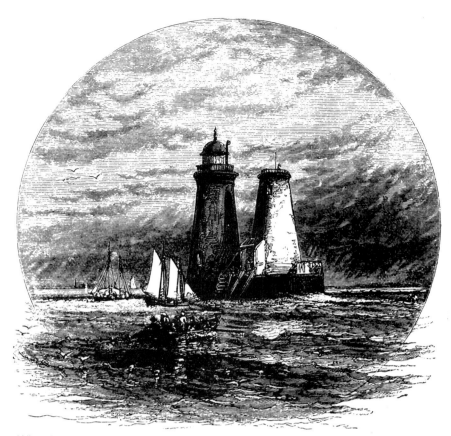

Whale's-back light. *Harper's*

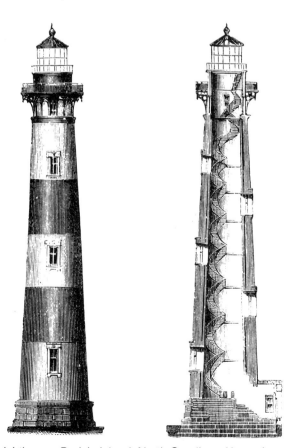

Lighthouse, Body's Island, North Carolina. *Harper's*

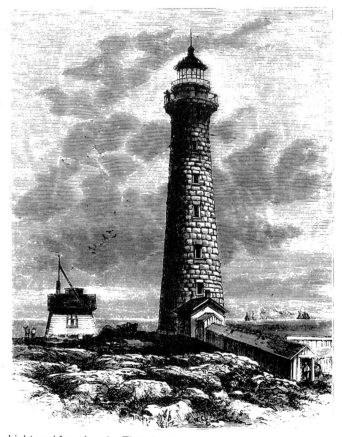

Light and fog signals, Thatcher's Island, Cape Ann, Massachusetts. *Harper's*

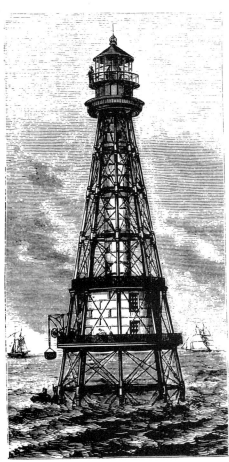

Lighthouse at Trinity Shoal, Gulf of Mexico. *Harper's*

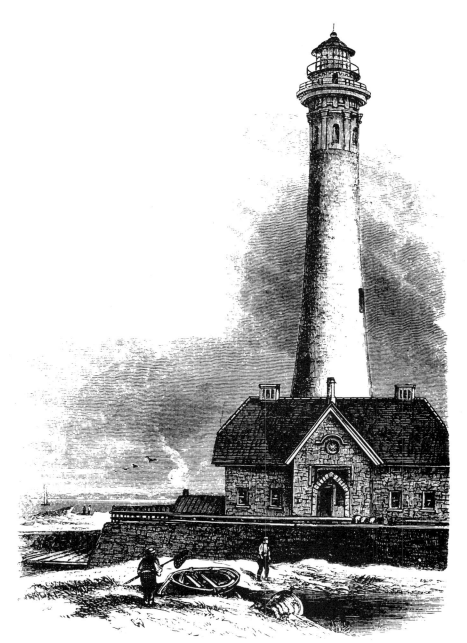

Fire Island Light, New York. *Harper's*

Lighthouse of Ghijiga. *Harper's*

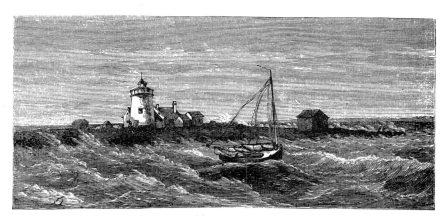

Bird Island Light, Buzzard's Bay, Massachusetts. *Harper's*

Love & Courtship

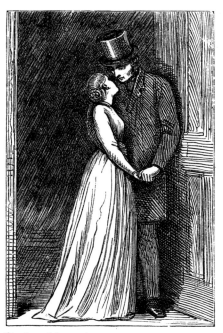

Century Magazine

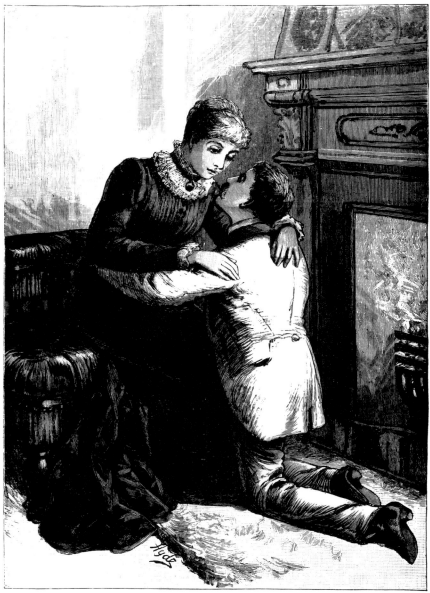

Leslie's

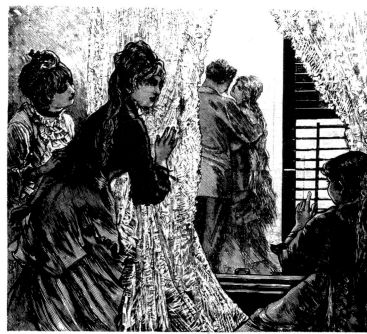

Leslie's

Century Magazine

Leslie's

Harper's, Vol. 41

Romeo and Juliet.
Fifty Years of Soviet Art

Love & Courtship continued

Life □

Harper's, Vol. 51

Harper's, Vol. 50

Scribner's, Vol. 3

Leslie's

Harper's

Fifty Years of Soviet Art

Love & Courtship continued

Leslie's, Vol. 10

Leslie's

Leslie's

Century Magazine

Leslie's

Leslie's

The Art of the Book

Notes of a Collector

Love & Courtship continued

Zig-Zag Journeys

Harper's

Faworski

Century Magazine

Machines

Candymaking machine. *Century Dictionary*

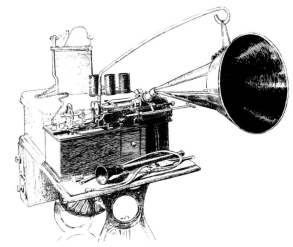

Phonograph. *Century Magazine*

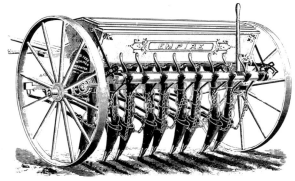

Grain drill. *Marvels of the New West*

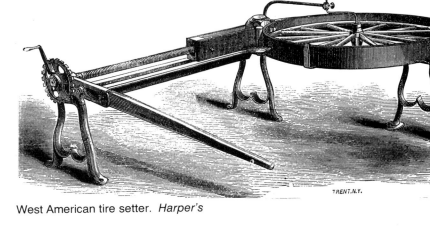

West American tire setter. *Harper's*

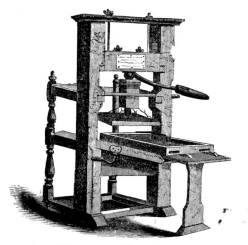

Franklin press . *Harper's*

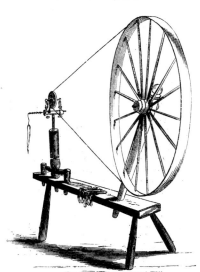

Spinning wheel. *Harper's*

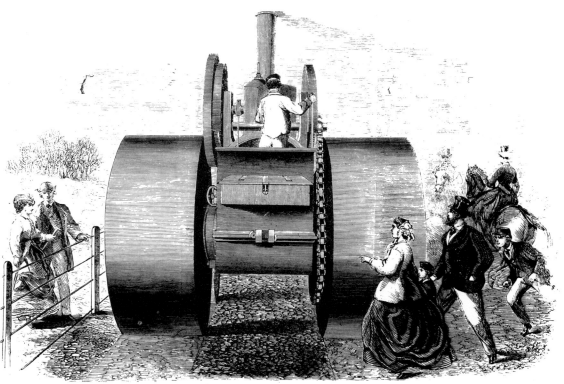

Steam road-roller. *Illustrated London News, 1866*

Potato digger. *Century Dictionary*

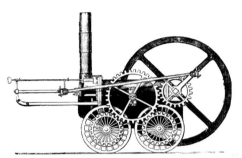

Trevithick's high-pressure train engine. *Harper's*

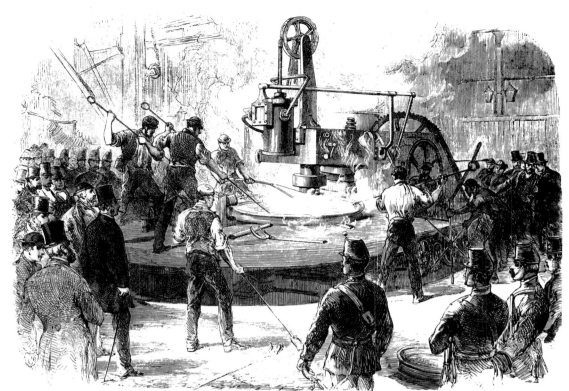

Tire expanding machine. *Illustrated London News, 1866*

Transplanter. *Century Dictionary*

The original phonograph. *Century Magazine*

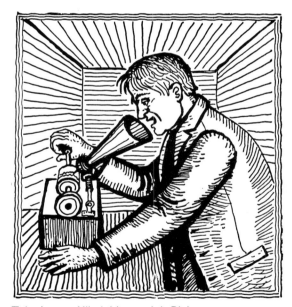

Telephone. *Nikolai Ivanovich Piskarev*

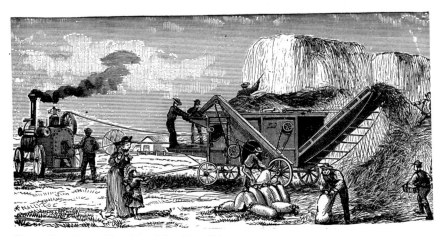

Steam thresher. *Marvels of the New West*

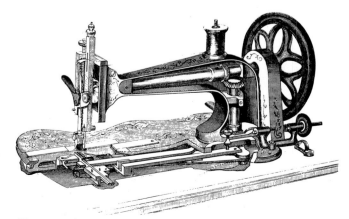

Singer sewing machine. *Harper's*

Madness

Police Gazette, 1888

Leslie's

Harper's

Leslie's

On a Mexican Mustang

The straitjacket behind.
Harper's

The straitjacket in front.
Harper's

Harper's

Leslie's

Harper's

Markets & Marketing

Early Advertising Art

The goose market of Strasburg. *Leslie's*

The bazaar. *Harper's*

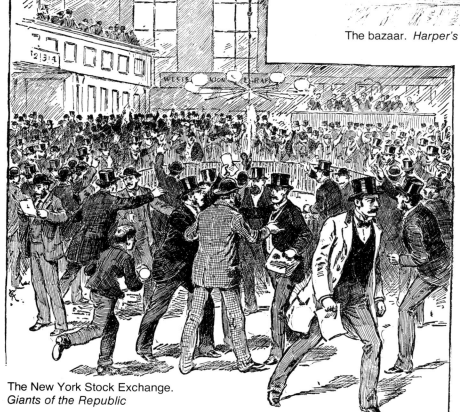

The New York Stock Exchange.
Giants of the Republic

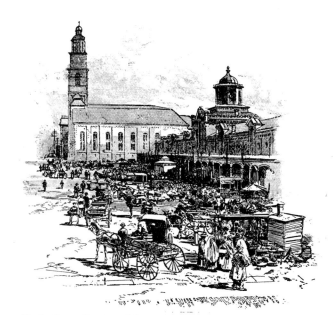

Marketing. *Century Magazine*

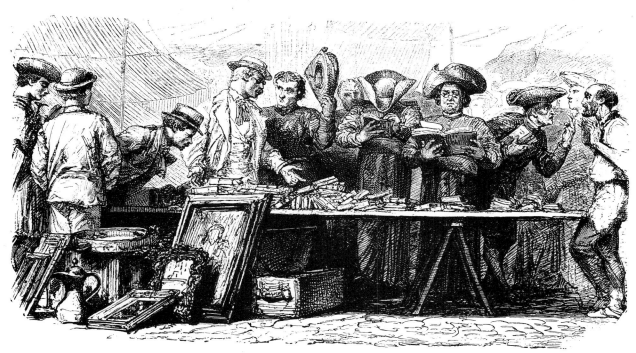

"Curiosity" stall in Rome. *The World: Its Cities and Peoples, Vol 5*.

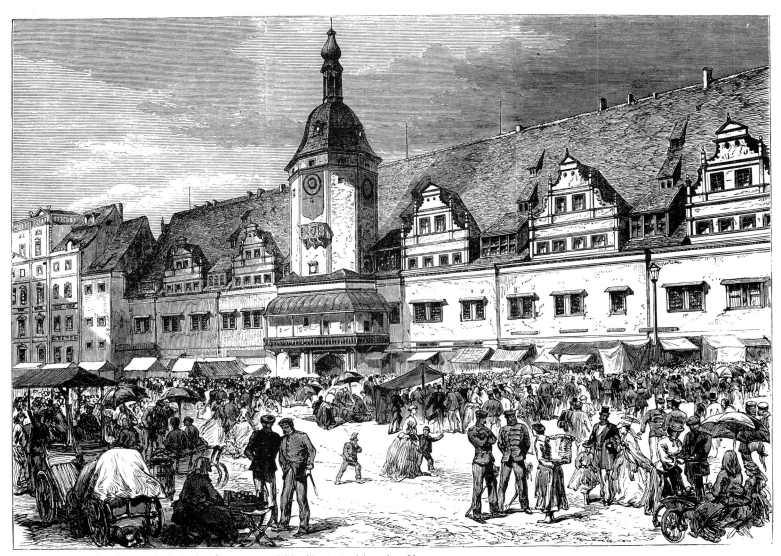

Marketplace and rathhaus in Leipzig, Germany, 1866. *Illustrated London News*

Merriment

Harper's

Harper's

Police Gazette

Leslie's

Harper's

St. Nicholas

Drawing by Hugh Thomson. *Our Village*

Punch

Drawing by E.A. Abbey, 1884. *Century Magazine*

Mobs & Riots

Girl spinners strike Clark's Thread Mills, Harrison, N. J.
Police Gazette

Peasants fighting Czarist troops.
Nikolai Ivanovich Piskarev

Tea riot in Boston. *Leslie's. Vol. 16*

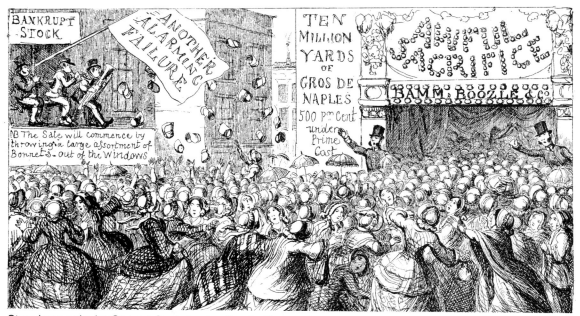

Storming a sale, by George Cruikshank. *Comic Almanack*

New York Stock Exchange during a panic. *Giants of the Republic*

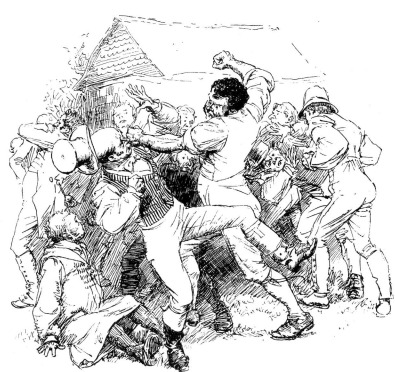

Brawl in merrie England, by Hugh Thomson. *Our Village*

Work of a mob in North Audley Street. *Leslie's, Vol. 21*

Nikolai Ivanovich Piskarev

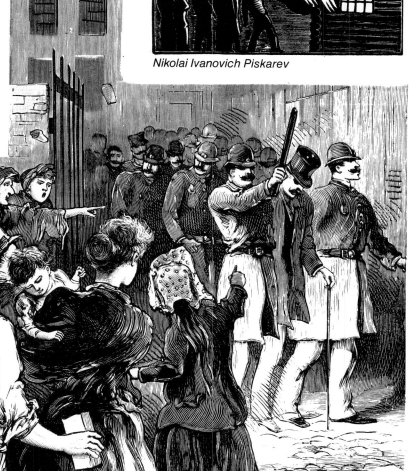

Employees of Clark's Thread Mills, Harrison, N.J., go on strike. *Police Gazette*

Motherhood

Harper's

Leslie's

Fifty Years of Soviet Art

Drawing by Hugh Thomson. *Our Village*

The World: Its Cities and Peoples

Essays on Polish Graphic Arts

Drawing by Hugh Thomson. *Our Village*

Essays on Polish Graphic Arts

Harper's, Vol. 16

Motherhood continued

Leslie's

Leslie's

Leslie's

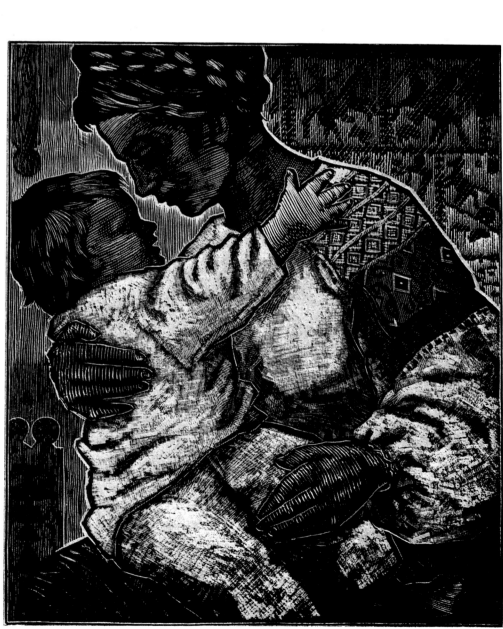

Nikolai Ivanovich Piskarev

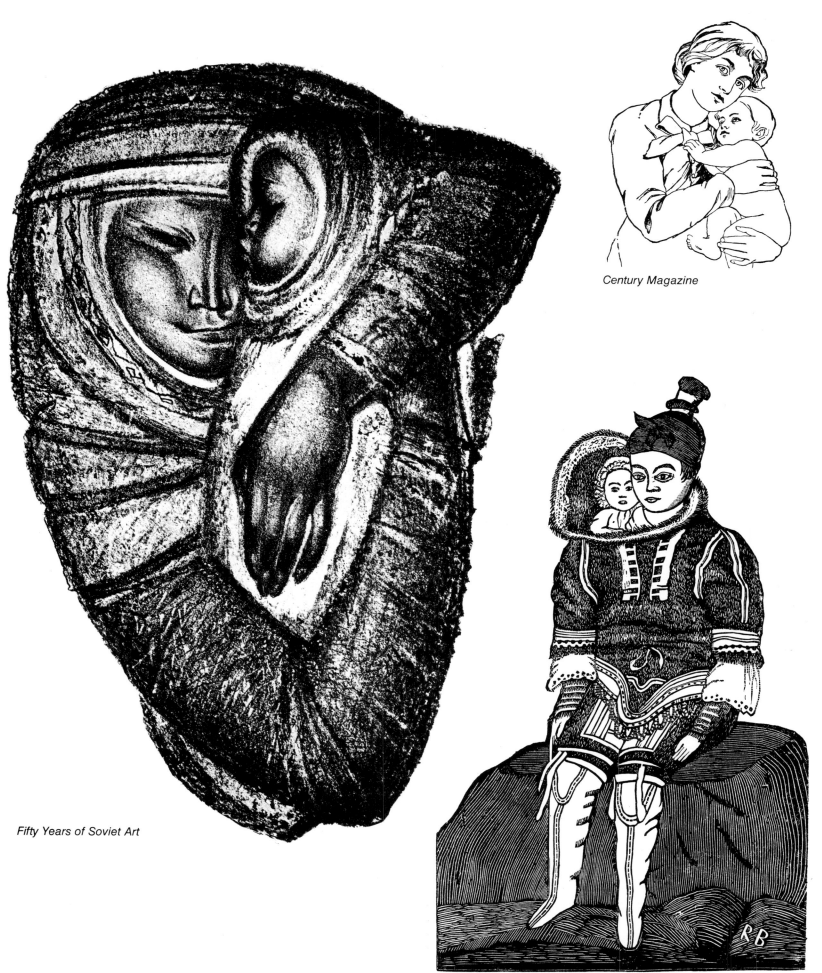

Century Magazine

Fifty Years of Soviet Art

The World: Its Cities and Peoples

Mountains & Valleys

The Andes Mountains and the Tambo River, Tacora, Peru. *Harper's, Vol. 36*

Great gorge south of Khandalla. *Illustrated London News*

Frozen expanse, Alaska. *Polar and Tropical Worlds*

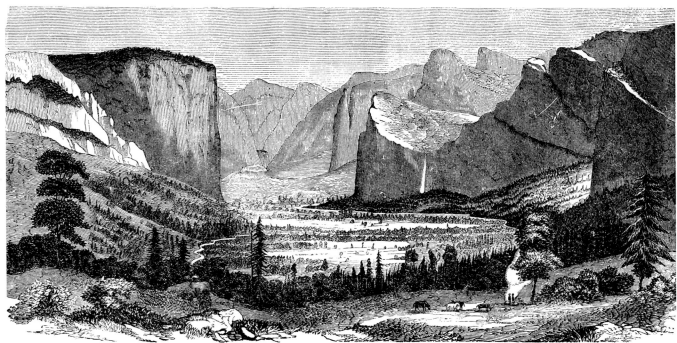

Yosemite Valley, California. *History of the United States*

Red Mountain, Montana. *Marvels of the New West*

Mount Tabor,
from the plain of Esdraelon,
North Palestine. *Zell's, Vol. 2*

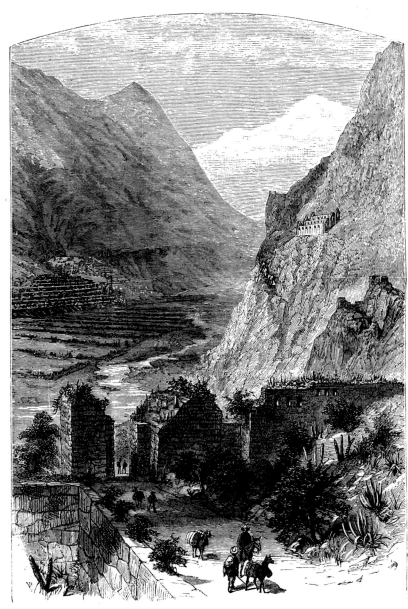

Gateway and valley of Ollantaytambo, Peru. *Harper's, Vol. 54*

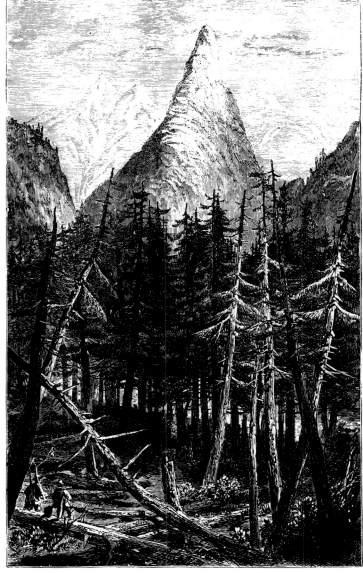

Thompson Mountain, New Mexico.
The World: Its Cities and Peoples, Vol. 2

Music

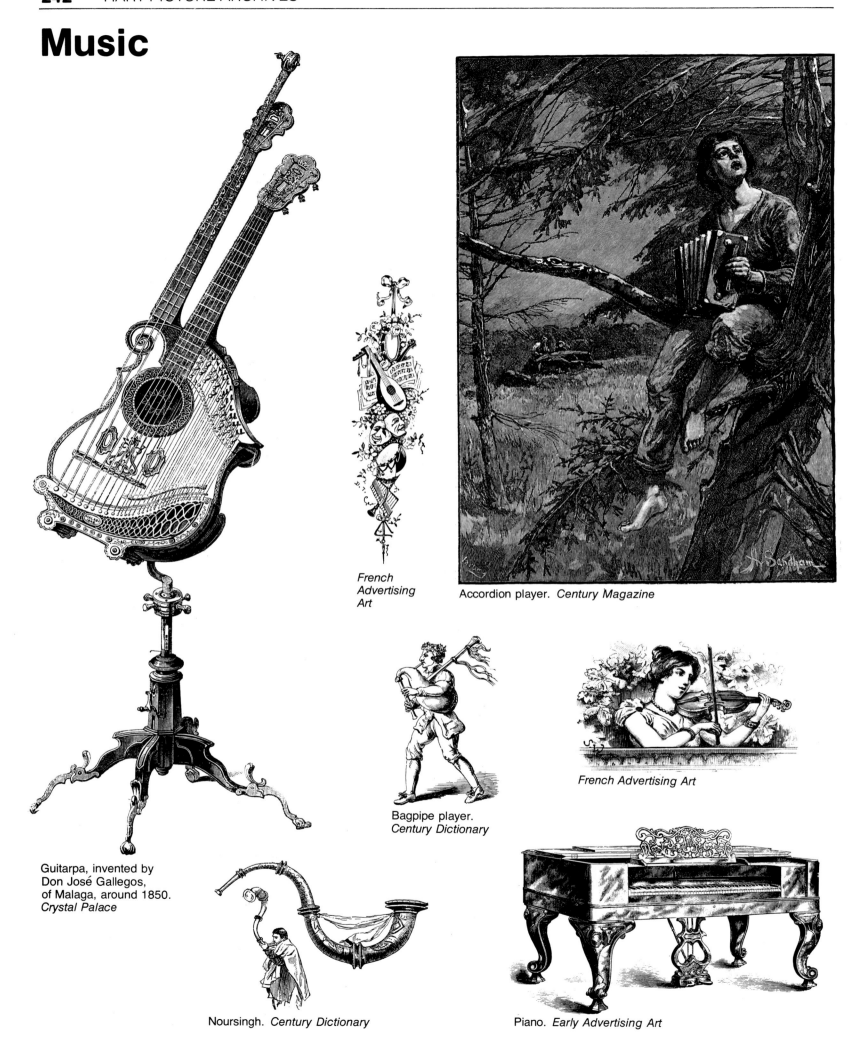

French Advertising Art

Accordion player. *Century Magazine*

Bagpipe player. *Century Dictionary*

French Advertising Art

Guitarpa, invented by Don José Gallegos, of Malaga, around 1850. *Crystal Palace*

Noursingh. *Century Dictionary*

Piano. *Early Advertising Art*

Harper's

Tabor. Zell's

Tambourine. *Antique Musical Instruments*

Century Magazine

Concertinas. *Century Dictionary*

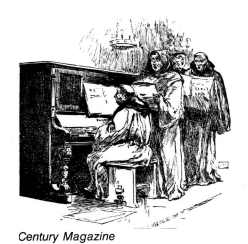

Century Magazine

Essays on Polish Graphic Arts

Music continued

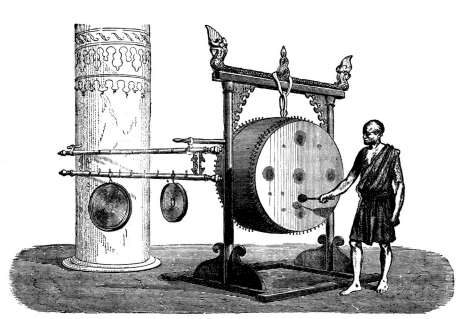

Chinese gong. *Voyages and Travels*

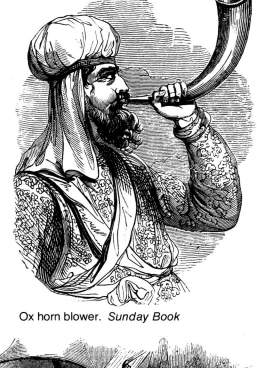

Ox horn blower. *Sunday Book*

Chimes. *Harper's*

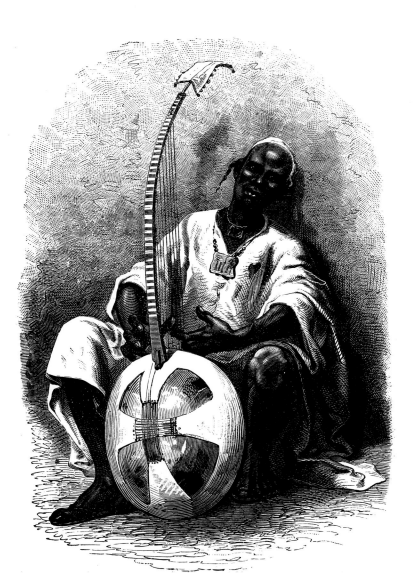

Griot of Niantanso (type of malinka) *The World: Its Cities and Peoples*

Trumpet.
*Century
Dictionary*

Notes of a Collector

Tom-toms.
Century Dictionary

Violin.
Century Magazine

Catalog of the Unusual

Ecuadorian flute. *Catalog of the Unusual*

French Advertising Art

Striking the lute. *Sunday Book*

The Art of the Book

Music continued

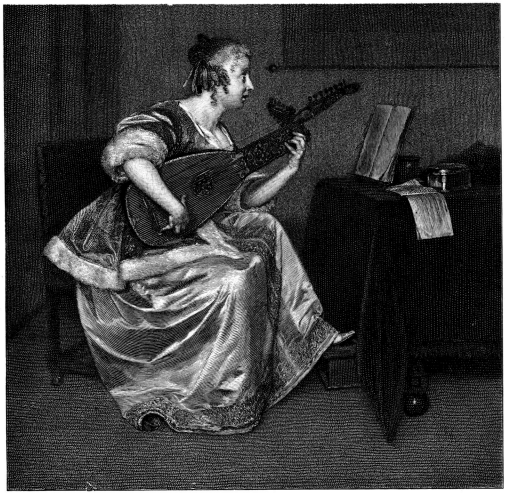

Lady with a lute. *Century Magazine*

Gramophone. *Meyers Lexikon*

Harper's

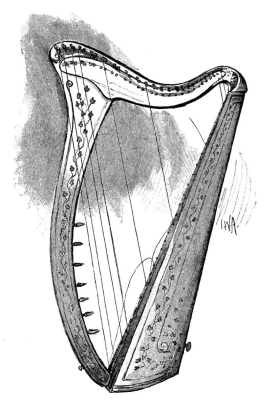

Moore's harp, Dublin Museum.
Century Magazine, 1890

Liszt organ.
Century Magazine

Marimba. *The World: Its Cities and Peoples*

Piano with lamp. *Harper's*

Painting found in a tomb at Thebes. *Harper's*

Mandolin. *Century Magazine*

Sang, a Chinese
musical instrument.
Century Dictionary

Church singing. *Century Magazine*

Flute lesson. *Illustrated London News*

Tuba.
Century Dictionary

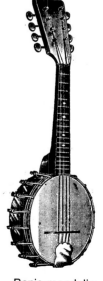

Banjo-mandolin.
Sears Catalogue

Music continued

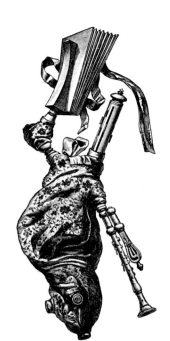

Bagpipe. *Meyers Lexikon*

The cornet player takes a bow. *Harper's, Vol. 8*

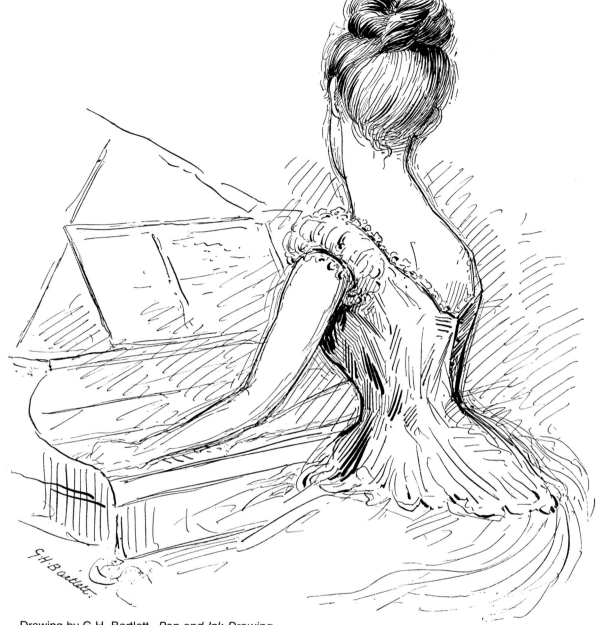

Drawing by G.H. Bartlett. *Pen and Ink Drawing*

Roman horn players. *Classic Myths*

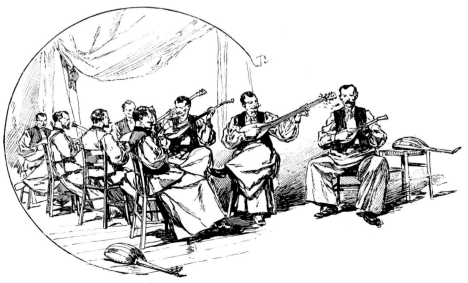

Servian guitarists. *Leslie's, Vol. 29*

French horns. *Meyers Lexikon*

Saxophone.
Century Dictionary

Cavalry trumpet. *Century Dictionary*

Tavern musician. *Illustrated London News*

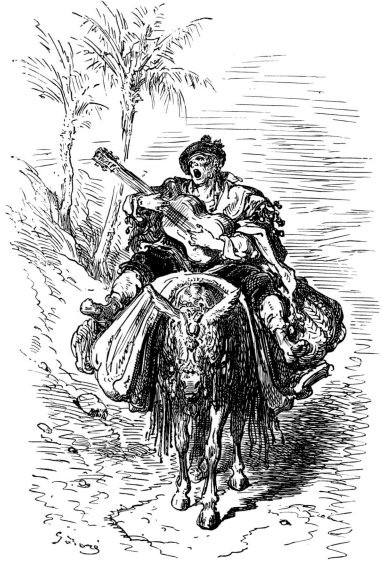

Minstrel. *Illustrated London News*

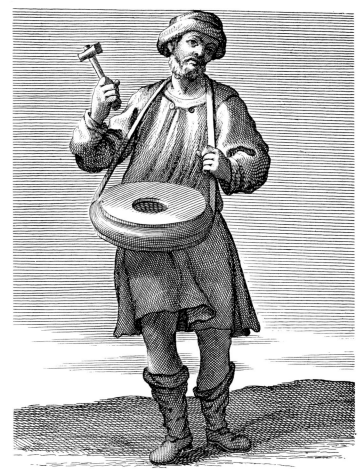

Playing an ancient drum. *Antique Musical Instruments*

Outlaws & Scalawags

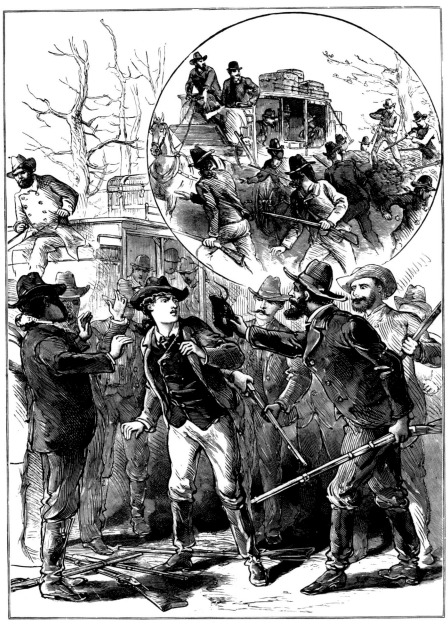

Female robbers dressed as men. *Police Gazette*

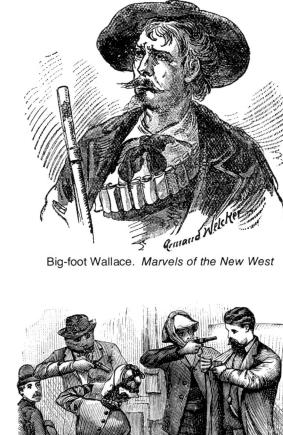

Big-foot Wallace. *Marvels of the New West*

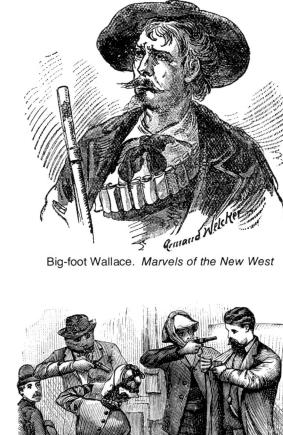

Train holdup. *Harper's*

The weigh of the transgressor. *Life*

Drunken rascal. *Punch*

One of the boys, by Frederic Remington, 1887. *Century Magazine*

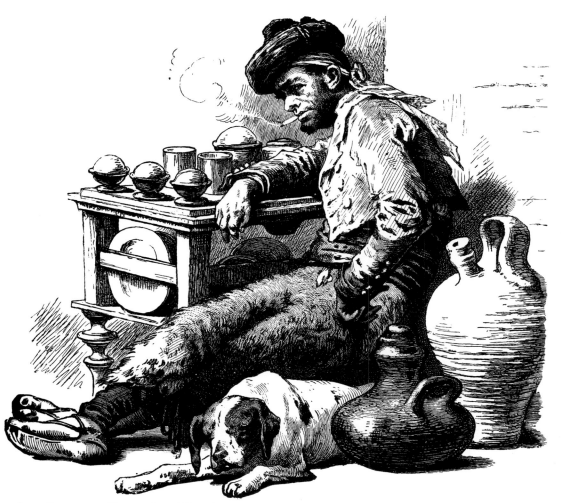

Argentine rogue. *Voyages and Travels*

A vagabond. *Harper's*

The tramp. *Harper's*

The thieves aimed their pistols. *Harper's*

Old Apple-Jack. *Harper's*

Portrait of the culprit. *Harper's*

Peoples of the World

Mongol guide, Loppsen. *Through Asia* □

Tadjik and Karakalpak from near Khiva, Russia.
The World: Its Cities and Peoples

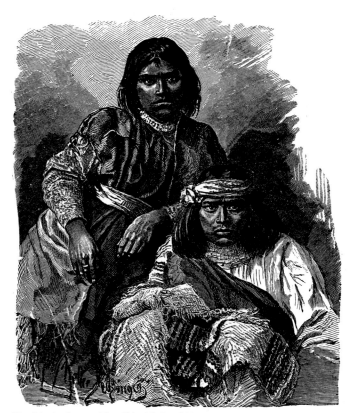

Pueblo Indians. *The World: Its Cities and Peoples*

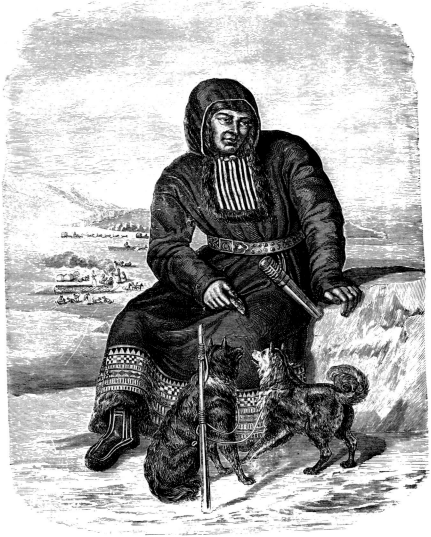

Kamtskadales. *The World: Its Cities and Peoples*

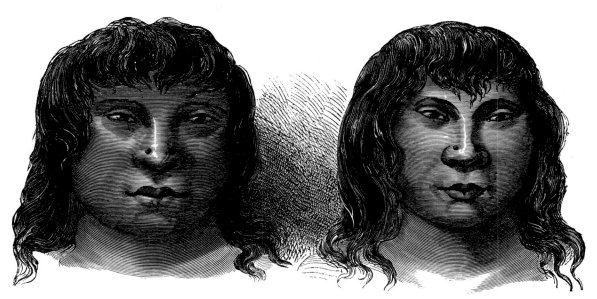

Miranhas Indians, from the Rio Negro. *The World: Its Cities and Peoples*

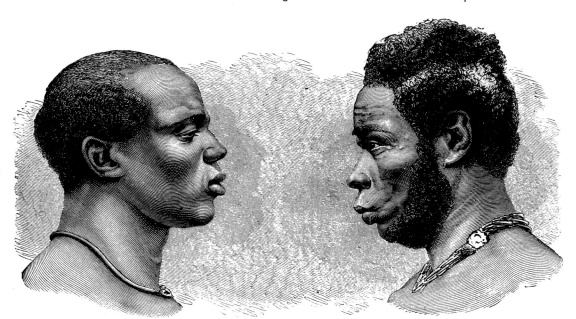

Cheyenne Indian.
Century Magazine

Native of Gaboon (left), and Tau type of Kruman (right).
The World: Its Cities and Peoples

A Mohammedan fakir. *Leslie's, Vol. 13*

Persians. *The World: Its Cities and Peoples*

Peoples of the World continued

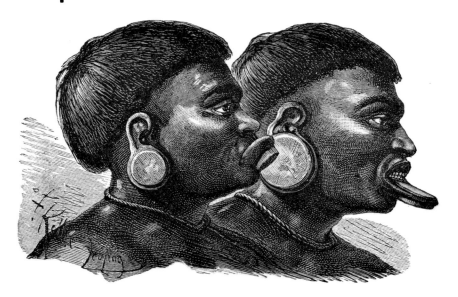

Niam-Niam headdress. *Harper's*

Kalmuk.
The World: Its Cities and Peoples

Mgogo.
Harper's

Mjiji. *Harper's*

Officer of the Guards,
Haidarabad, Sudan.
Indika

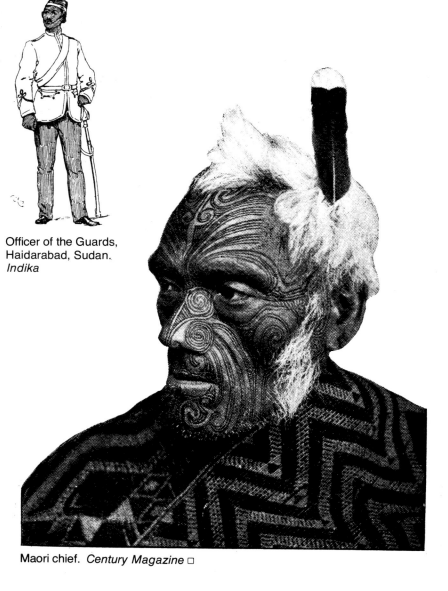

Maori chief. *Century Magazine* □

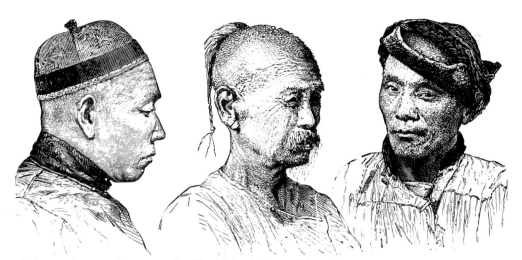

Chinese faces, Swatow. *The World: Its Cities and Peoples*

Tehuelt chief. *Voyages and Travels*

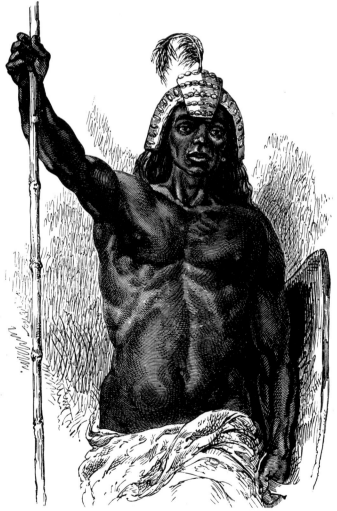

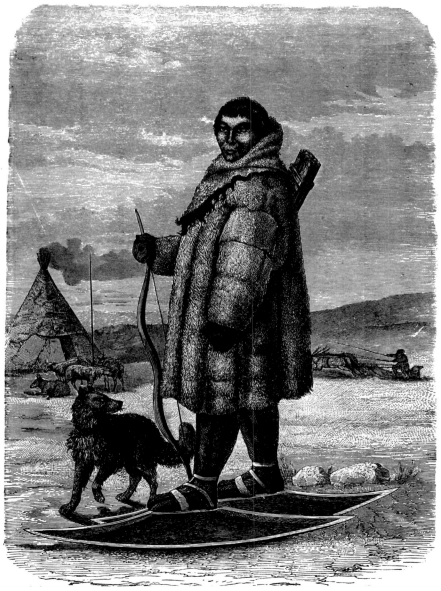

Chief of the Lira tribe. *The World: Its Cities and Peoples*

Siberian of the Yakutsk Province. *Polar and Tropical Worlds*

Peoples of the World continued

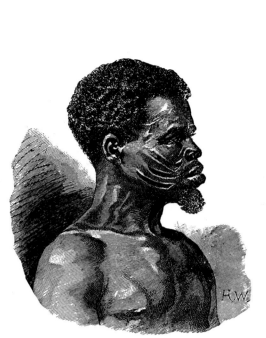

Native, Niger Delta. *In Darkest Africa*

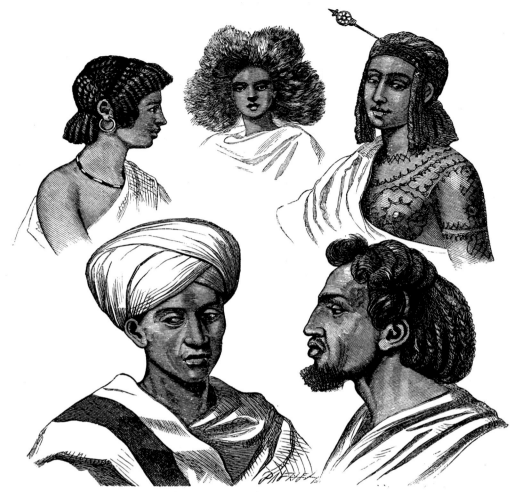

Abyssinians. *The World: Its Cities and Peoples*

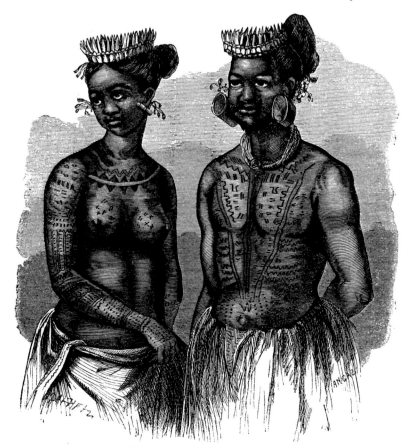

Romanzoff Islanders, Caroline Archipelago.
Natural History of Man, America and Asia

Senegalese youth.
The World: Its Cities and Peoples

Huascar, thirteenth emperor of the Incas.
The World: Its Cities and Peoples

Siberian peasant. *Polar and Tropical Worlds*

Bedouin, Cairo. *Picturesque Palestine*

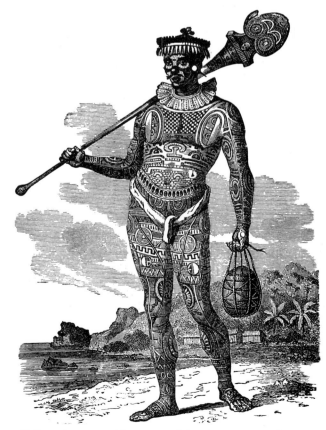

Tattooed savage, Marquesan Islands.
The World: Its Cities and Peoples

Performers

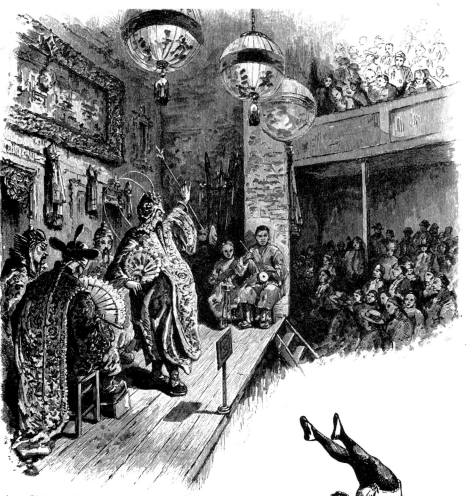

In a Chinese theatre.
Century Magazine

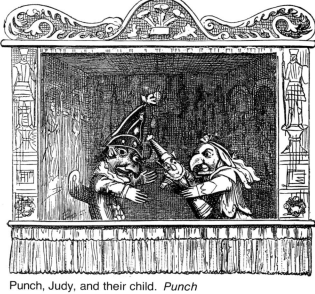

Punch, Judy, and their child. *Punch*

John Howard Payne as "Young Norval."
Leslie's, Vol. 16

Ballerina, after an etching from Jacques Caillot's "I Balli di Sfessania," 1602. *Plays, Players, & Playwrights*

The acrobat.
Police Gazette, 1892

The French stage—strolling players. *Leslie's, Vol. 16*

Auctioneer on stilts. *Harper's*

The great Bertoldi performs.
Police Gazette, 1892

Junius Brutus Booth as "Sir Giles Overreach." *Century Magazine*

The knife-thrower and his young assistant. *St. Nicholas*

Pulcinella. *Plays, Players & Playwrights*

Performers continued

A French theatre during Molière's management. *Leslie's, Vol. 16*

Performing in a Vsevolod Meyerhold production. *Plays, Players, & Playwrights*

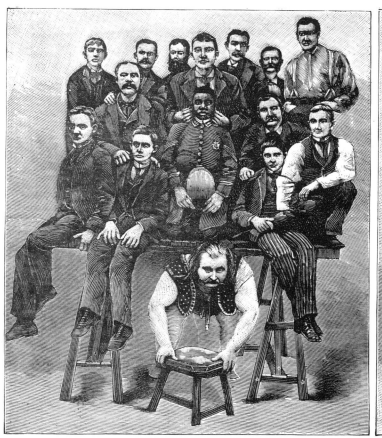

Louis Cyr—the modern Samson. *Police Gazette, 1890*

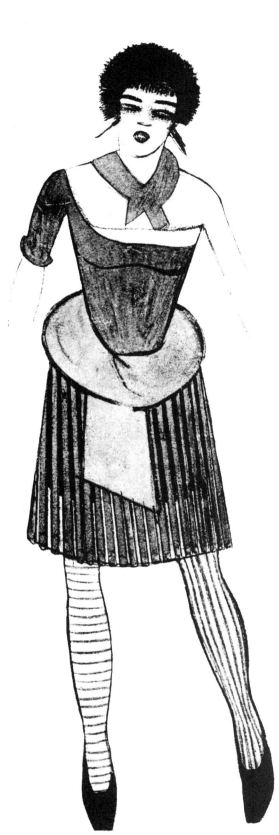

Kamernyj Theatre and Its Artists □

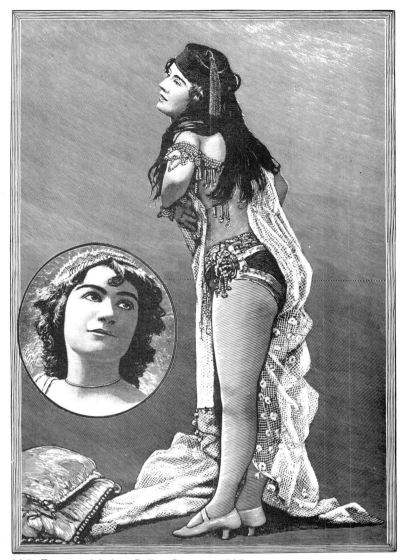

Little Egypt and Anita. *Police Gazette, 1895*

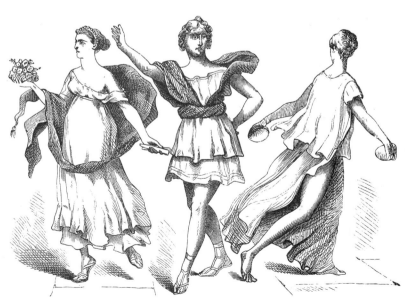

Public dancers. *Harper's*

Presidents

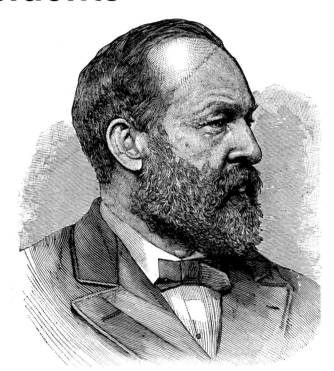

James A. Garfield. *History of the United States*

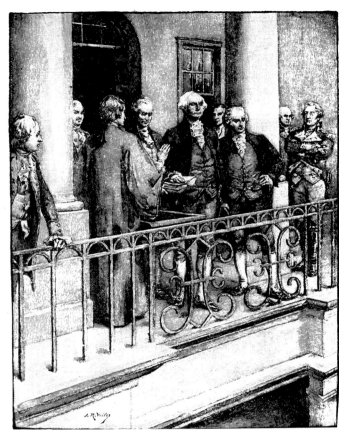

Washington taking the oath of office. *Century Magazine*

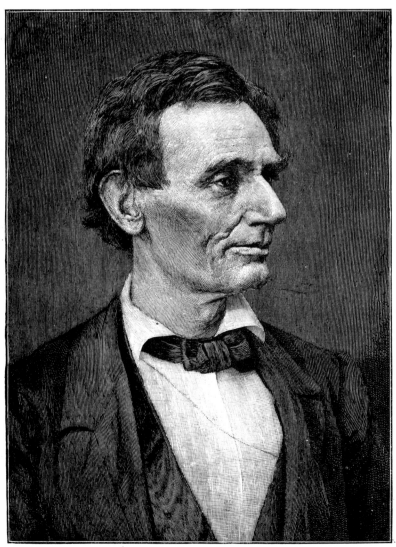

Abraham Lincoln. *Giants of the Republic*

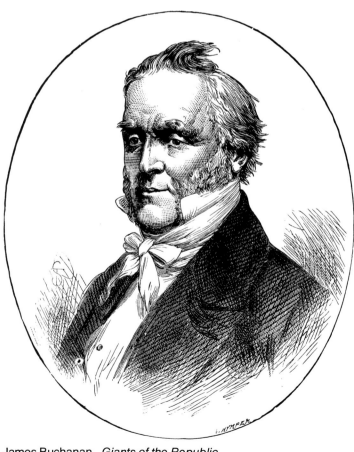

James Buchanan. *Giants of the Republic*

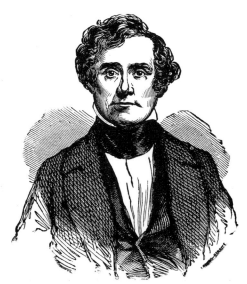

Franklin Pierce. *History of the United States*

Rutherford B. Hayes. *Leslie's*

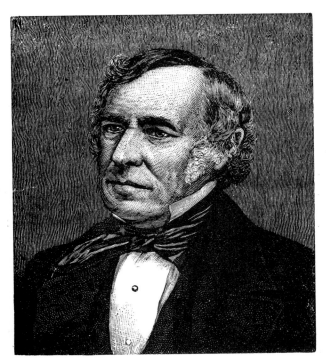

Zachary Taylor. *Giants of the Republic*

Martin Van Buren. *Harper's*

Andrew Johnson. *Zell's*

James Monroe. *Zell's*

Presidents continued

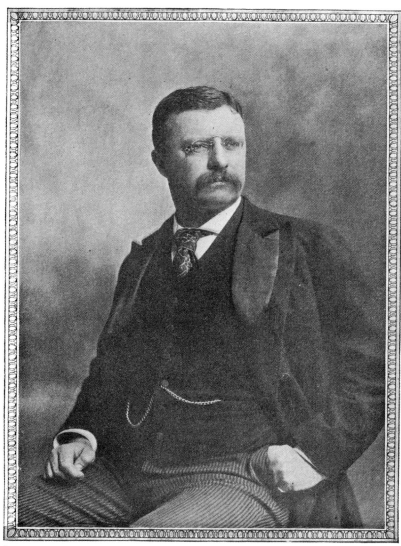

Theodore Roosevelt. *St. Nicholas* □

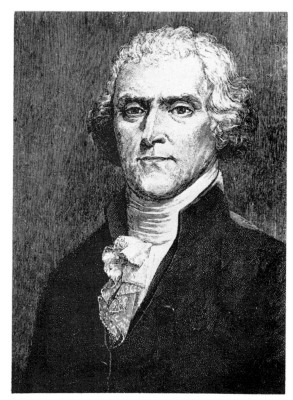

Thomas Jefferson. *Giants of the Republic* □

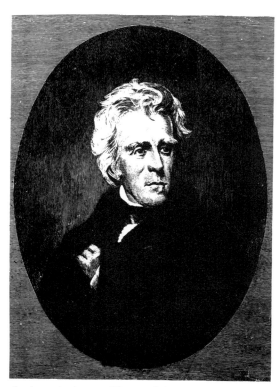

Andrew Jackson. *Giants of the Republic*

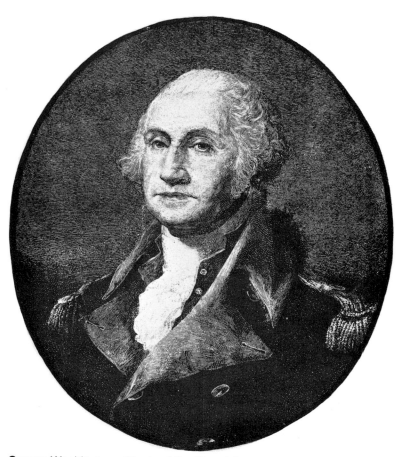

George Washington. *Giants of the Republic* □

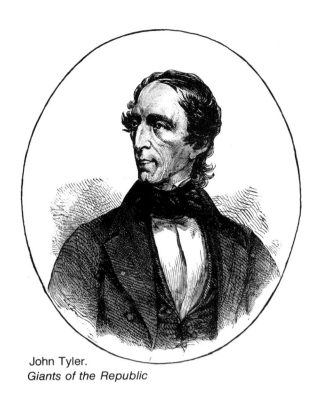

John Tyler.
Giants of the Republic

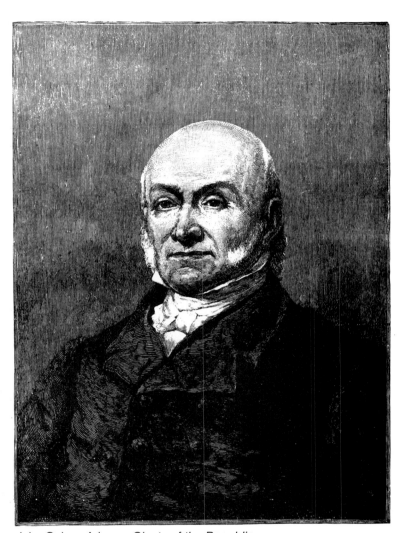

John Quincy Adams. *Giants of the Republic*

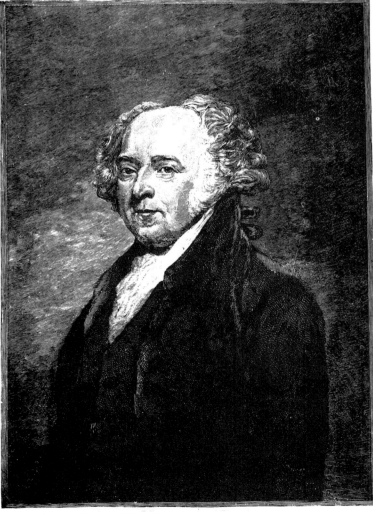

John Adams. *Giants of the Republic*

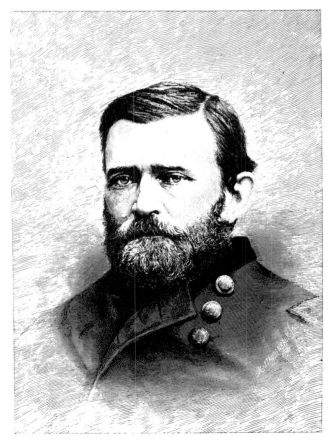

Ulysses S. Grant. *Harper's Roundtable*

Professions

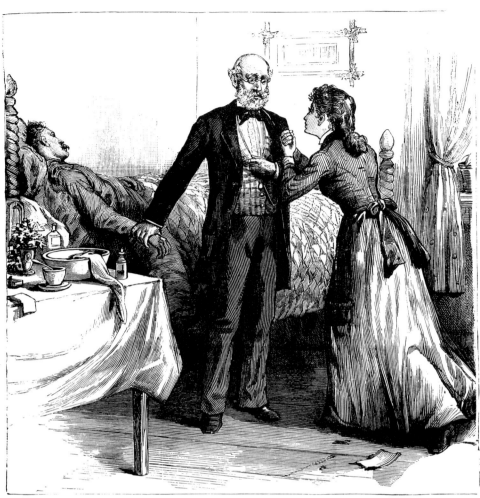

Lawyer, by E.W. Kemble.
Century Magazine

Doctor. *Leslie's*

Russian priest. *Harper's*

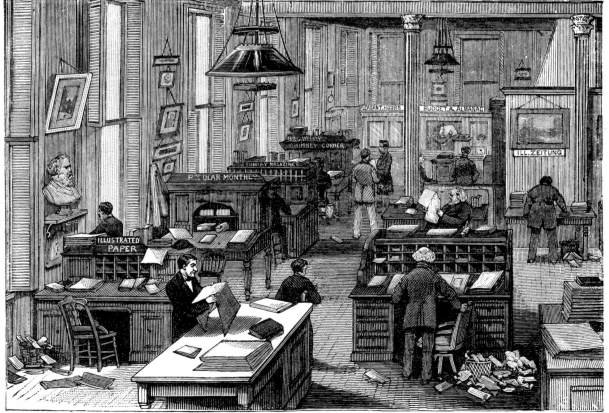

Editors. *Leslie's, Vol 10*

Professor. *Leslie's*

Produce brokers. *Harper's*

Auctioneer. *Harper's*

Street preacher. *Harper's*

Reading & Writing

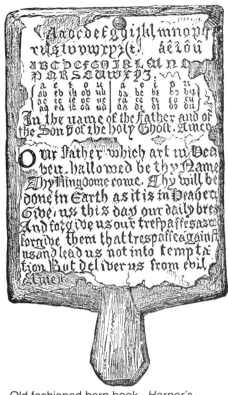

Old fashioned horn book. *Harper's*

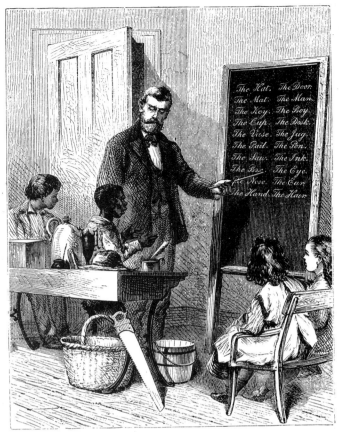

Reading lesson. *Harper's*

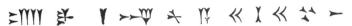

Cuneiform. *Harper's*

Typewriter. *Century Magazine, 1890*

Century Magazine, 1894

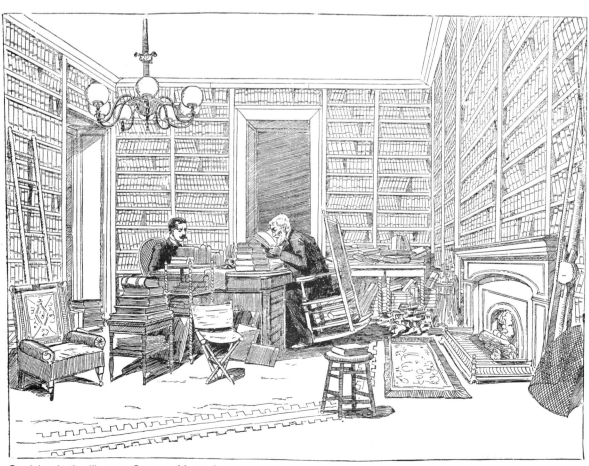

Studying in the library. *Century Magazine*

Reading room of a New England fishing town. *Leslie's*

Nikolai Ivanovich Piskarev

Cuneiform. *Harper's*

Stylus. *Sunday Book*

Reading & Writing continued

A scribe. *Fifty Years of Soviet Art*

A pleasant pastime. *Century Magazine*

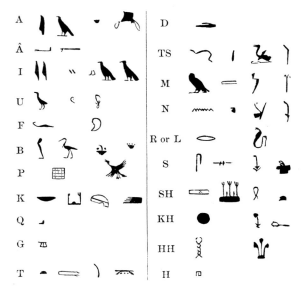

Egyptian hieroglyphics. *Harper's*

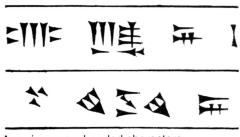

Assyrian arrow-headed characters.
Century Dictionary

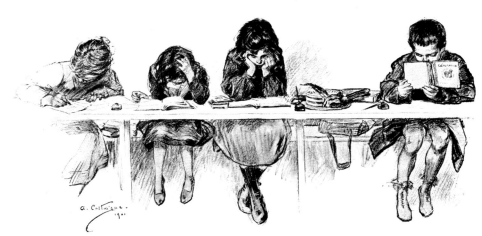

Study period. *St. Nicholas* □

Taking pen in hand. *Nikolai Ivanovich Piskarev*

HIEROGLYPHIC.	CURSIVE.	PHŒNICIAN.	GREEK.	ENGLISH.
		Δ	Δ	D
		𐤅	Φ	F or V
		𐤒	P	R
			Λ	L
		ᴜ	Σ	S

Evolution of letters. *Harper's*

Public scribe. *The Aldine*

Reptiles & Amphibians

Cystignathus ocellatus.
Century Dictionary

Cobra-de-capello.
Century Dictionary

Passerita nycterizans.
Century Dictionary

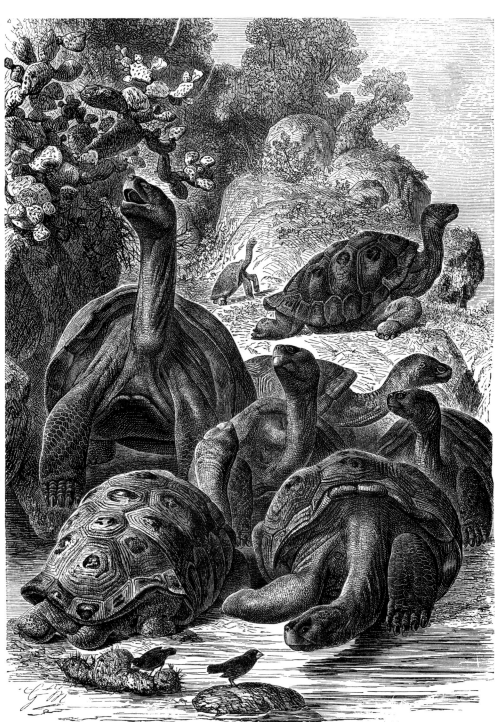

Giant tortoises of the Galapagos Islands. *Lydekker*

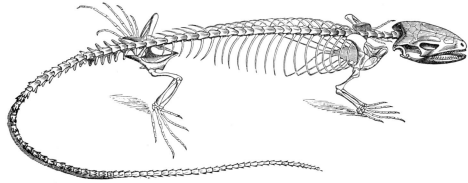

Skeleton of a lizard. *Lydekker*

Triceratops flabellatus.
Meyers Lexikon

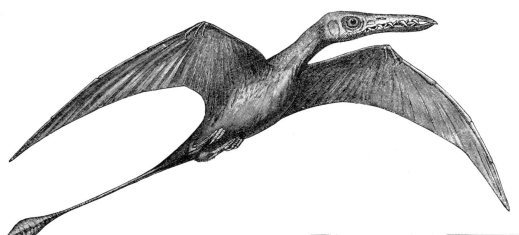

Rhamphorhynchus. *Meyers Lexikon*

Green snake. *Century Dictionary*

Head and tail of the common viper.
Harper's

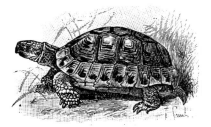

European tortoise. *Century Dictionary*

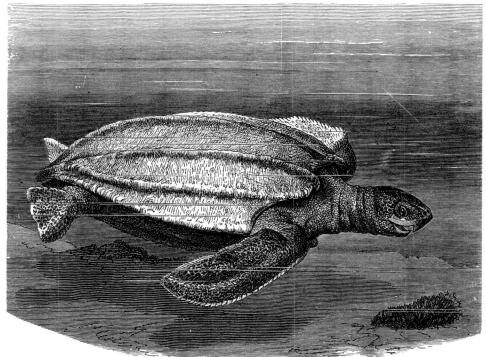

Leathery turtle. *Lydekker*

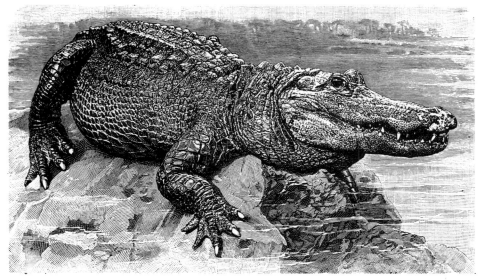

Alligator. *Lydekker*

Spine-tailed lizard.
Century Dictionary

Reptiles & Amphibians continued

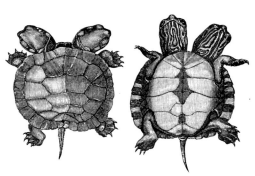

Two-headed tortoise. *Century Dictionary*

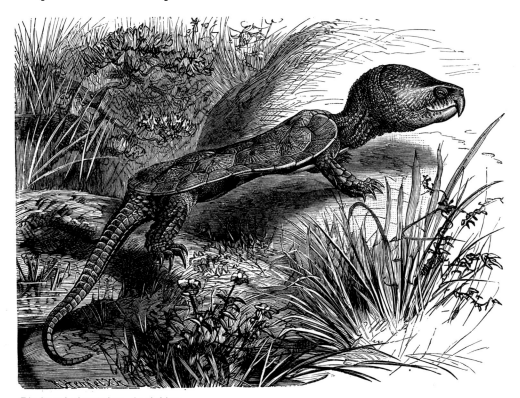

Big-headed tortoise. *Lydekker*

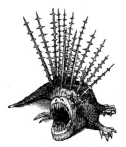

Naosaurus.
Meyers Lexikon

Iguanodon bernissartensis.
Meyers Lexikon

Skink. *Century Dictionary*

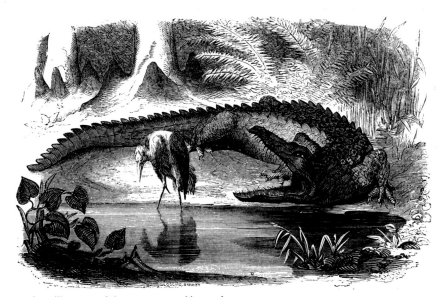

An alligator seizing a crane. *Harper's*

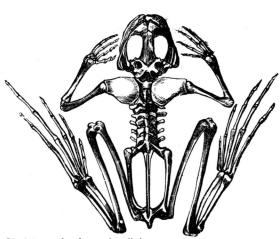

Skeleton of a frog. *Leslie's*

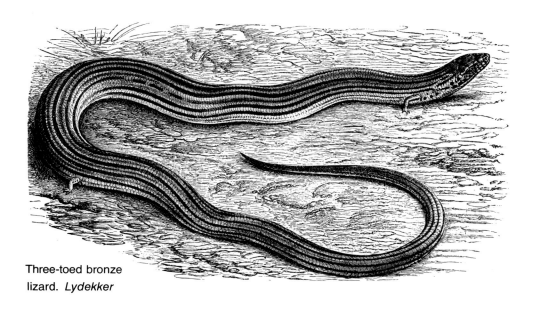

Three-toed bronze
lizard. *Lydekker*

Flying frog. *Century Dictionary*

Menobranchus or Necturus maculatus.
Century Dictionary

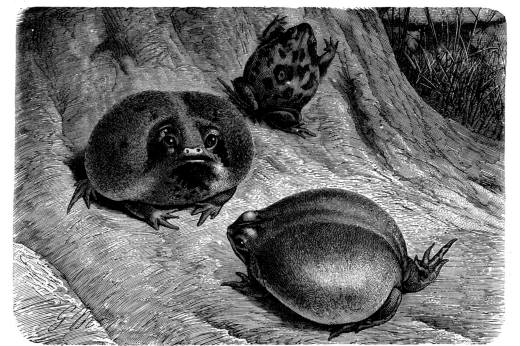

East African short-headed frogs. *Lydekker*

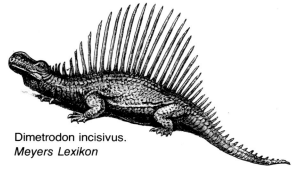

Dimetrodon incisivus.
Meyers Lexikon

Surinam toad. *Century Dictionary*

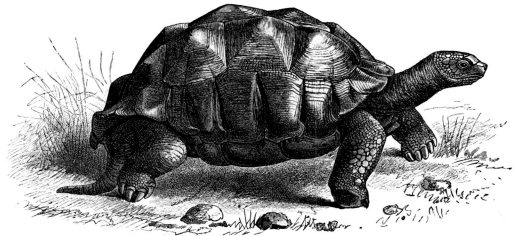

Elephant tortoise. *Lydekker*

Rites, Rituals, & Customs

Easter egg-rolling in Germany.
Harper's

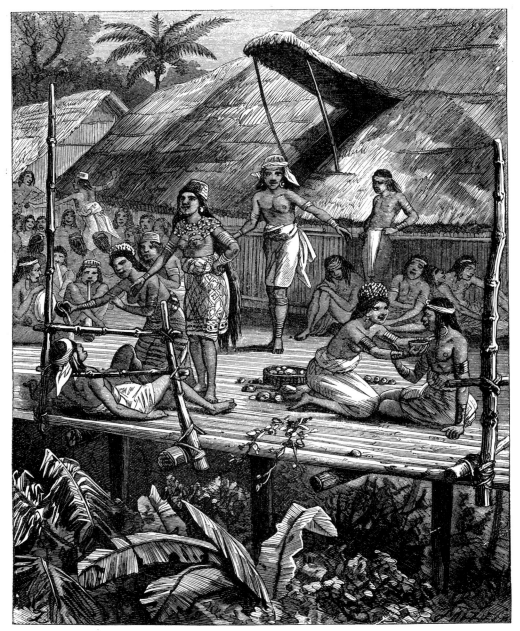

The Dayaks of Borneo feast. *Riverside Natural History*

Ark of the Covenant.
Sunday Book

Homage. *Aleksandr Vasin*

Chinese coffin bearers, with white cock on coffin, luring home one of the spirits of the dead. *Harper's*

Part of an Egyptian funeral procession, with acts of mourning. *Sunday Book*

Fifty Years of Soviet Art □

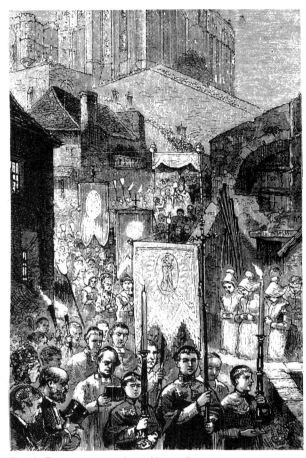

Dutch Easter procession. *Harper's*

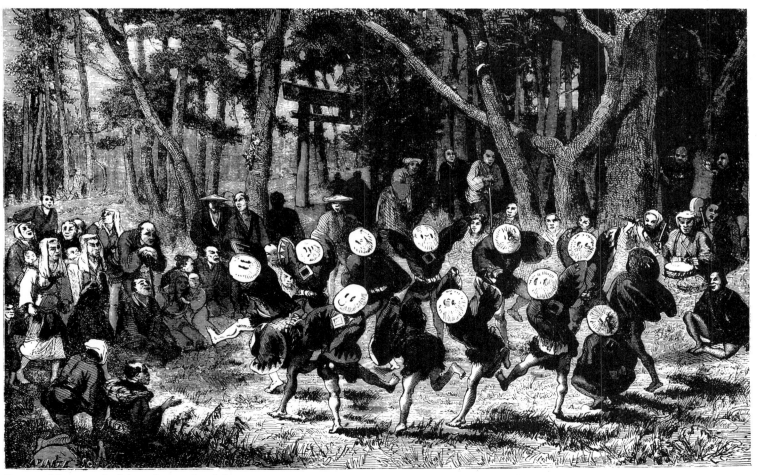

Dance of the round of rice, Japan. *Leslie's*

Rites, Rituals, & Customs continued

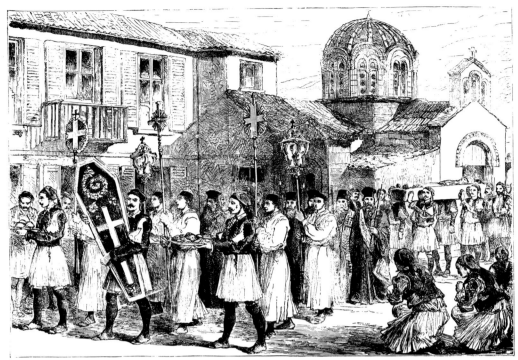

Greek funeral at Levadia (Attica). *The World: Its Cities and Peoples, Vol 2*

Wedding celebrants.
French Advertising Art

Town fête. *French Advertising Art*

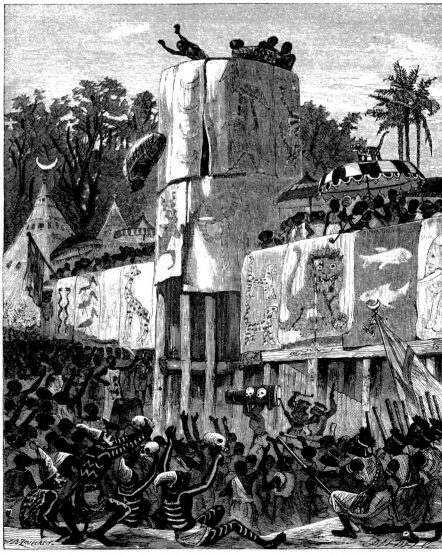

Amazon basket sacrifice. *The World: Its Cities and Peoples, Vol.2*

Fetich tree. *Fetichism*

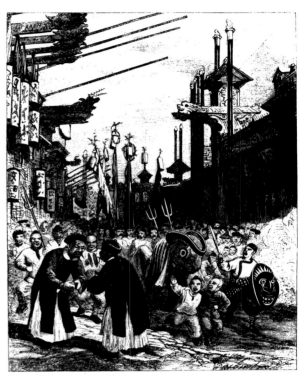

Chinese New Year's festival.
The World: Its Cities and Peoples, Vol. 1

French roadside, pause for prayer. *Harper's*

Prussian procession. *Harper's* □

Ruins

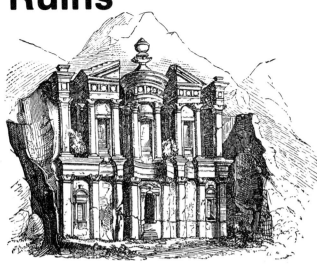

Facade of rock-cut tomb at Petra, El Dier.
Sunday Book

Ruins of the gate of the Propylaea of Athens.
Life of Greeks and Romans

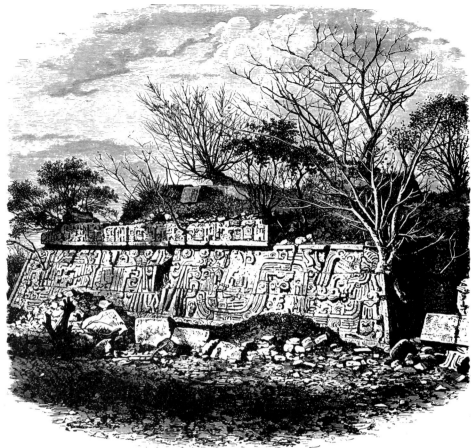

Aztec ruin, Peru. *The World: Its Cities and Peoples, Vol. 5*

Ruins of ancient wall, topped with
modern structure, at Carato, Italy.
Life of Greeks and Romans

Aztec ruins of Cajamar, Peru. *Harper's*

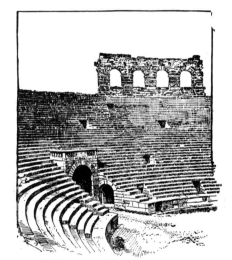

Amphitheatre at Verona, showing
vomitories. *Century Dictionary*

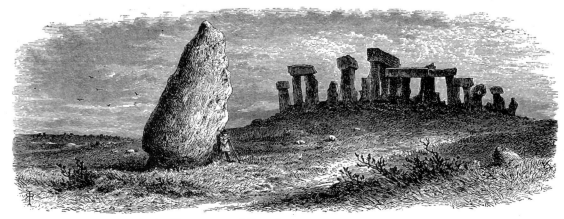

Stonehenge from the North. *Voyages and Travels*

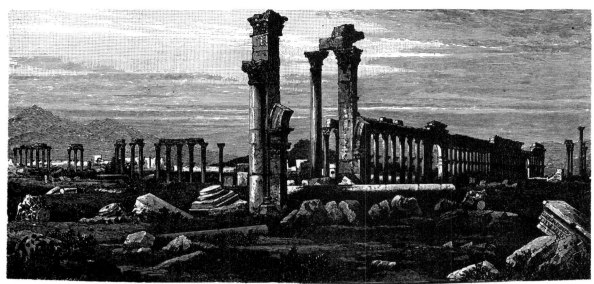

Grand Colonnade, Palmyra. *Voyages and Travels*

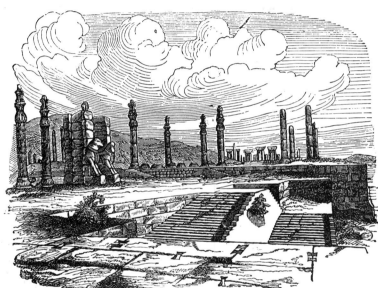

Persepolis. *Zigzag Journeys*

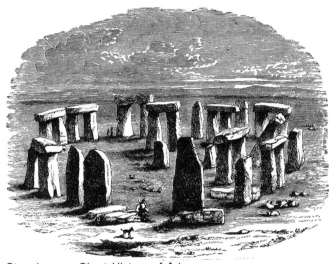

Stonehenge. *Short History of Art*

Roman theatre, Arles. *Century Dictionary*

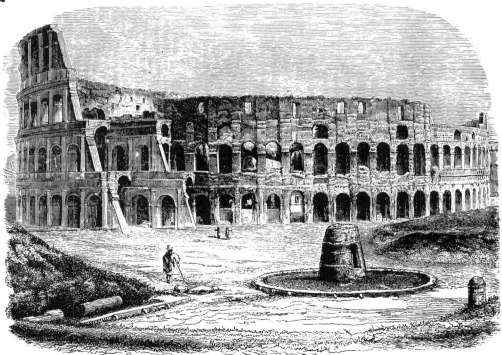

The Colosseum, Rome. *The World: Its Cities and Peoples, Vol 2*

Sculpture, Statues, & Monuments

Spring. *Leslie's*

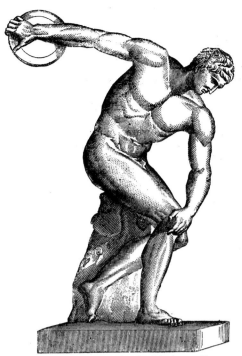

The discus thrower in the Vatican, Rome. *Life of Greeks and Romans.*

Idol. *Punch*

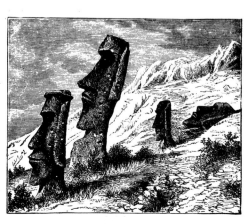

Easter Island statues. *Century Magazine*

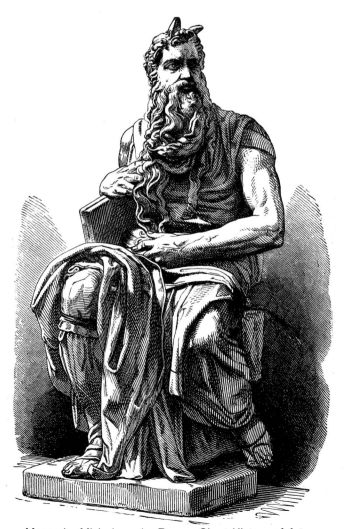

Moses by Michelangelo, Rome. *Short History of Art*

Statue of Apollo Citharoedus in the Vatican, Rome. *Century Dictionary, Vol. 2*

Ancient stone sculpture, Cuzoo.
Harper's

The wounded at Scutari. *The Aldine*

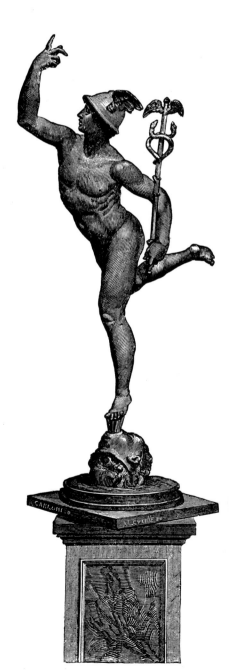

Mercury, Cellini. *Leslie's*

Sculpture, Statues, & Monuments continued

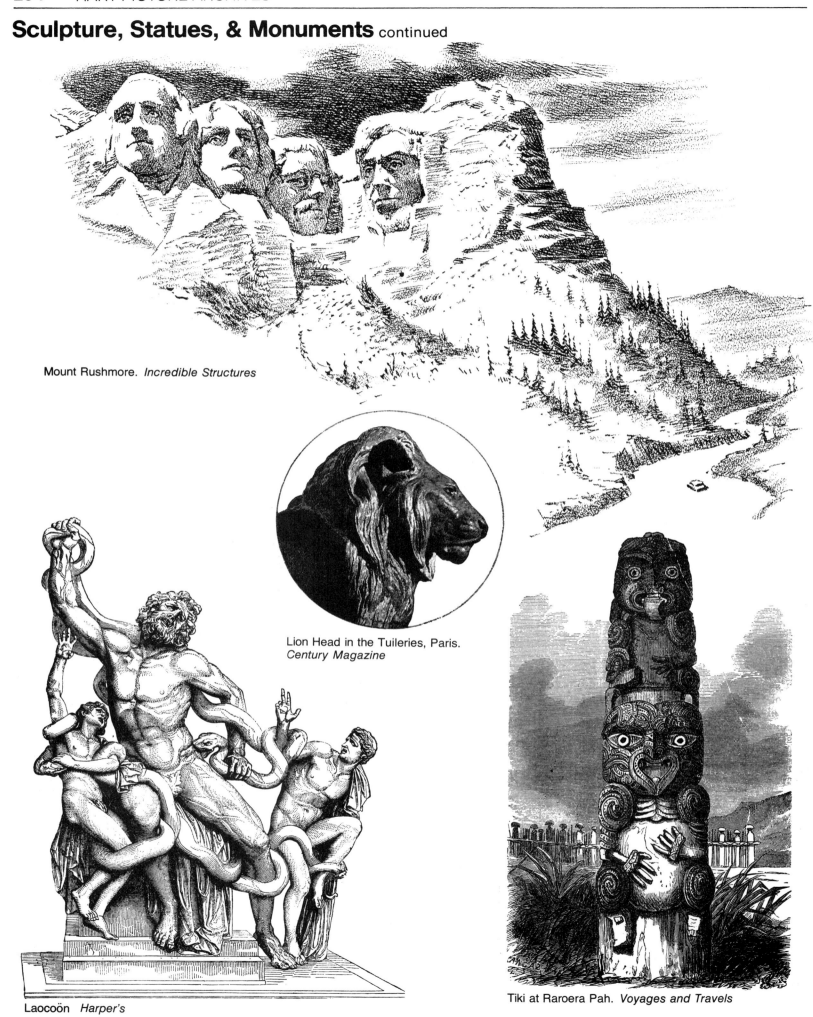

Mount Rushmore. *Incredible Structures*

Lion Head in the Tuileries, Paris.
Century Magazine

Laocoön *Harper's*

Tiki at Raroera Pah. *Voyages and Travels*

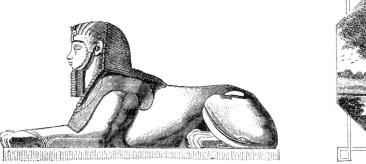

Sphinx at Thebes. *Short History of Art*

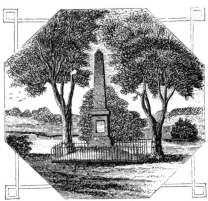

Monument at Concord.
Field Book of the Revolution

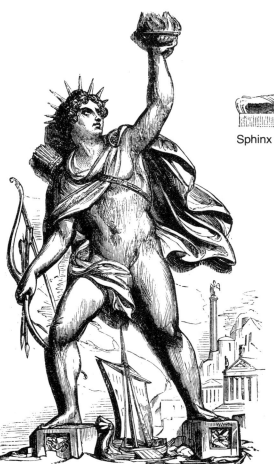

The Colossus of Rhodes.

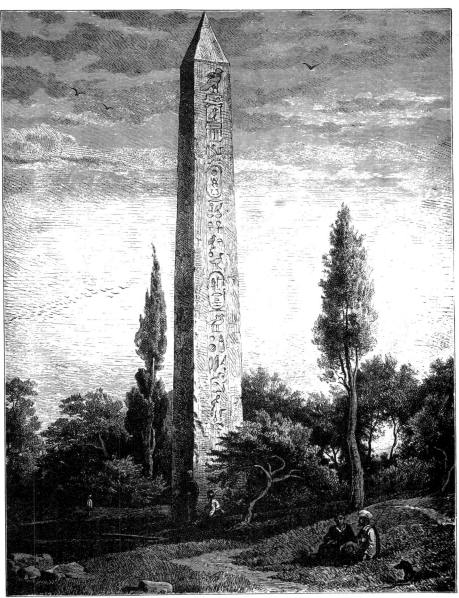

Obelisk of the Temple of the Sun at Heliopolis. *Harper's*

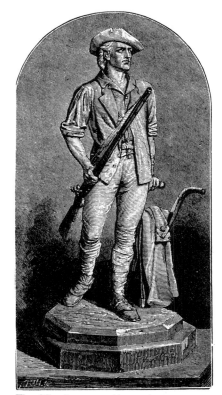

The Minute-man. *Harper's*

Ships & Boats

Bull boat. *Century Magazine*

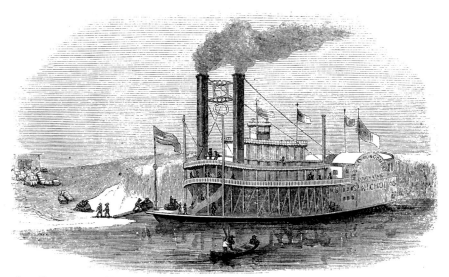

Loading cotton. *Harper's*

Rowing after snipe. *Century Magazine*

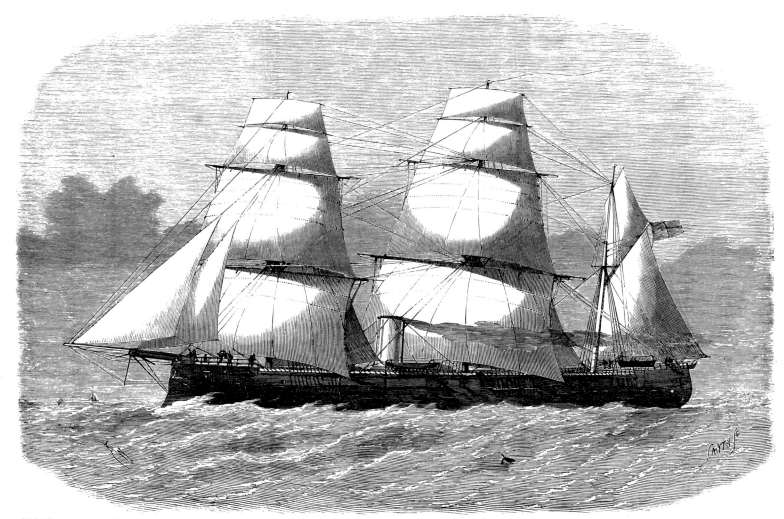

H.M.S. Amazon (destroyed by the collision with the steam-packet, Osprey). *Illustrated London News*

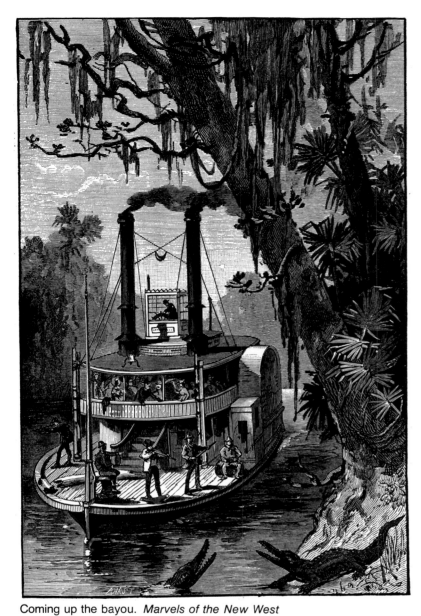

Coming up the bayou. *Marvels of the New West*

Church at Martigues, France. *Century Magazine*

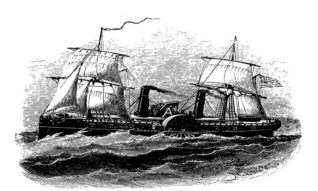

The frigate Vanderbilt. *Field Book of the Revolution*

Spanish caravel. *Harper's*

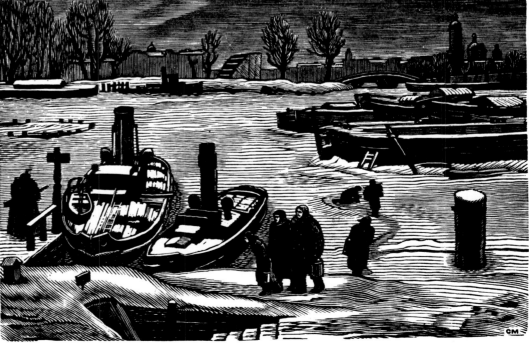

Nikolai Ivanovich Piskarev

Ships & Boats continued

Russian vessel.
Mikhail Ivanovich Pikov

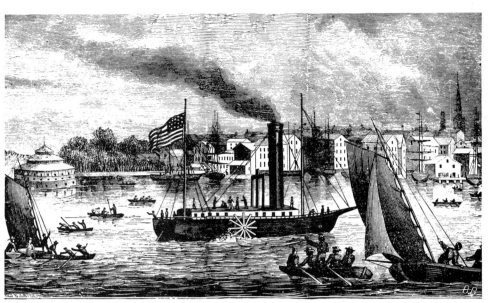

Fulton's First steamboat. *Harper's*

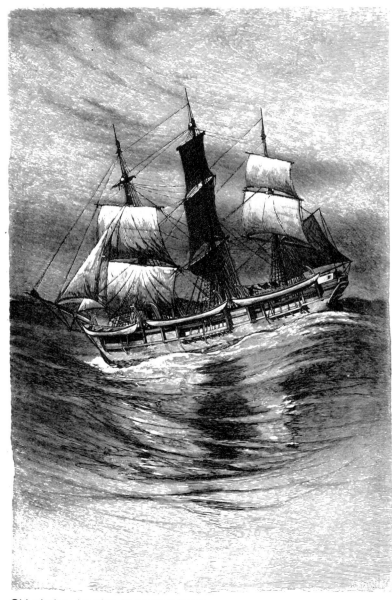

Old whaler. *London Illustrated News*

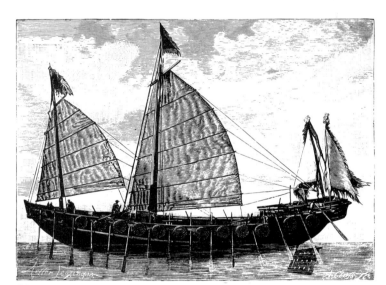

Chinese war junk. *Century Magazine*

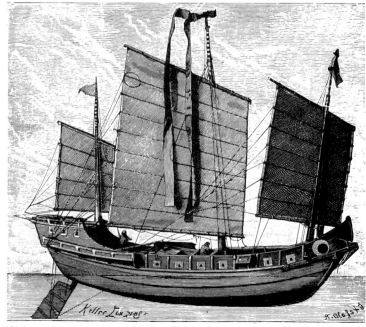

Chinese trading junk. *Century Magazine*

Harper's Roundtable

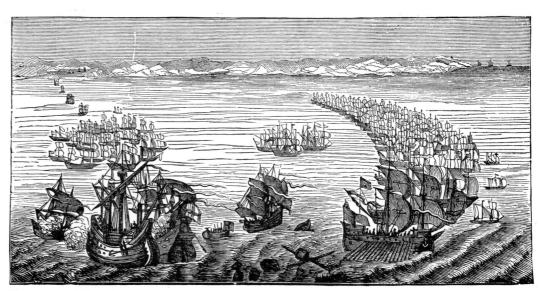

Voyages and Travels

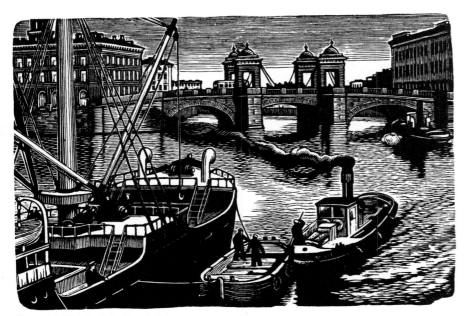

Sergei Mikhailovich Mochalov

The World: Its Cities and Peoples

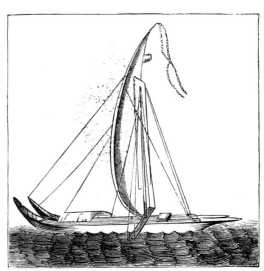

Harper's

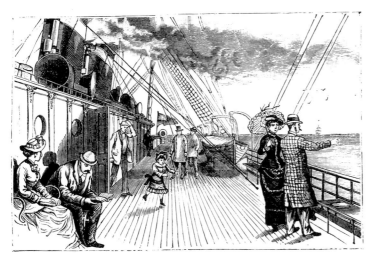

Promenade deck of an ocean steamer. *Leslie's, Vol. 14*

Sears Catalogue

Ships & Boats continued

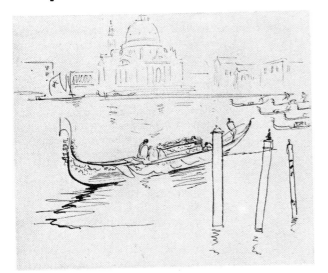

Venice. *Fifty Years of Soviet Art*

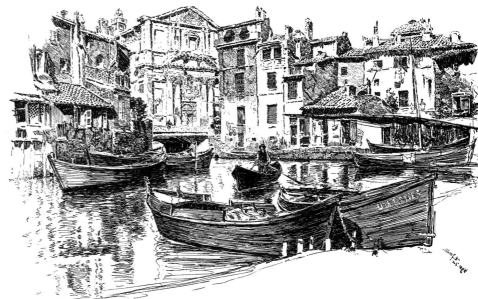

Century Magazine

Pilot boat. *Zig Zag Journeys*

Century Magazine

On a Mexican Mustang

Catchpenny Prints

Century Magazine

Century Dictionary

Harper's Roundtable

Leslie's

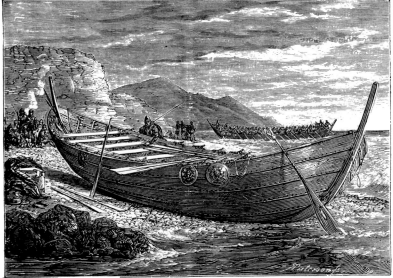

Voyages and Travels

Harper's

Shoes & Boots

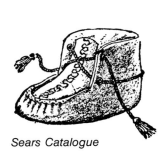

Sears Catalogue

Gaiter.
*French
Advertising Art*

Shoe, 9th century.
Harper's

Early Advertising Art

French Advertising Art

Shoe, 14th century.
Crystal Palace

Shoe, 14th century.
Crystal Palace

Century Magazine

Sears Catalogue

Queen Victoria's blue satin slipper.
Crystal Palace

Lady's shoe, 1850.
Crystal Palace

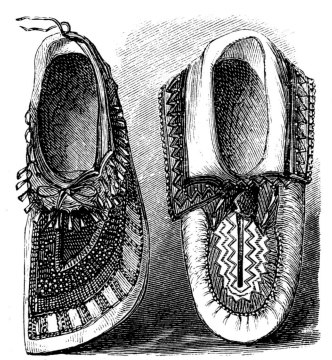

Sunday Book

Ancient Irish brogues.
Century Dictionary

Dictionary of Art

Baby's boot.
Sears Catalogue

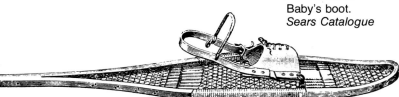

Harper's

Snowshoes. *Meyers Lexikon*

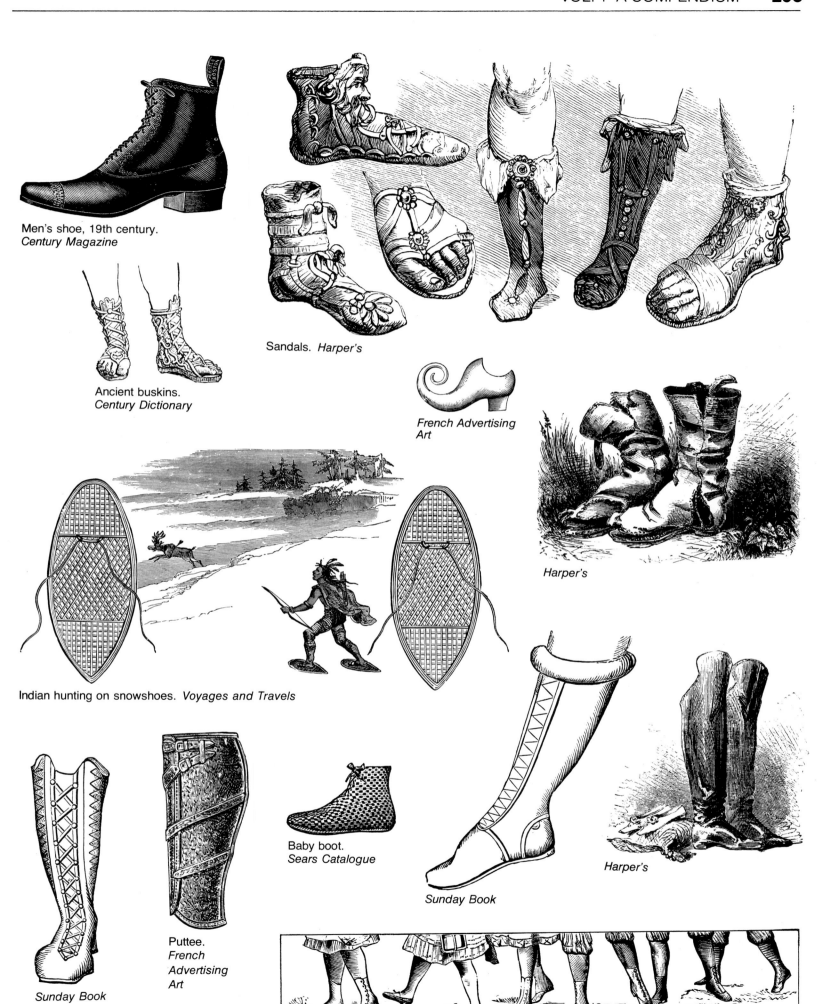

Men's shoe, 19th century.
Century Magazine

Ancient buskins.
Century Dictionary

Sandals. *Harper's*

French Advertising
Art

Harper's

Indian hunting on snowshoes. *Voyages and Travels*

Sunday Book

Puttee.
*French
Advertising
Art*

Baby boot.
Sears Catalogue

Sunday Book

Harper's

Century Magazine

Signs, Seals, & Symbols

Monogram of Horus,
Egyptian sun god.
Bible Encyclopaedia

Seal of the State
of New York.
Field Book of the Revolution

Michelangelo's seal.
Harper's

Seal of the State
of Kentucky.
Field Book of the Revolution

Riddle seal of Oxford.
Century Dictionary

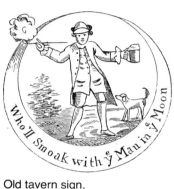

Old tavern sign.
History of Signboards

War-horse caparisoned,
seal of Phillip of Burgundy.
Century Dictionary

Amulets .
Century Dictionary

Caduceus.
*Century
Dictionary*

Cross. *Harper's*

Cattle brand, Bob on
the Square Ranch, Texas, 1875.
Symbols, Signs & Signets

The sun. *Tribute Book*

Victory laurel.
*Symbols, Signs
& Signets*

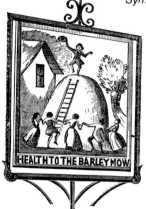

Tavern sign.
History of Signboards

Pottery mark:
Montelupo, 1600.
Symbols, Signs & Signets

Great seal of Albert the Bear.
Century Magazine

Pine tree flag. *Harper's*

Seal of the State
of Massachusetts.
Field Book of the Revolution

Bishop's seal. *Harper's*

Printer's logo.
History of Signboards

I AM THE ONLY
RUNNING FOOTMAN

Inn sign. *History of Signboards*

Leo the lion. *Harper's*

Aquarius the water carrier. *Harper's*

Sagittarius the archer. *Harper's*

Capricorn the goat. *Harper's*

Pisces the fishes. *Harper's*

Scorpio the scorpion. *Harper's*

Gorgon, Greek symbol
for terror.
Symbols, Signs & Signets

Personification of the days of the week.
Harper's

Pulaski's seal.
*Field Book
of the Revolution*

Assyrian seal.
Bible Encyclopaedia

Claim stake.
Harper's

Chinese standard. *Harper's*

Elephant and castle
tavern sign, circa 1668.
History of Signboards

Great seal of George III.
Field Book of the Revolution

Printer's mark, USSR.
Fifty Years of Soviet Art

Mark of Ramses II,
King of Egypt, 1324–1258 B.C.
*Symbols, Signs
& Signets*

Seal of the State
of Texas. *Zell's*

Peace symbol.
*Symbols, Signs
& Signets*

Revolutionary War
road sign. *Field
Book of the
Revolution*

Signs, Seals, & Symbols continued

The labarum. *Harper's*

Banner, 10th century. *Leslie's*

Emblem of Asshur. *Century Dictionary*

Liberty bell. *Harper's*

Dog star. *Harper's*

Seal of St. George. *Century Magazine*

Printer's mark, Brussels, 1476. *Symbols, Signs & Signets*

Assyrian standards. *Harper's*

Ankh, Egyptian symbol of life. *Symbols, Signs and Signets*

Hobo sign meaning "good camp." *Symbols, Signs and Signets*

Seal of St. Anthony. *Dictionary of Art*

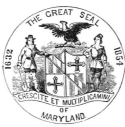

Dragon's eye. *Symbols, Signs and Signets*

Seal of the State of Maryland. *Field Book of the Revolution*

Seal of the State of Ohio. *Zell's*

U.S. Admiralty seal. *Field Book of the Revolution*

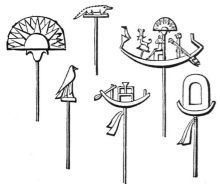

Egyptian standards. *Bible Encyclopaedia*

Phylacterium found at St. Dunstan's, Fleet Street, London. *Century Dictionary, Vol. 7*

Seal of the State of Virginia. *Field Book of the Revolution*

Seal of the State of Oregon. *Harper's*

Death. *Life*

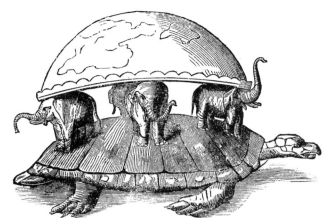

The Hindu earth. *Harper's*

Seal of the State of
West Virginia. *Zell's*

Tobacconer's sign. *History of Signboards*

Seal of the State of
Rhode Island. *Zell's*

Comic and tragic masks. *Leslie's*

Colonel Cochran's
tombstone, 1812.
*Field Book of
the Revolution*

Baker's sign,
Pompeii, 70 A.D.
History of Signboards

Advertising the end of the state
lottery in England, 1826. *Harper's*

Centennial medal.
Giants of the Republic

Seal of Shallum,
1000 B.C.
Harper's

Scarab. *Century Magazine*

Deer stamp from Veracruz.
Design Motifs of Ancient Mexico

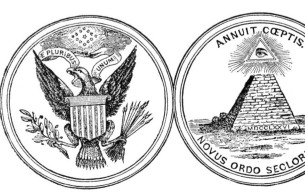

Great seal of the United States. *Field Book of the Revolution*

Silhouettes & Shadows

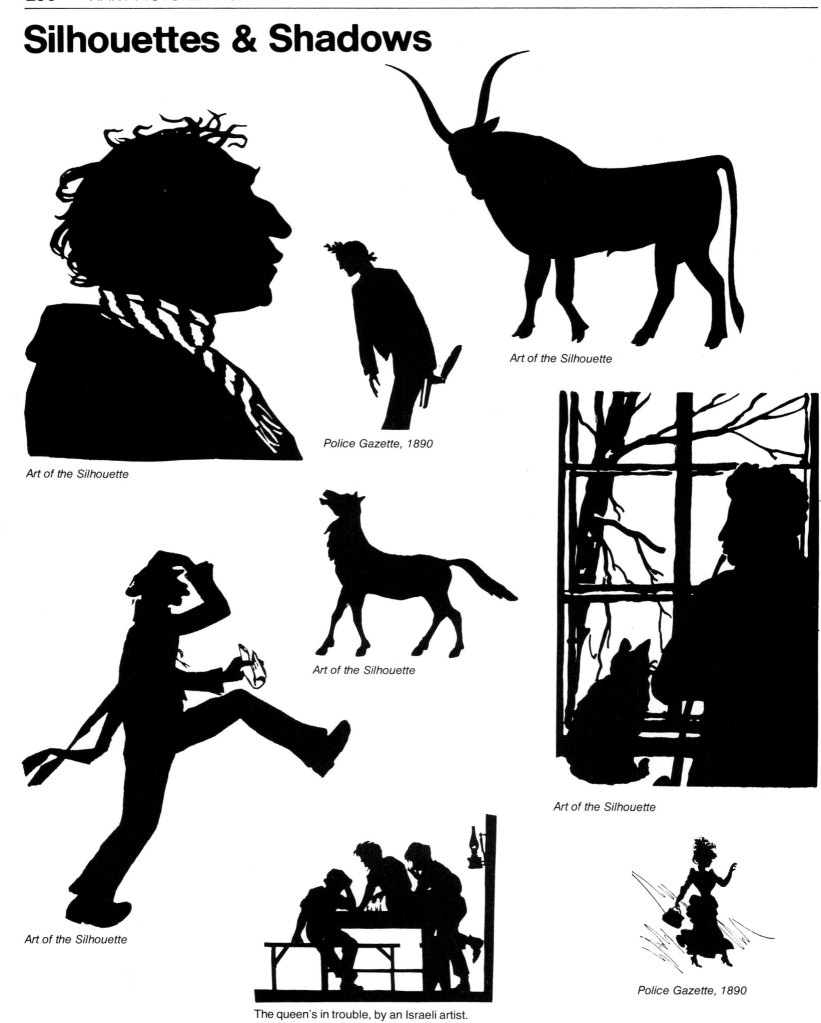

Art of the Silhouette

Police Gazette, 1890

Art of the Silhouette

Art of the Silhouette

Art of the Silhouette

Art of the Silhouette

The queen's in trouble, by an Israeli artist.

Police Gazette, 1890

The Art of the Silhouette

The Art of the Silhouette

The Art of the Silhouette

The Art of the
Silhouette

Punch

Harper's

Police Gazette, 1890

The Art of the Silhouette

The Art of the Silhouette

Silverware

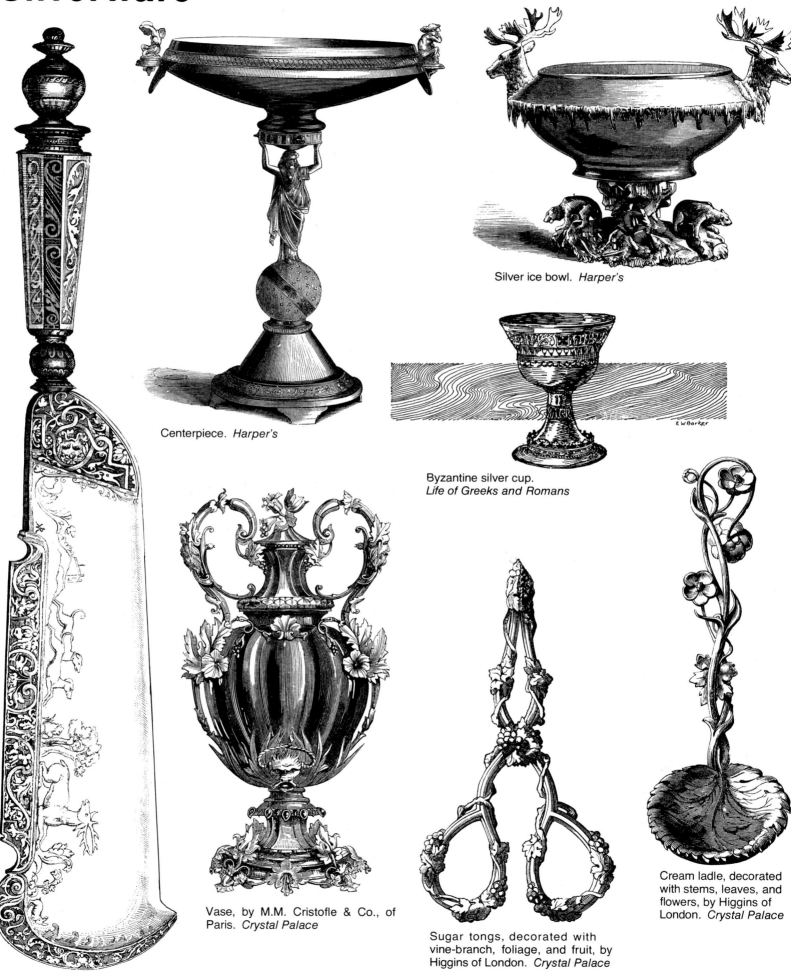

Centerpiece. *Harper's*

Silver ice bowl. *Harper's*

Byzantine silver cup.
Life of Greeks and Romans

Vase, by M.M. Cristofle & Co., of
Paris. *Crystal Palace*

Sugar tongs, decorated with
vine-branch, foliage, and fruit, by
Higgins of London. *Crystal Palace*

Cream ladle, decorated
with stems, leaves, and
flowers, by Higgins of
London. *Crystal Palace*

Huntsman's cleaver.
L'Art Pour Tous

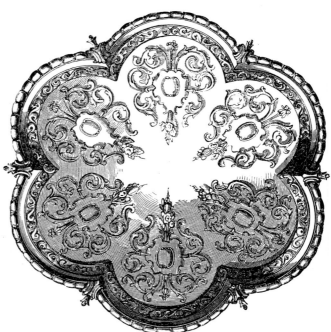

Silver engraved coffeepot.
Century Magazine, 1890

Scissors with Italian
style ornamentation by
Thornhill. *Crystal Palace*

Tray of magneto-plated silver,
by Prime and Son, Birmingham, England.
Crystal Palace

Tiger-ware, with
mount in silver-gilt.
*Century Dictionary,
Vol. 9*

Claret jug, by Dodd of
London. *Crystal Palace*

Butter dish. *Illustrated London News*

Tea set. *Harper's*

Dessert fork and spoon, by G.W.
Adams of London.
Crystal Palace

Sleep & Repose

St. Nicholas

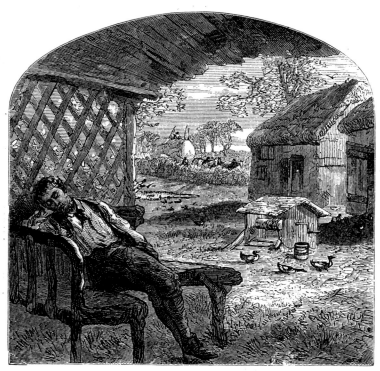

Leslie's

Harper's

Nikolai Ivanovich Piskarev

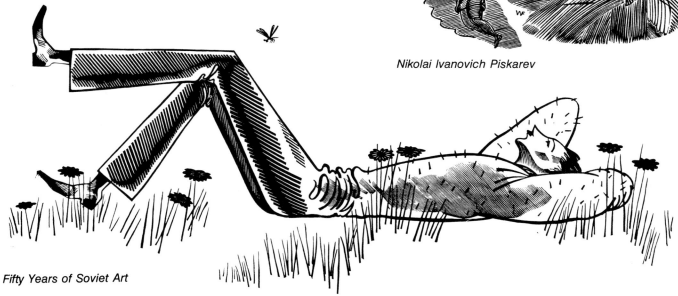

Fifty Years of Soviet Art

Leslie's

Nikolai Ivanovich Piskarev

Drawing by Hugh Thomson. *Our Village*

Harper's

Smoking & Tippling

Sketch by Gavarni. *Harper's*

A glass of aguardiente. *Century Magazine*

Calumet. *Century Dictionary*

Early Advertising Art

Sailor's boarding house. *Harper's, 1873*

The Art of the Book

Illustrated London News

Century Magazine, 1889

Drawing by Hugh Thomson. *Our Village*

Nadir Abdurakhmanov

Catalog of the Unusual

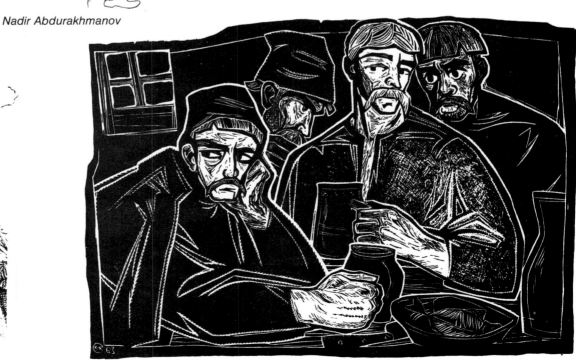

Graphic Arts of Lvov

Smoking & Tippling continued

Turkish pipe.

Harper's

Punch

Catalog of the Unusual

Scene in a Dutch theater. Harper's

Early Advertising Art

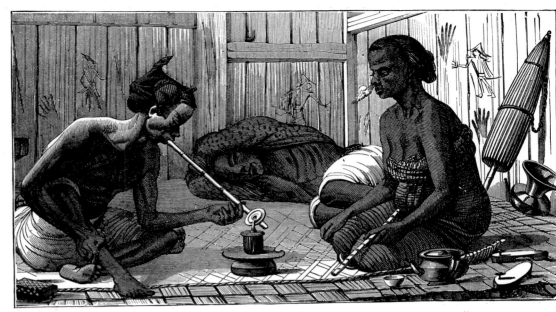

Riverside Natural History

Punch

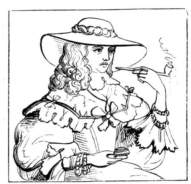

Harper's

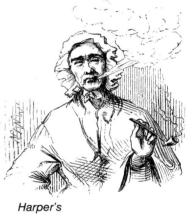

Harper's

Major Pitcairn stirring his brandy. *Harper's, Vol. 50*

Aleksandr Vasin

Early Advertising Art

Society Swells

Punch

Life

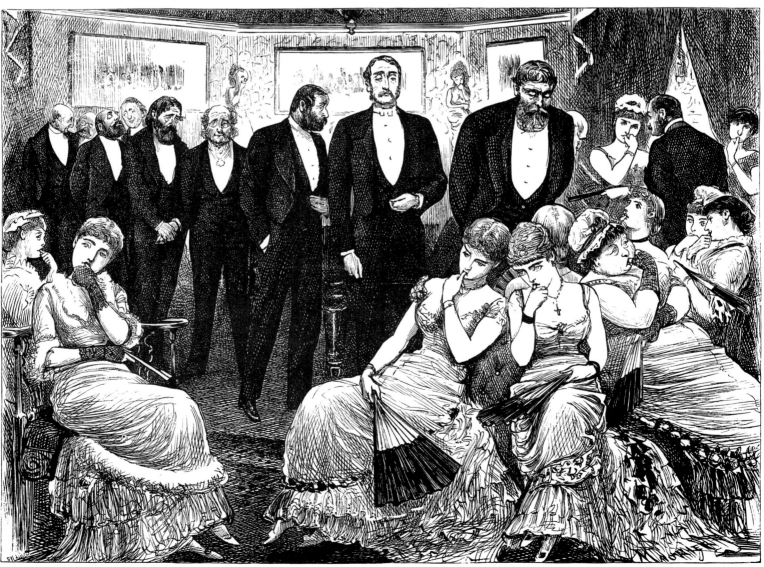

Punch

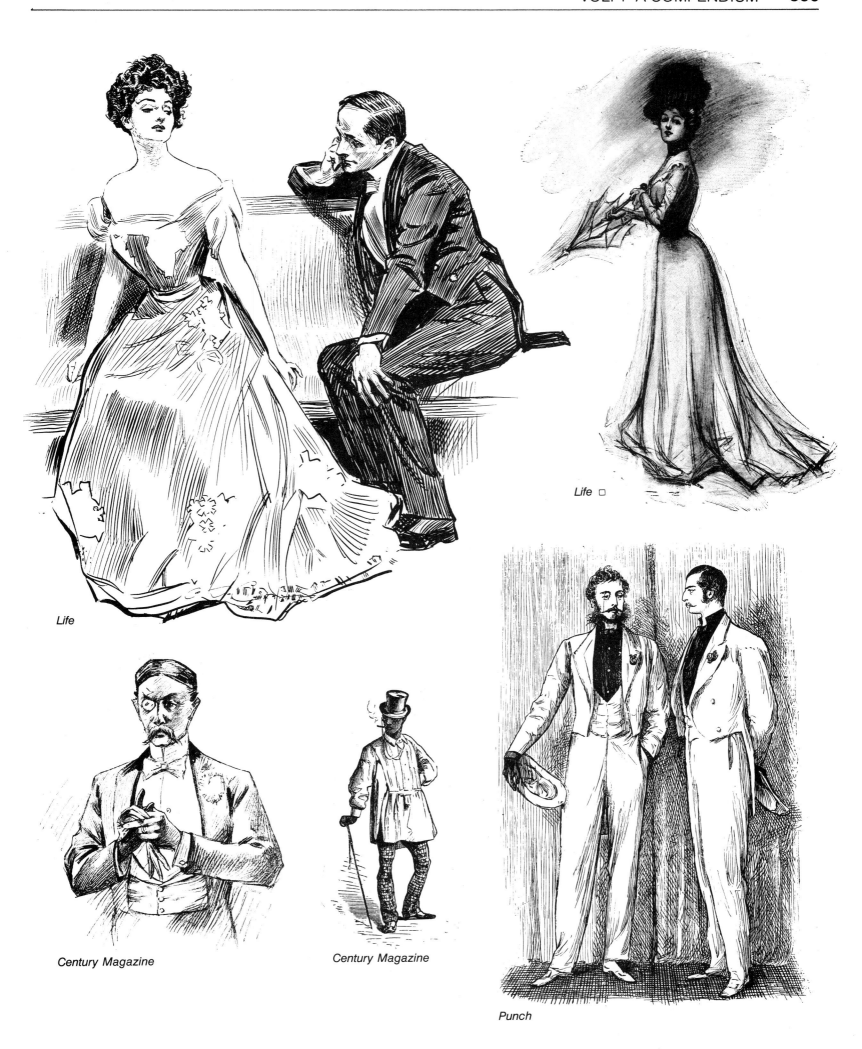

Life

Life □

Century Magazine

Century Magazine

Punch

Sorrow

Harper's, Vol. 54

Nikolai Ivanovich Piskarev

Graphic Arts of Lvov

Harper's

The Art of the Book □

The Art of the Book

Leslie's

Sport

Hunting. *Harper's*

Young lady baseballists. *Police Gazette*

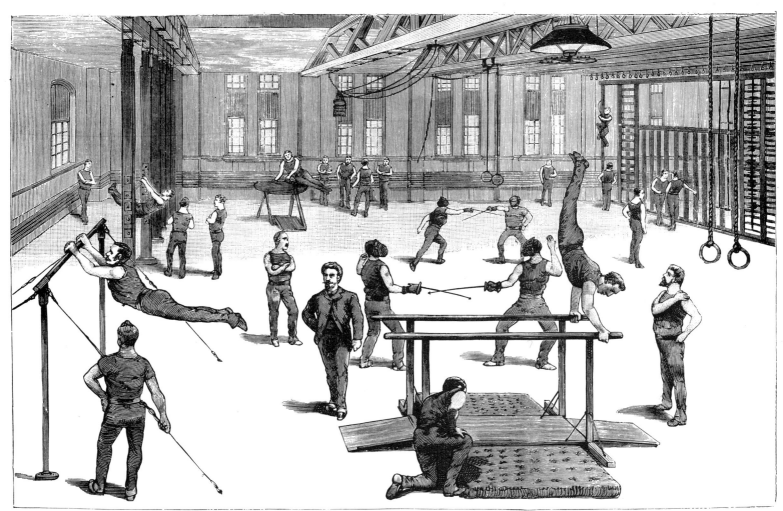

Gymnasium. *Leslie's*

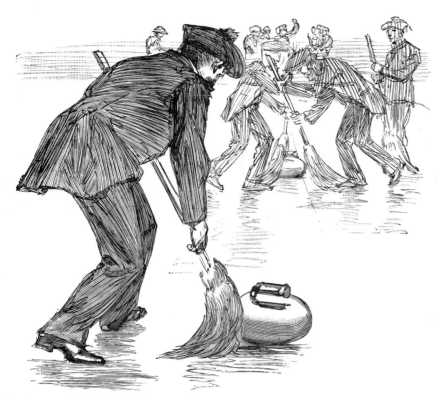

Curling match. *Century Magazine*

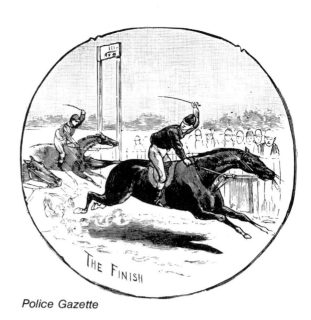

Police Gazette

Fishing equipment. *Harper's*

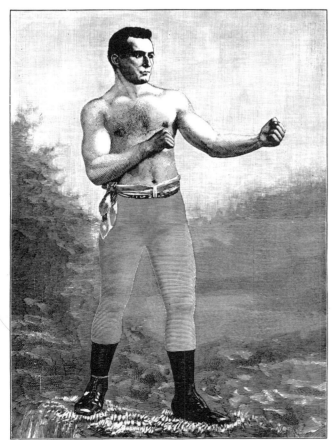

Jake Kilrain. *Police Gazette*

E.N. Crane (Brotherhood League). *Harper's Weekly*

Sport continued

Lacrosse. *Harper's*

Yale defeated by Princeton, Thanksgiving Day, 1893.
Police Gazette

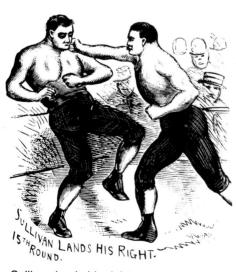

Sullivan lands his right.
Police Gazette

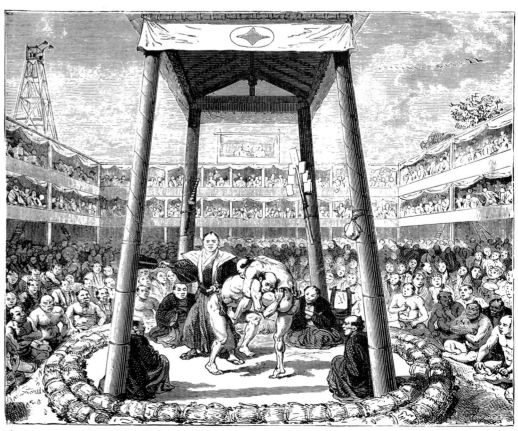

Japanese wrestlers. *Voyages and Travels*

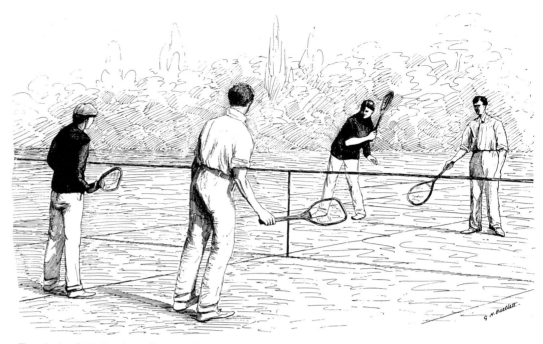

Tennis, by G.H. Bartlett. *Pen and Ink Drawing*

Bear hunting. *Harper's*

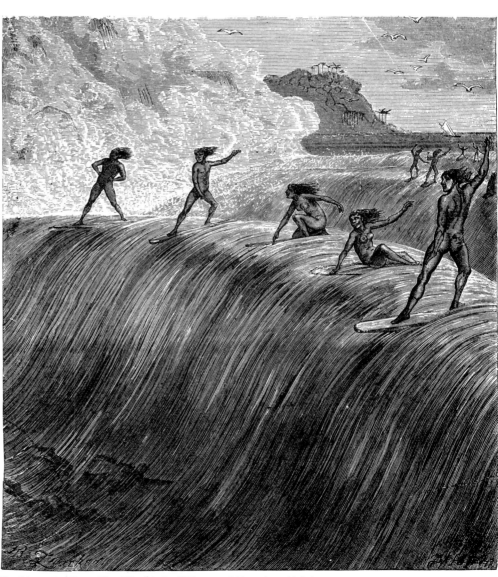

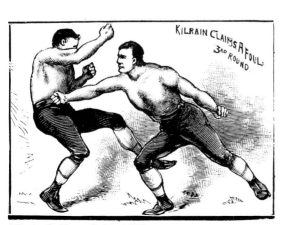

Kilrain-Sullivan fight, 1889.
Police Gazette

Surf-board riding. *The World: Its Cities and Peoples, Vol 4*

Sport continued

The croquet player. *Leslie's*

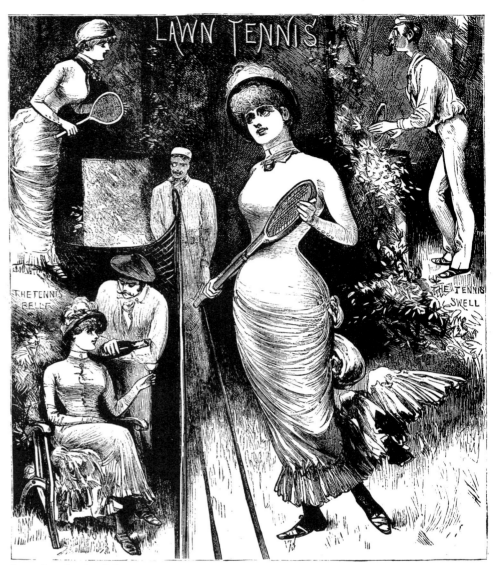

Lawn tennis. *Leslie's*

Basketball. *Incredible Athletic Feats* □

French Advertising Art

French Advertising Art

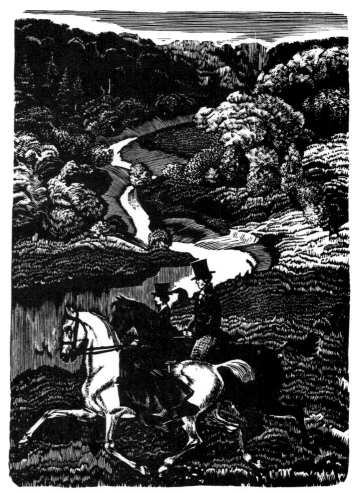

Riding. *Sergei Mikhailovich Mochalov*

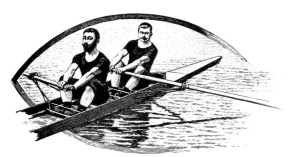

French Advertising Art

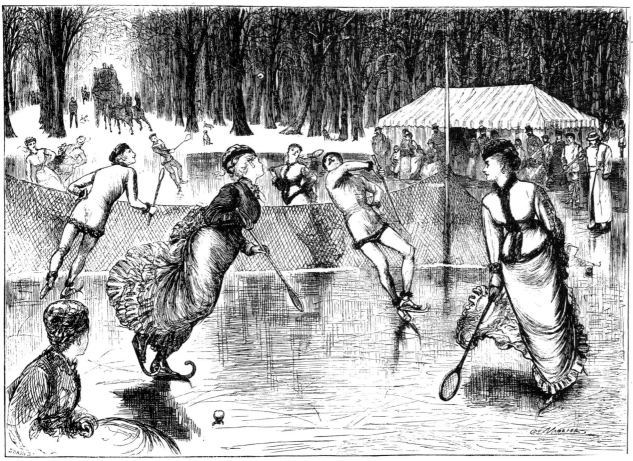

Rink tennis. *Punch, 1876*

Surprise

Police Gazette, 1892

Leslie's

Police Gazette, 1883

Harper's

Century Magazine

Century Magazine

Drawing by Louis Loeb. *Century Magazine* ▢

Drawing by Hugh Thomson. *Our Village*

Tombs & Graves

Mummy cases and marble sarcophagi. *Sunday Book*

Sioux graves. *Harper's*

Corner of a graveyard. *Leslie's*

Scene at a cemetery. *Leslie's*

Ancient Arab burial ground. *Picturesque Palestine, Vol. 1.*

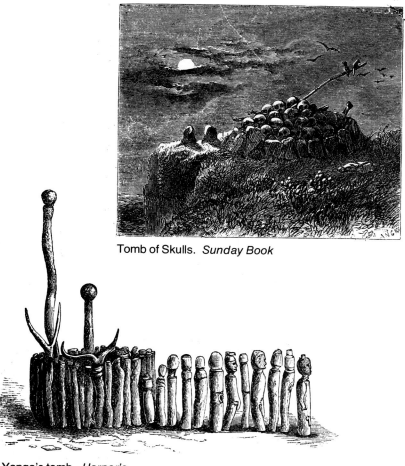

Tomb of Skulls. *Sunday Book*

Yanga's tomb. *Harper's*

Tomb of Queen Mary. *Harper's*

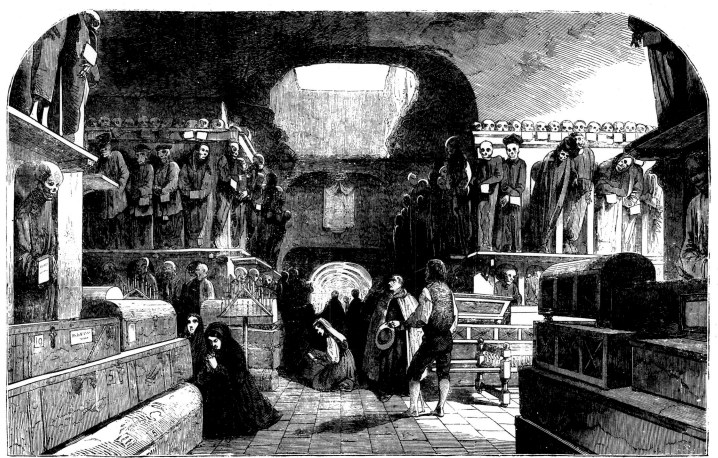

Cemetery at Capuchin convent, Palermo. *Leslie's, Vol. 14*

Tools

Wrench.
*Sears
Catalogue*

Wooden snow shovel. *Sears Catalogue*

Saw. *Sears Catalogue*

Plow. *Meyers Lexikon*

Straight incisor cutters.
Sears Catalogue

Socket-framing chisel.
Sears Catalogue

Starhack saw. *Century Magazine*

Hand drill.

Rail fork.
*Century
Dictionary*

Nail pincers. *Sears Catalogue*

Goodell's automatic screwdriver.
Sears Catalogue

Diamond mortar.
Century Dictionary

Wire potato scoop. *Sears Catalogue*

Open-all tool.
Catalog of the Unusual □

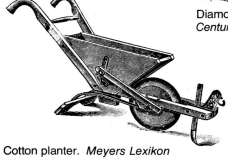

Cotton planter. *Meyers Lexikon*

Hook disgorger. *Century Dictionary*

Bandsaw. *Century Dictionary*

Pincers.
*Sears
Catalogue*

Magic hammer. *Catalog of the Unusual*

Ratchet screwdriver. *Sears Catalogue*

Drill and ratchet braces.
Sears Catalogue

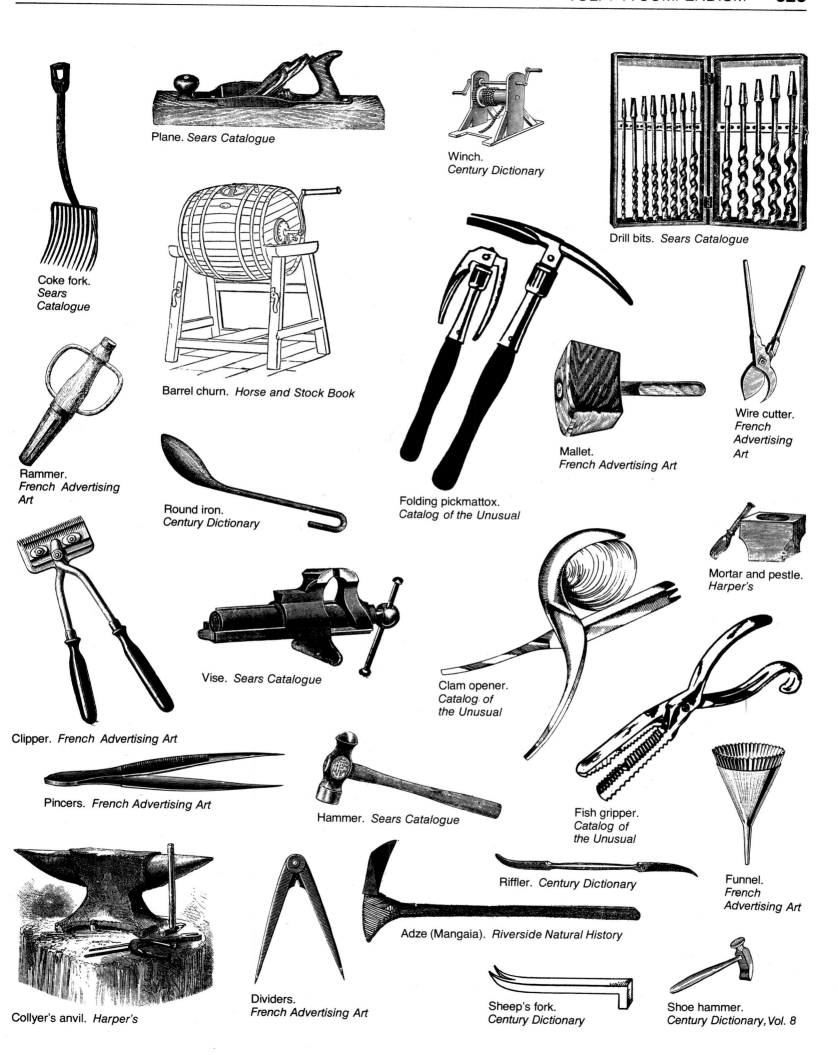

Plane. *Sears Catalogue*

Winch.
Century Dictionary

Drill bits. *Sears Catalogue*

Coke fork.
*Sears
Catalogue*

Barrel churn. *Horse and Stock Book*

Rammer.
*French Advertising
Art*

Round iron.
Century Dictionary

Folding pickmattox.
Catalog of the Unusual

Mallet.
French Advertising Art

Wire cutter.
*French
Advertising
Art*

Mortar and pestle.
Harper's

Vise. *Sears Catalogue*

Clam opener.
*Catalog of
the Unusual*

Clipper. *French Advertising Art*

Pincers. *French Advertising Art*

Hammer. *Sears Catalogue*

Fish gripper.
*Catalog of
the Unusual*

Funnel.
*French
Advertising Art*

Riffler. *Century Dictionary*

Adze (Mangaia). *Riverside Natural History*

Collyer's anvil. *Harper's*

Dividers.
French Advertising Art

Sheep's fork.
Century Dictionary

Shoe hammer.
Century Dictionary, Vol. 8

Towers

The Serranos gate, Valencia, Spain.
Zell's

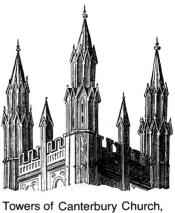
Towers of Canterbury Church,
Kent, England. *Short History of Art*

The Menagerie Tower. *The World: Its Cities and Peoples*

Bell tower.
*Short History
of Art*

Fortifications of Carcassonne, France.
Century Dictionary

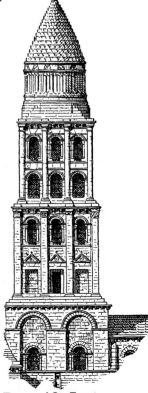
Tower of St. Front,
Périgueux, France.
Century Dictionary

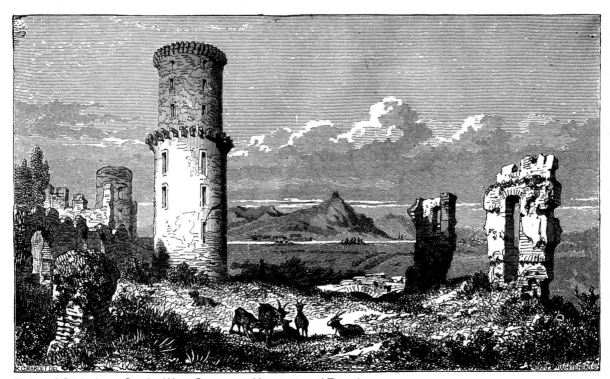
Ruins of Godesburg Castle, West Germany. *Voyages and Travels*

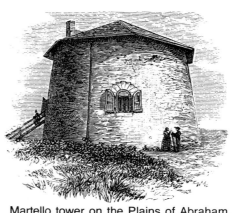

Martello tower on the Plains of Abraham, Quebec, Canada. *Harper's*

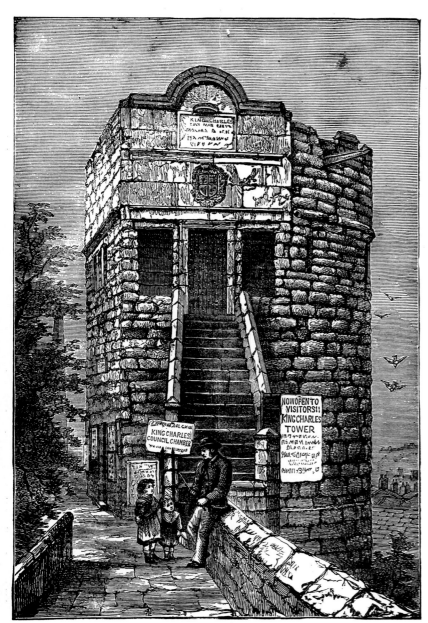

King Charles tower, Chester, England. *Century Magazine*

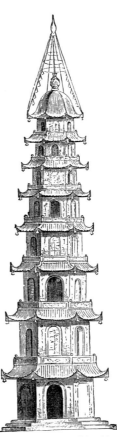

Porcelain tower at Nanking, China. *Architectural Styles*

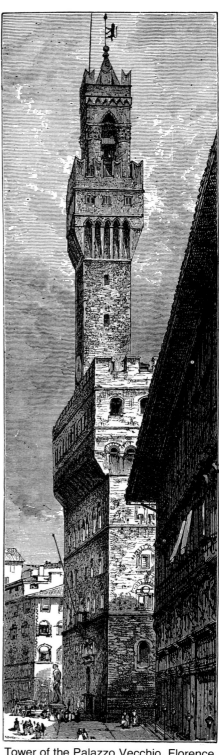

Tower of the Palazzo Vecchio, Florence, Italy. *Illustrated London News*

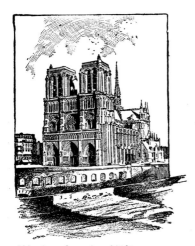

Western facade of Nôtre Dame Cathedral, Paris, France. *Century Dictionary*

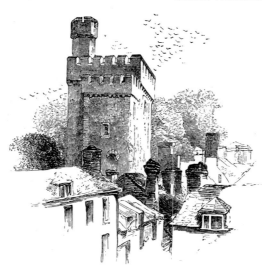

Century Magazine

Toys & Games

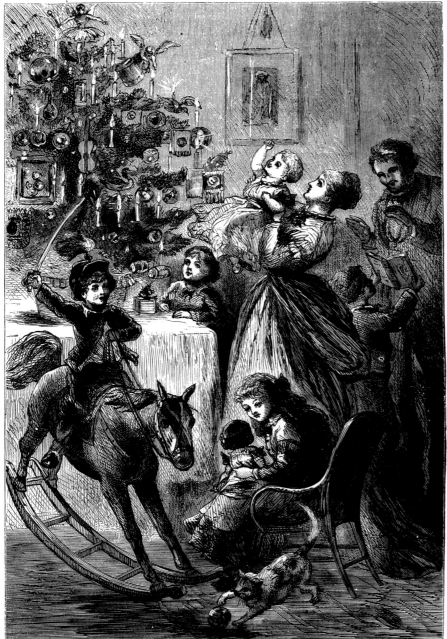

The Christmas tree. *Harper's*

Child's doll from Central Africa, circa 1900. *Riverside Natural History*

Rocking horse. *Handbook of Early Advertising Art*

Early woodcut portraying kite-flying. *Catchpenny Prints*

The turning point. *St. Nicholas*

Sears Catalogue

Leap-frog, by Hugh Thomson. *Our Village*

Rocking-horse. *Early Advertising Art*

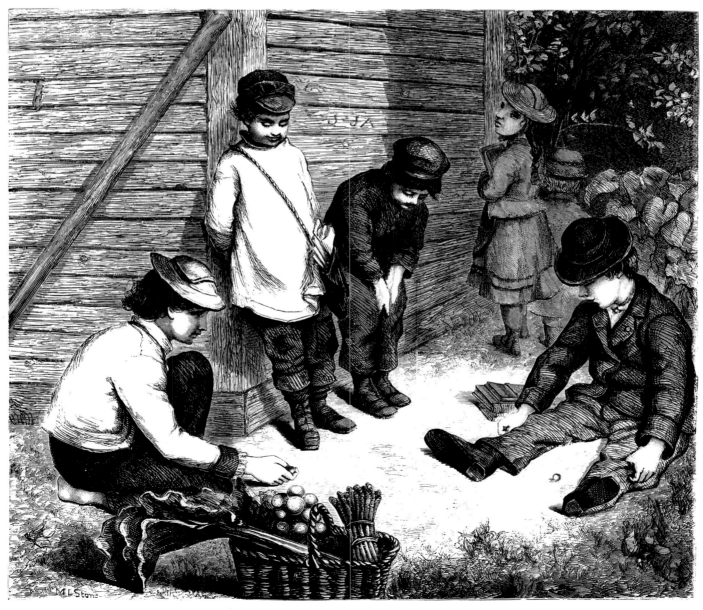

Playing with marbles. *Leslie's*

Trades & Occupations

Bartender. *On a Mexican Mustang*

Coachman. *Century Magazine*

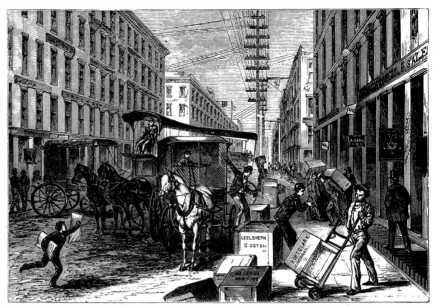

Delivery man. *Harper's*

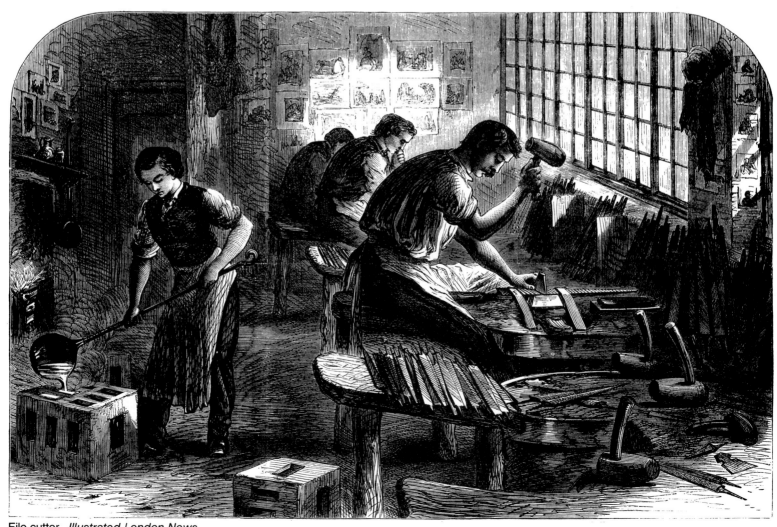

File cutter. *Illustrated London News*

Tailors. *Century Magazine*

Sheep shearer: *Marvels of the New West*

Butcher, by E.W. Kemble. *St. Nicholas*

Printers. *Harper's*

Loggers. *St. Nicholas*

Trades & Occupations continued

Gold leaf workers. *Harper's*

Basket maker. *Century Magazine*

Diamond cutters. *Harper's*

Cowboy. *Zell's*

Barber. *Century Magazine*

Photographer. *Police Gazette, 1891*

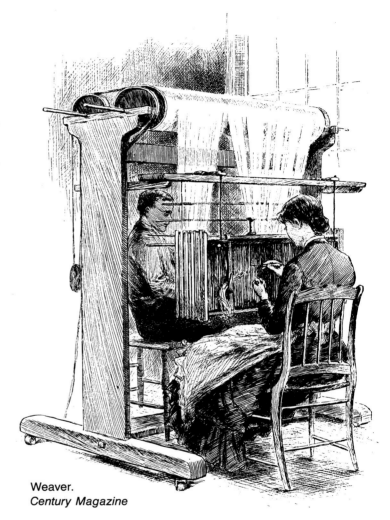

Weaver.
Century Magazine

Seamstress.
Century Magazine

Telephone repairman.
Harper's

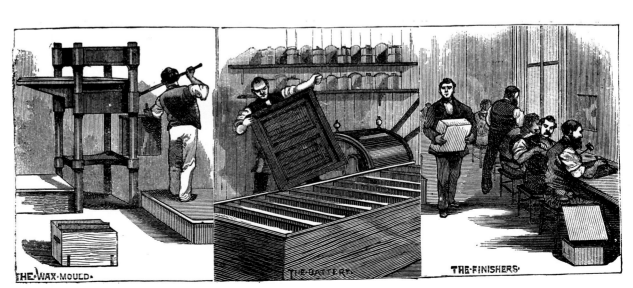

Electrotypers. *Leslie's*

Trades & Occupations continued

Bee-keepers. *Standard Horse and Stock Book*

Stereotype foundry. *Harper's*

Cutting mica. *Harper's*

Carpenter. *Harper's*

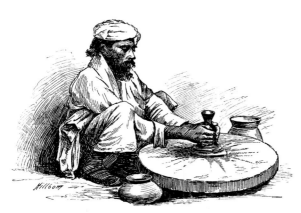

Hindu potter, Lahore, India. *Indika*

Costermonger. *Punch*

Milk delivery man. *Harper's*

Cheese seller. *Harper's*

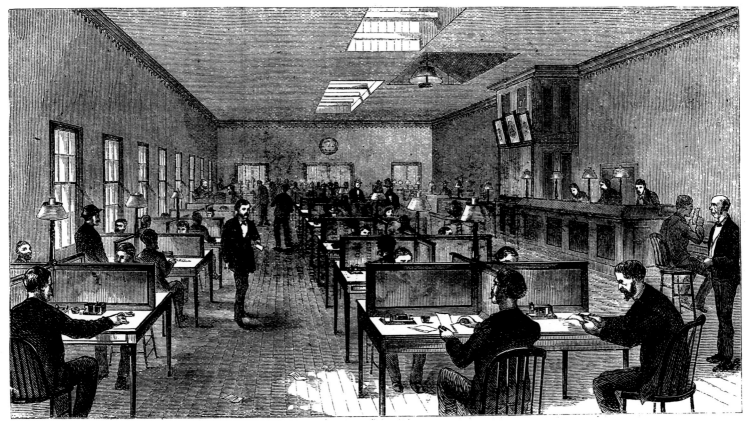

Telegraph operators. *Harper's*

Vegetation

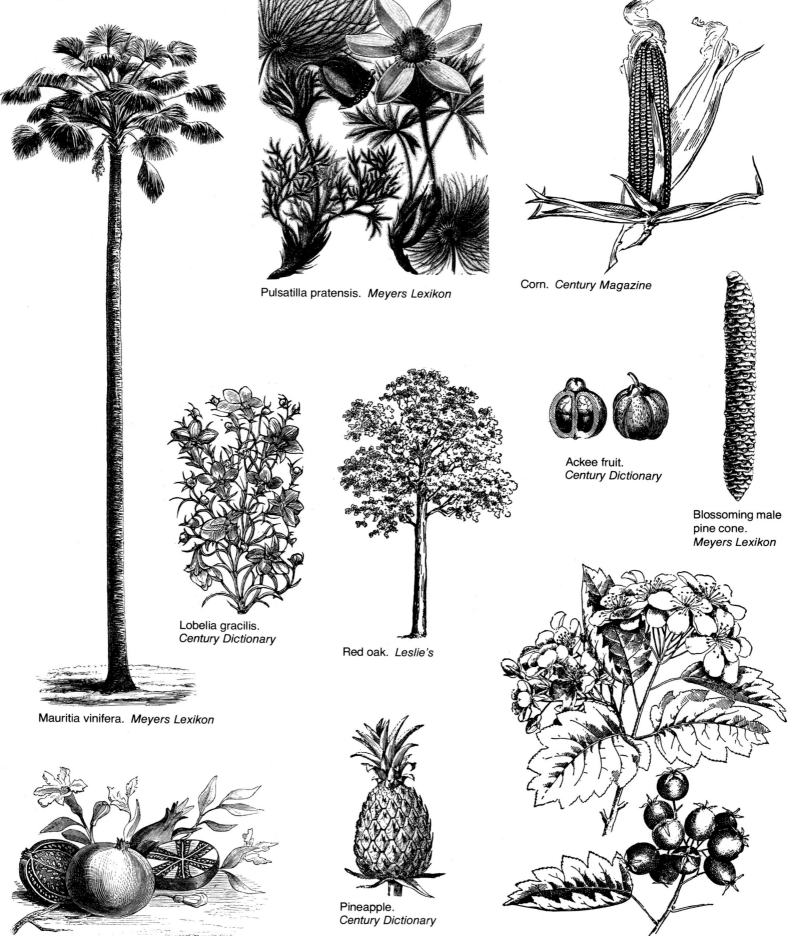

Pulsatilla pratensis. *Meyers Lexikon*

Corn. *Century Magazine*

Ackee fruit.
Century Dictionary

Blossoming male
pine cone.
Meyers Lexikon

Lobelia gracilis.
Century Dictionary

Red oak. *Leslie's*

Mauritia vinifera. *Meyers Lexikon*

Pomegranates. *A Guide to Trees*

Pineapple.
Century Dictionary

Hawthorn. *A Guide to Trees*

Sunflower.
Century Dictionary

Pinus pinea (stone pine). *Sunday Book*

Japanese clover. *Standard Horse and Stock*

Pistachio tree with fruits.
Century Dictionary

Houseleek. *Harper's*

Brasenia purpurea. *Meyers Lexikon*

Pine.
A Guide to Trees

Araucaria imbricata. *Meyers Lexikon*

Sycamore figs. *Sunday Book*

Vegetation continued

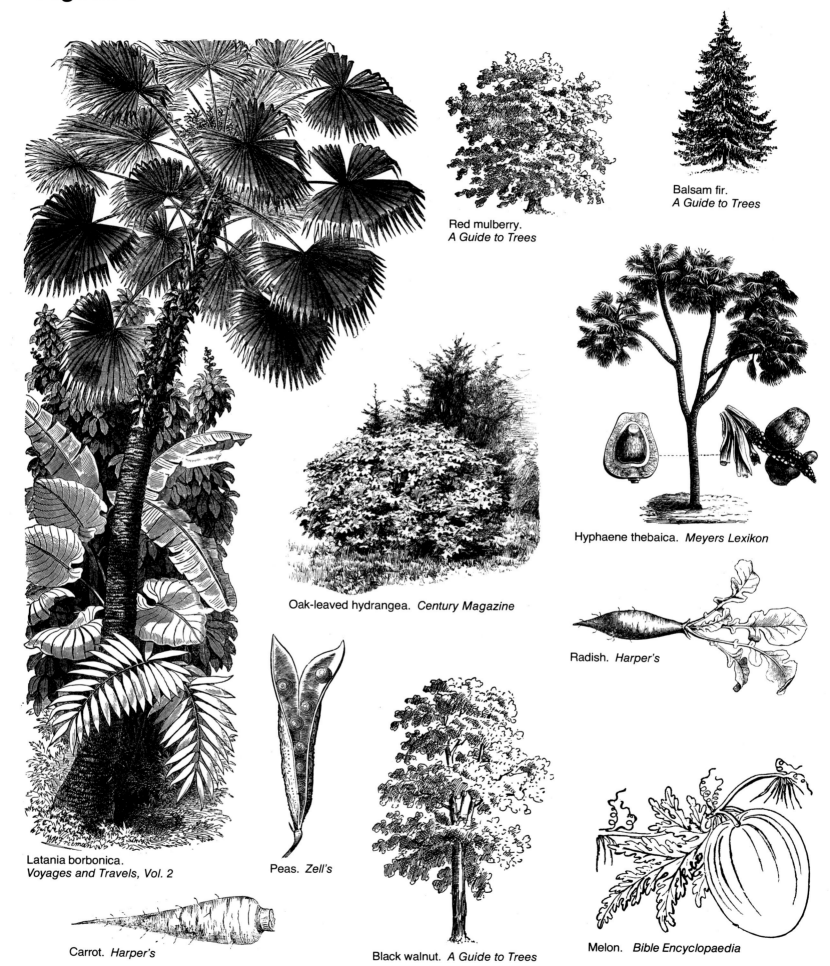

Red mulberry.
A Guide to Trees

Balsam fir.
A Guide to Trees

Hyphaene thebaica. *Meyers Lexikon*

Oak-leaved hydrangea. *Century Magazine*

Radish. *Harper's*

Latania borbonica.
Voyages and Travels, Vol. 2

Peas. *Zell's*

Carrot. *Harper's*

Black walnut. *A Guide to Trees*

Melon. *Bible Encyclopaedia*

Wild plum. *A Guide to Trees*

Heavywood pine (Rocky Mountains). *Harper's*

American elm.
A Guide to Trees

Acorn.
Leslie's

Norway spruce.
A Guide to Trees

Figs. *Sunday Book*

Pandanus odoratissimus.
Meyers Lexikon

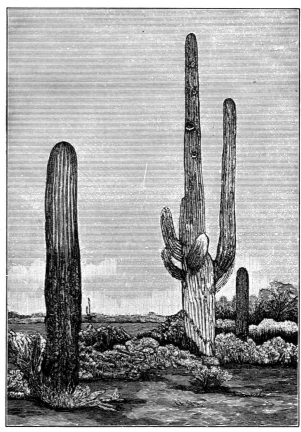

Arizona cacti. *Marvels of the New West*

Vegetation continued

Norway spruce. *A Guide to Trees*

Papyrus antiquorum. *Bible Encyclopaedia*

Iris leaf. *Leslie's*

Iris. *Leslie's*

Tall fescue grass.
Standard Horse and Stock

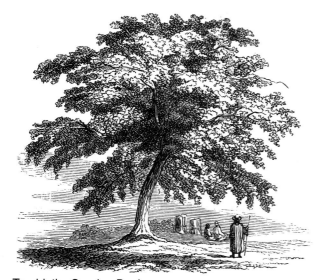

Terebinth. *Sunday Book*

Sunflowers. *Marvels of the New West*

Hairy violet and heartsease.
Zell's

Virginia juniper.
A Guide to Trees

Lentils. *Sunday Book*

Grapes, by G.H. Bartlett. *Pen and Ink Drawing*

Vehicles & Transportation

Norwegian sleigh. *Leslie's*

Arabian litter. *Zell's*

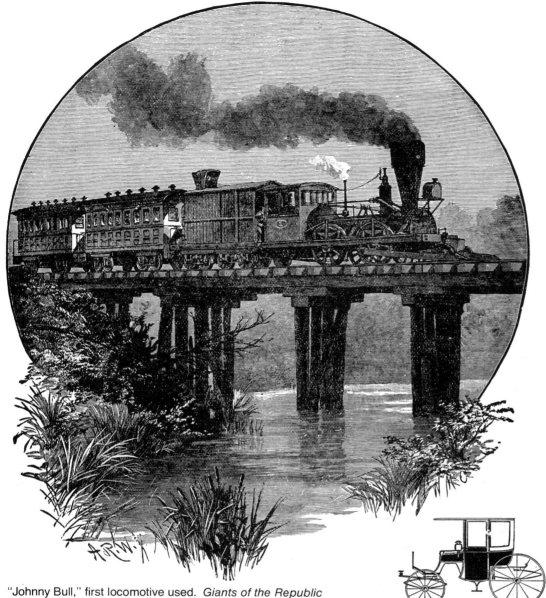

"Johnny Bull," first locomotive used. *Giants of the Republic*

Coupe rockaway.
Century Dictionary, Vol. 8

Arabah. *Century Dictionary*

Sears and Roebuck's three-seat carriage, 1902.
Sears Catalogue

Friedman road wagon, 1901-1902.
Early Advertising Art

Nikolai Ivanovich Piskarev

Egyptian palanquin. *Sunday Book*

Bibles and whiskey in the same wagon. *Samantha at the World's Fair*

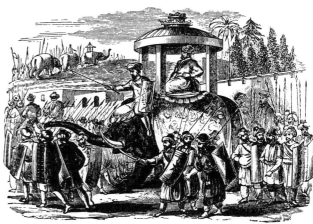

Howdah of an Indian prince. *Sunday Book*

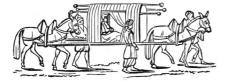

Persian litter. *Zell's, Vol. 2*

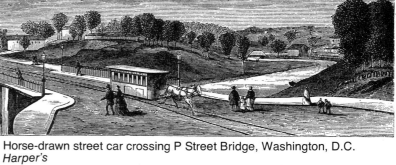

Horse-drawn street car crossing P Street Bridge, Washington, D.C.
Harper's

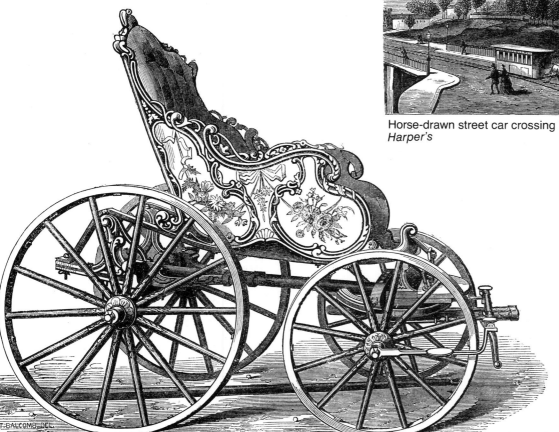

Horse-drawn street car.
Catalog of the Unusual

Calash. *Century Dictionary, Vol. 2*

Old carriage of French or Flemish pattern. *Illustrated London News*

Vehicles & Transportation continued

Locomotive by Oliver Evans of Philadelphia, 1802; scow equipped to travel on land or water. *Harper's, Vol. 50*

Sedan chair of the Grand Duke of Tuscany.
Illustrated London News

Mule wagon. *Harper's*

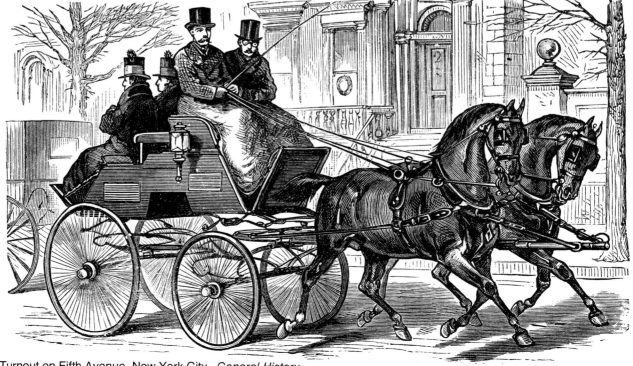

Turnout on Fifth Avenue, New York City. *General History*

The "Baldwin" locomotive, 1846. *Leslie's*

Child's seat drop front.
Illustrated Catalogue of Carriages

Swamp highway mishap. *Leslie's*

Machine for riveting
carriage wheels.
*Illustrated Catalogue
of Carriages*

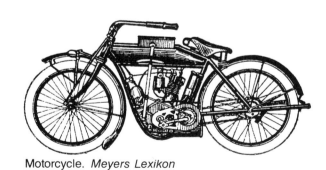

Motorcycle. *Meyers Lexikon*

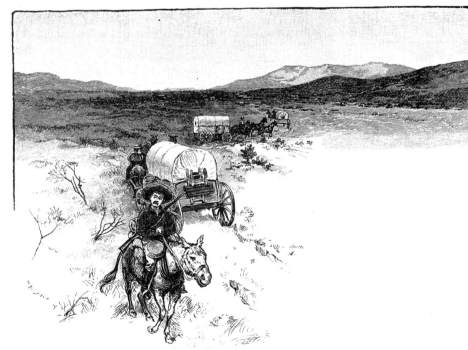

Wagon train in Arizona territory. *Century Magazine*

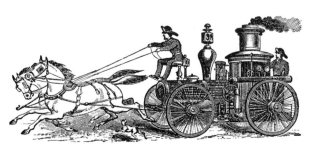

Horse-drawn fire engine. *Harper's*

Vehicles & Transportation continued

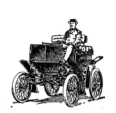

Electric automobile.
Century Dictionary

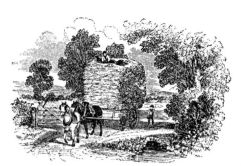

Hay wagon. *Century Magazine*

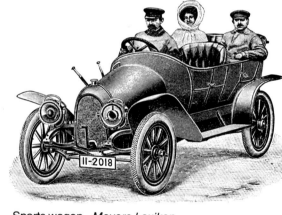

Century Magazine

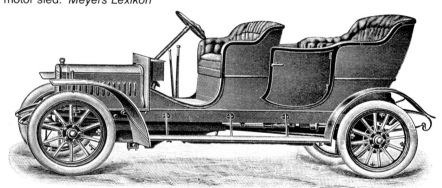

German motor sled. *Meyers Lexikon*

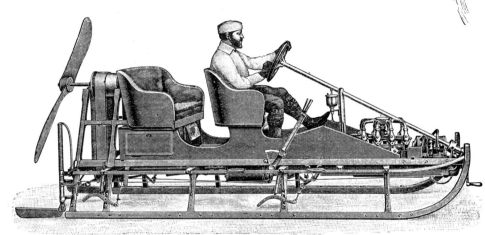

Phaeton. *Meyers Lexikon*

Sports wagon. *Meyers Lexikon*

Wagon on the Great Missouri Trail approaching Santa Fe, New Mexico. *Harper's*

Grocery wagon, circa 1900. *Sears Catalogue*

Calèche, or Canadian hansom.
The World: Its Cities and Peoples, Vol. 6

Turkish arabah drawn by oxen. *Sunday Book*

Horse-drawn sleigh. *Sears Catalogue*

Landaulet. *Meyers Lexikon*

Century Magazine

Surrey. *Sears Catalogue*

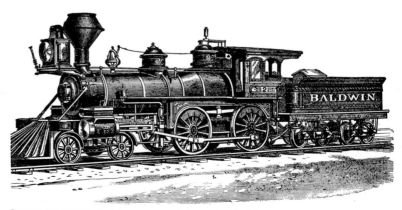

Steam locomotive. *Voyages and Travels, Vol. 1*

Village Scenes

Court House at Appomattox, Virginia. *Century War Book*

Sunday in Brittany, France. *Harper's*

Branford Center, Connecticut. *Tribute Book*

A village in Loyale, West Africa. *The World: Its Cities and Peoples*

Bethlehem. *Sunday Book*

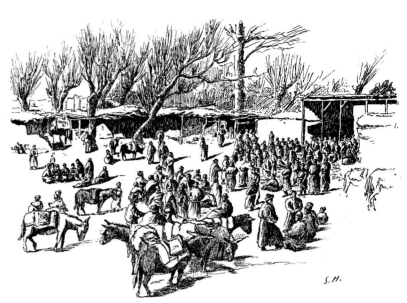

Village near Khotan, China. *Polar and Tropical Worlds*

Russian village. *Fifty Years of Soviet Art* □

Village Scenes continued

Georgetown, Colorado. *Harper's*

Edam, Holland. *Century Magazine*

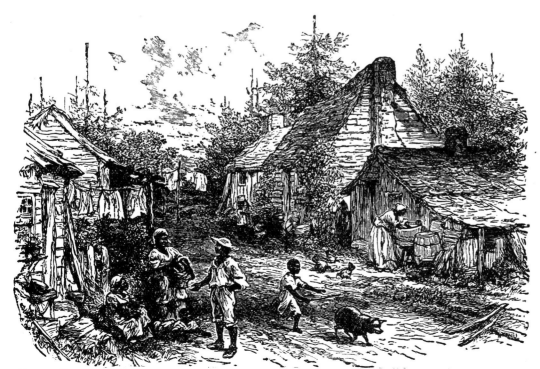

Negro village in Alabama, near the turn of the century. *Century Magazine*

Sarkis Muradian

Siasconset, Massachusetts. *Harper's*

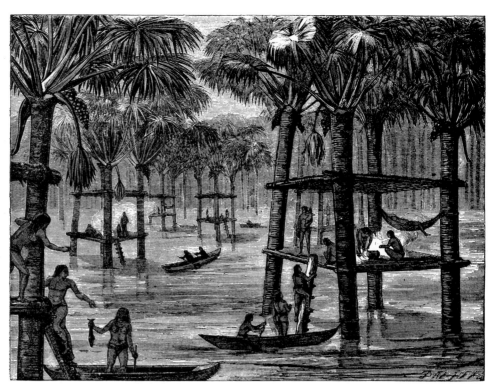

Lake dwellers of the Orinoco River, Venezuela. *Voyages and Travels*

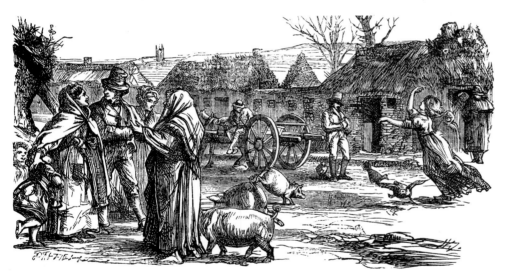

English village. *Leslie's*

Fontainebleau, France.
The World: Its Cities and Peoples

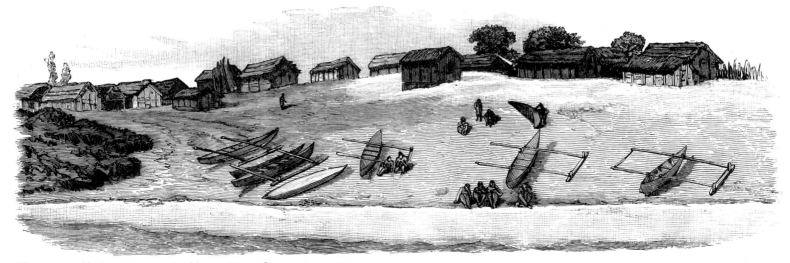

Morondava, Madagascar, on the Mozambique Channel. *Leslie's*

Violence

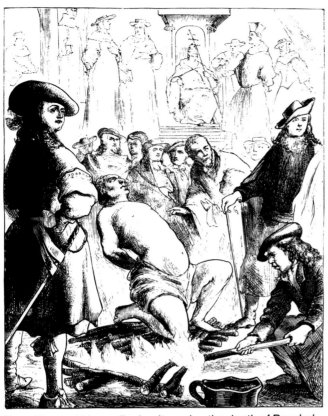

Pope Pius and his cardinals witnessing the death of Paschal, from an ancient engraving. *Harper's*

Police Gazette, 1897

Posters of Lithuania ☐

Leslie's

Leslie's, Vol. 10

Harper's

Painting by Horace de Callias, 1872. □

Police Gazette, 1890

War & Warriors

Nikolai Ivanovich Piskarev

Saxon warrior. *Historians' History*

Fifty Years of Soviet Art

Confederate soldier. *Century War Book*

Harper's

French soldier. *The World: Its Cities and People*

Infantryman's route march.
Century Magazine

Duel between a Union cavalryman and a Confederate trooper. *Century War Book*

Fighting in the streets of Essling, Austria. *Century Magazine* □

War & Warriors continued

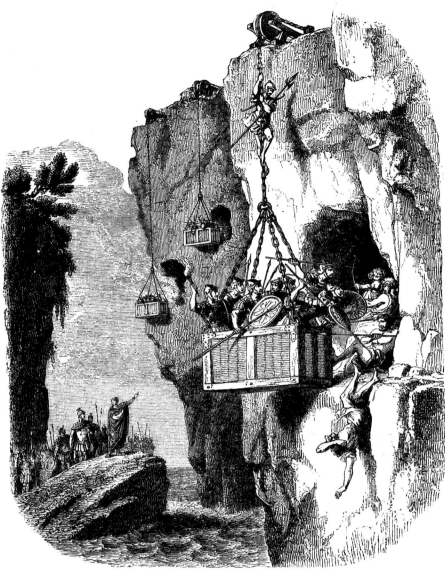

Jews in caves, being attacked by Roman soldiers. *Century Magazine*

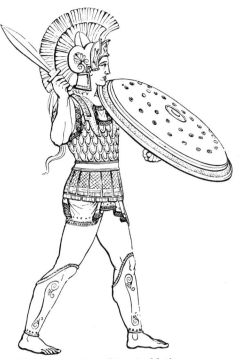

Grecian warrior. *Classic Myths*

Fifty Years of Soviet Art.

Warrior with acontium.
Century Dictionary, Vol. 1

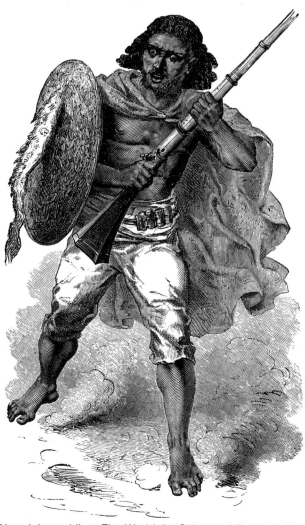

Abyssinian soldier. *The World: Its Cities and Peoples, Vol. 6*

The Art of the Book

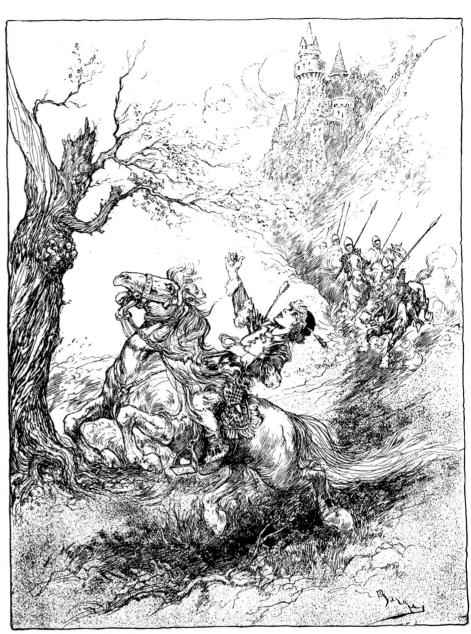

Medieval chase. *St. Nicholas*

Early Frankish warrior.
Historians' History

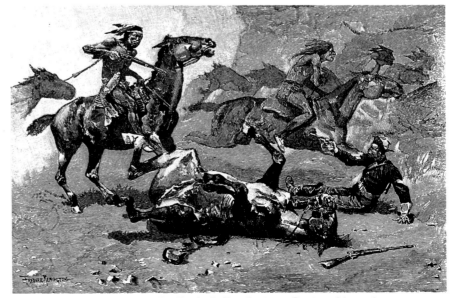

Custer's last battle: painting by Frederic Remington. *Century Magazine*

War & Warriors continued

Medieval Japanese archer. *Leslie's*

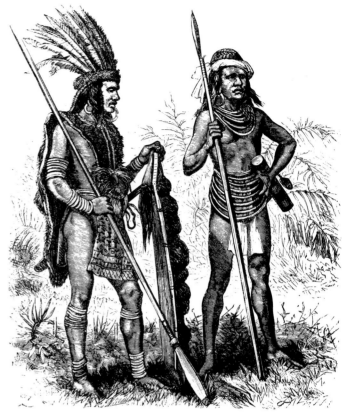

Dayak warrior and dusum. *The World: Its Cities and Peoples*

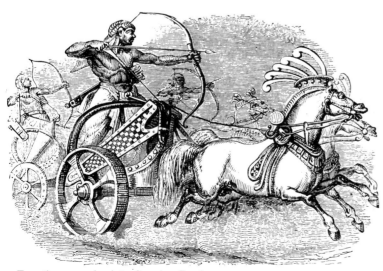

Egyptian war-chariot. *Sunday Book*

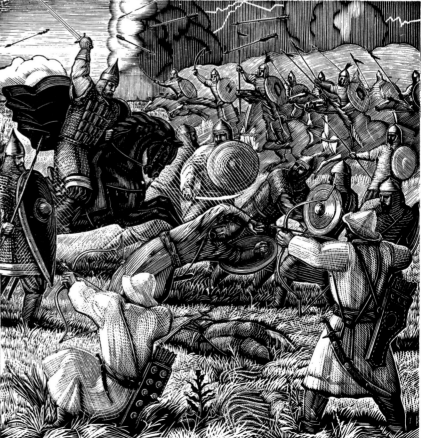

Fifty Years of Soviet Art

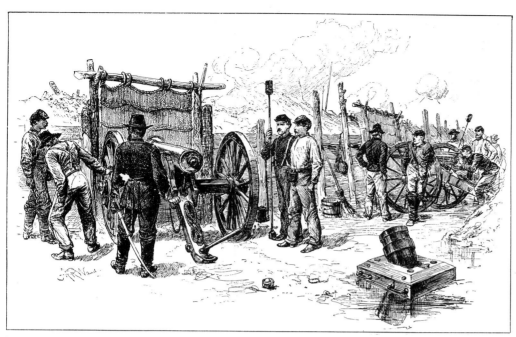

Union artillery at Petersburg protected by mantelets. *Century War Book*

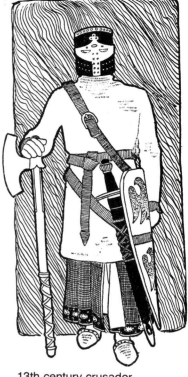

13th century crusader.
Historians' History

Medieval swordsman. *The Art of the Book*

French fusilier. *Punch*

Warriors of the Bronze Age. *The World: Its Cities and Peoples, Vol. 7*

Weather

Century Magazine

Children's Books

Graphic Arts of Lvov

Punch

Fifty Years of Soviet Art

Century Magazine

Voyages and Travels, Vol. 2

Weather continued

Fifty Years of Soviet Art

Harper's

Children's Books

Field Book of the Revolution

Punch

Fifty Years of Soviet Art

Fifty Years of Soviet Art

Anatoly L'vovich Kaplan □

Tribute Book

Fifty Years of Soviet Art

Wild Animals

Kangaroo. *Harper's*

Skunk. *Century Dictionary*

Irawadi squirrel. *Lydekker*

Fox. *Buffon*

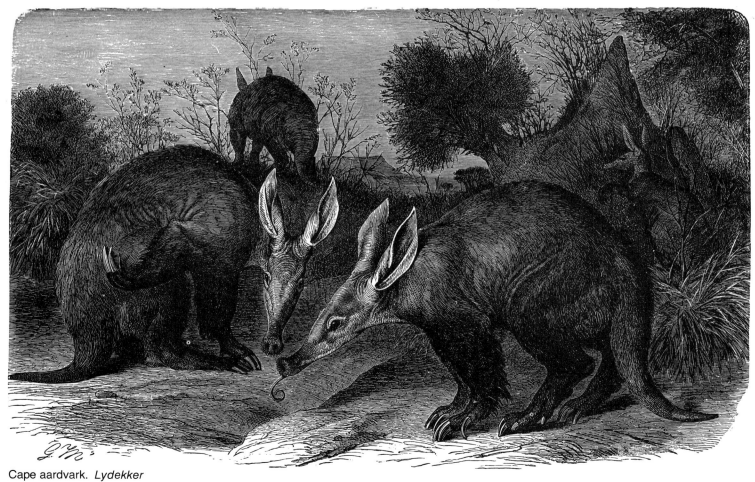

Cape aardvark. *Lydekker*

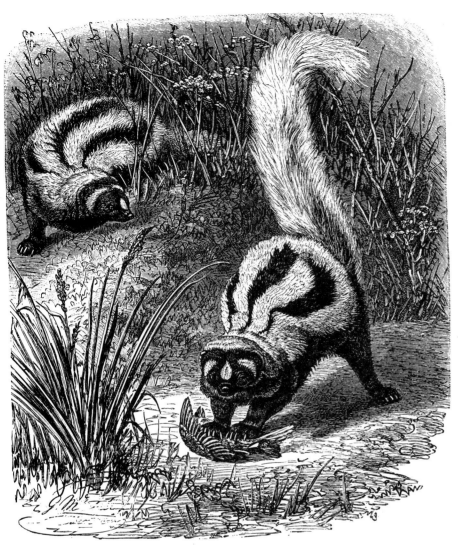

Cape polecat. *Lydekker*

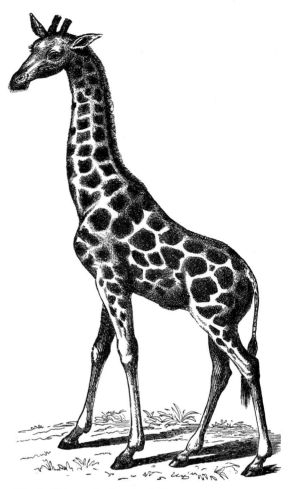

South African giraffe. *Lydekker*

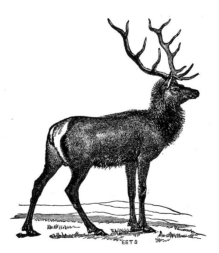

Wapiti, or American elk. *Century Dictionary*

Coyote. *Century Dictionary*

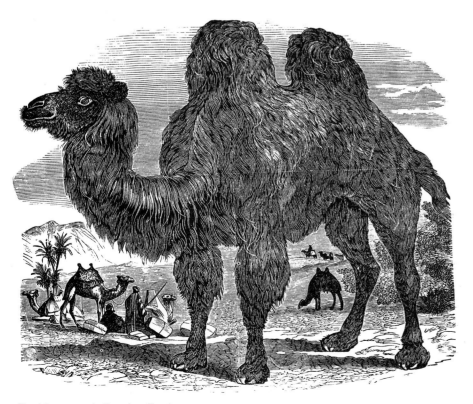

Bactrian camel. *Sunday Book*

Wild Animals continued

Peba, or Texan armadillo.
Century Dictionary

Mouse. *Bible Encyclopaedia*

Marmoset. *Zell's*

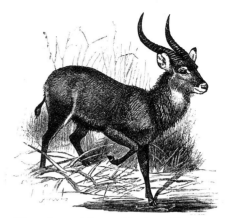

Sing-sing antelope. *Century Dictionary*

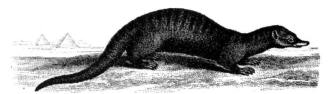

Ichneumon. *Buffon*

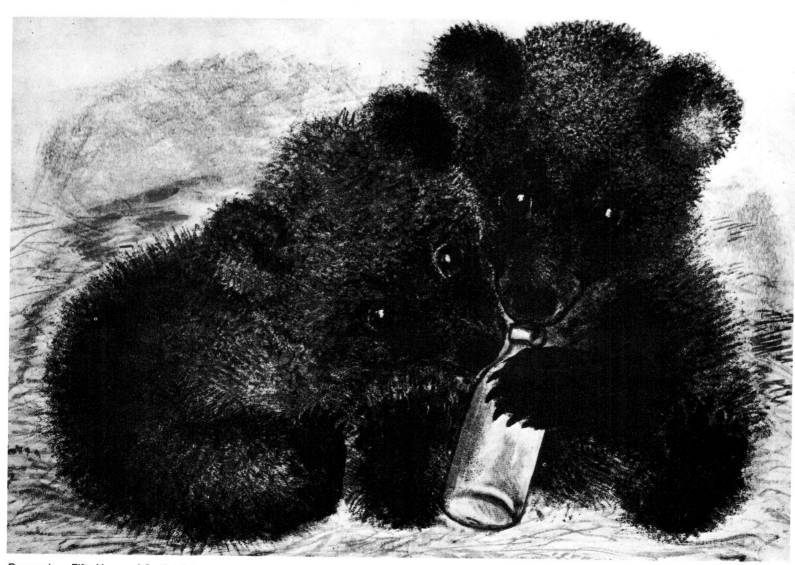

Bear cubs. *Fifty Years of Soviet Art* □

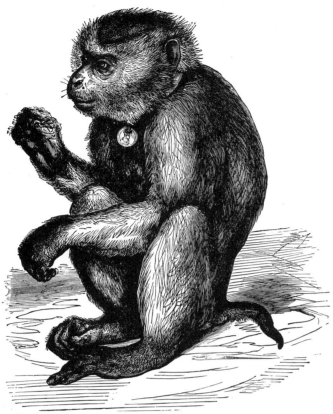

Burmese pig-tailed monkey. *Lydekker*

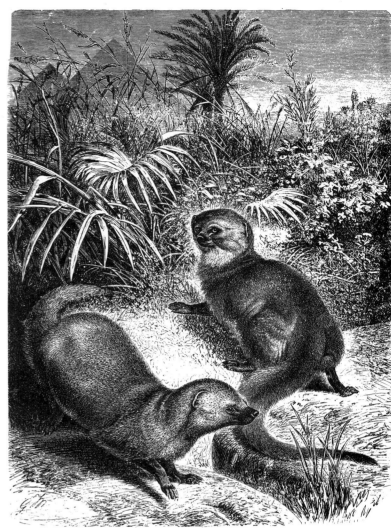

Egyptian mongooses. *Lydekker*

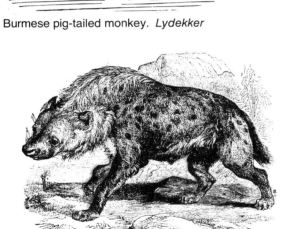

Laughing hyena. *Harper's*

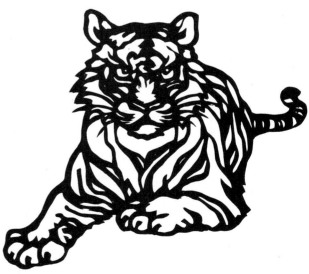

Tiger. *Chinese Cutout*

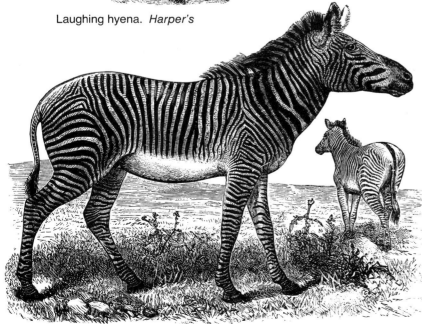

Grévy's zebra. *Lydekker*

Wild Animals continued

Canadian otter. *Century Dictionary*

Opossum.
Century Dictionary

Wolves. *The Art of the Book*

Wild ox of Java. *Wonders of the Whole World*

Malayan bear. *Lydekker*

Padamelon wallaby. *Lydekker*

Buffalo. *Century Dictionary*

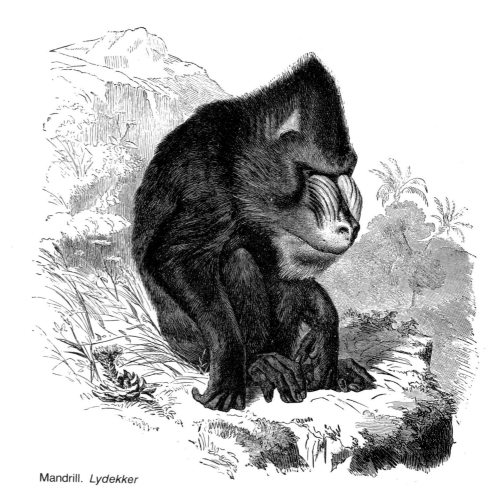

Mandrill. *Lydekker*

Water-buffaloes in the Nile. *Picturesque Palestine*

Wild Animals continued

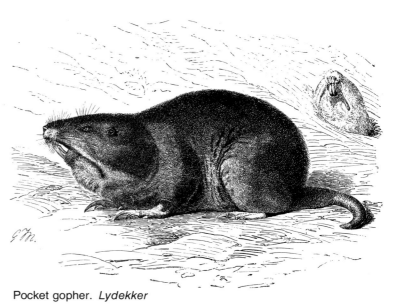

Pocket gopher. *Lydekker*

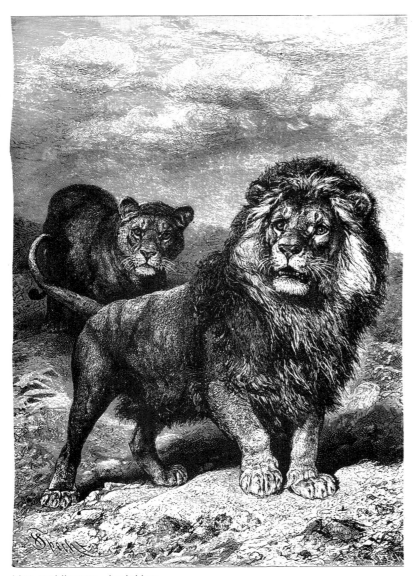

Lion and lioness. *Lydekker*

Guib. *Buffon*

Raccoon. *Century Dictionary*

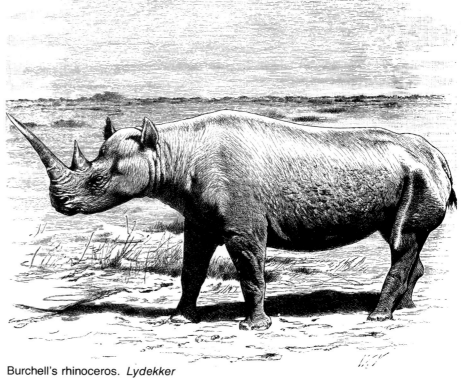

Burchell's rhinoceros. *Lydekker*

Alpaca. *Lydekker*

Clouded tiger cat. *Century Dictionary*

Aswail, or sloth bear.
Century Dictionary

Spider monkey.
Century Dictionary

Skeleton of Mastodon giganteus.
Zell's

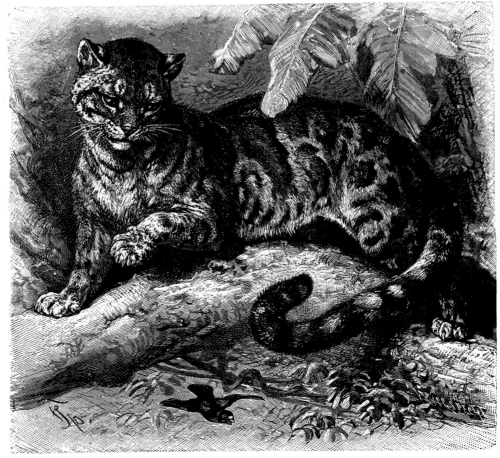

Clouded leopard. *Lydekker*

Wild Animals continued

Elephant. *Lydekker*

Aye-aye. *Century Dictionary*

Wombat. *Century Dictionary*

Prairie dog. *Zell's*

Family of red deer. *Lydekker*

Family of European wild swine. *Lydekker*

Head of the korigum or Senegal antelope. *Lydekker*

Great anteater. *Zell's*

Orangutans. *Lydekker*

Brazilian tree porcupine. *Lydekker*

Guinea pig. *Lydekker*

Xmas

Toboggans on toboggan-slide.
Century Magazine

Angels. *Harper's*

"Winter Sports: Coasting in the Country," by Granville Perkins. *Harper's Weekly, Feb. 17, 1877*

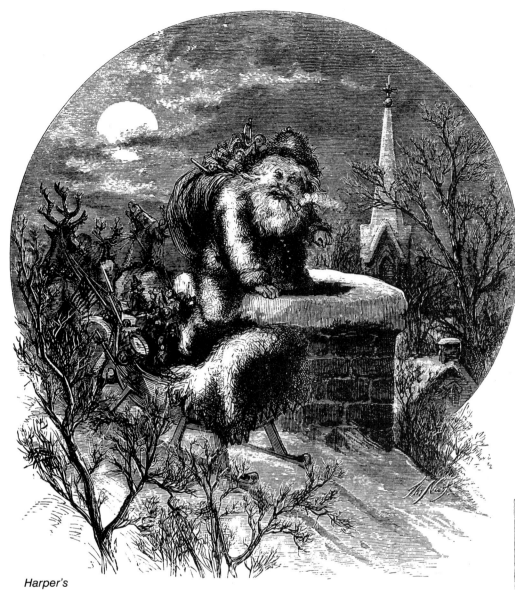

Harper's

Old-Fashioned Christmas

Christmas time in Sweden. *Harper's, Vol. 42*

Old-Fashioned Christmas

Xmas continued

Old-Fashioned Christmas

Old-Fashioned Christmas

Old-Fashioned Christmas

Old-Fashioned Christmas

Old-Fashioned Christmas

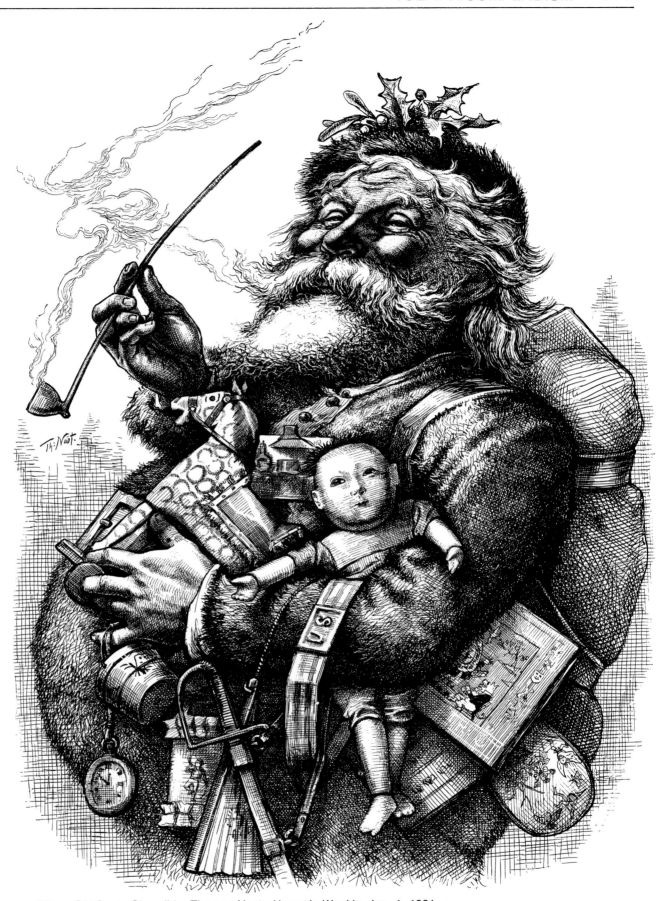

"Merry Old Santa Claus," by Thomas Nast. *Harper's Weekly, Jan. 1, 1881*

SOURCES

SOURCES

AL'BINA MAKURAITE. Korsakaite, Ingrida. Moscow: Soviet Artist (Sovetskii Khudozhnik), 1972.

ALDINE; see THE ALDINE.

ALEKSANDR POSTEL'. Kiev: Mistetstvo, 1972.

ALEKSANDR VASIN. Bubnova, Liudmila. Moscow: Soviet Artist (Sovetskii Khudozhnik), 1972.

ANATOLY L'VOVICH KAPLAN. Soviet Union, 19--.

ANTIQUE FIREARMS; full title, *Antique European and American Firearms at the Hermitage Museum.* Tarassuk, L. Leningrad: Iskusstvo Publishing House, 1972.

ANTIQUE MUSICAL INSTRUMENTS; full title, *Antique Musical Instruments and Their Players (Gabinetto Armonico).* Bonanni, Filippo. New York: Dover Publications, Inc., 1964 (from plates which first appeared in Rome in 1723).

ARABIAN NIGHTS: full title, *The Arabian Nights; Entertainments.* Townsend, Rev. Geo. Fyler, ed. London: Frederick Warne and Co., no date.

ARCHITECTURAL STYLES; full title, *A Handbook of Architectural Styles.* Collett-Sanders, W. London: Chatto & Windus, 1910.

ART OF THE BOOK, THE (fourth edition, 1961-1962). Antipina, Z.A., ed. Moscow: Book (Kniga), 1967.

ART OF THE BOOK, THE (fifth edition, 1963-1964). Antipina, Z.A., ed. Moscow: Book (Kniga), 1968.

ART OF THE BOOK, THE (sixth edition, 1965-1966). Antipina, Z.A., ed. Moscow: Book (Kniga), 1970.

ART OF THE BOOK, THE (seventh edition, 1967). Antipina, Z.A., ed. Moscow: Book (Kniga), 1971.

ART OF THE SILHOUETTE, THE. Kuznetsova, Eva Vasilievna. Leningrad: Artist of the R.S.F.S.R. (Khudozhnik R.S.F.S.R.), 1970

BASE BALL; full title, *Base Ball: The History, Statistics and Romance of the American National Game From Its Inception to the Present Time.* Church, Seymour R. San Francisco, Calif.: Seymour Church, 1902.

BASICS OF FISHING, THE. Williamson, Alan T. New York: Hart Publishing Co., Inc., 1966.

BIBLE ENCYCLOPAEDIA; full title, *The Popular and Critical Bible Encyclopaedia and Scriptural Dictionary.* Fallows, Rt. Rev. Samuel. Chicago: The Howard-Severance Company, 1901.

BUFFON; full title, *Histoire Naturel: Plates of Natural History.* Buffon, circa 1882.

BUNCH OF VIOLETS, A. Jerome, Irene E., ed.

Boston: Lee and Shepard, 1888.

CARUSO'S CARICATURES. Caruso, Enrico. New York: The Aste Press, no date.

CATALOG OF THE UNUSUAL. Hart, Harold H. New York: Hart Publishing Co., Inc., 1973.

CATCHPENNY PRINTS; full title, *Catchpenny Prints: 163 Popular Engravings from the Eighteenth Century.* New York: Dover Publications, Inc., 1970.

CENTURY DICTIONARY; full title, *The Century Dictionary and Cyclopedia* (twelve vol.). New York: The Century Company, 1889-1913.

CENTURY MAGAZINE; full title, *The Century Illustrated Monthly Magazine.* New York: The Century Company, Bound Vol. 1 (undated); Vol. 6 (undated); Vol. 8 (undated); Vol. 38 (May-Oct., 1889); Individual issues, Jan., 1883; Apr., 1884; July, 1885; Aug., 1885; May, 1888; Oct., 1889; Jan., 1890; Apr., 1890; June, 1890; July, 1890; Aug., 1890; Feb., 1891; Jan., 1892; Mar., 1892; May, 1894; Jul., 1895; Sep., 1895; Oct., 1895; Nov., 1895; Jan., 1896; Feb., 1896; Mar., 1896; Apr., 1896; May, 1896; Jun., 1896; Dec., 1901.

CENTURY WAR BOOK, THE. Johnson, Robert Underwood, and Clarence Clough Buel, eds. New York: The Century Company, 1894.

CHILDREN'S BOOKS; full title, *Pictures and Stories from Forgotten Children's Books.* Arnold, Arnold. New York: Dover Publications, Inc., 1969.

CHINESE CUTOUT. Available from China Books and Periodicals, 125 Fifth Avenue, New York, N.Y.

CLASSIC MYTHS; full title, *The Classic Myths in Literature and Art.* Gayley, Charles Mills. Boston: Ginn and Company, 1893.

COMIC ALMANACK, THE. Thackeray, Albert Smith, Gilbert A. Beckett, The Brothers Mayhew. London: Chatto and Windus, Second Series, 1844-1853.

CRANFORD. Mrs. Gaskell. New York: The Macmillan Company, 1853.

CRYSTAL PALACE; full title, *The Art Journal: Illustrated Catalogue of "The Industry of All Nations"* (Crystal Palace Exhibition) London: George Virtue, 1851.

CURIOUS WOODCUTS OF FANCIFUL AND REAL BEASTS. Gesner, Konrad. New York: Dover Publications, Inc., 1971.

DAVID SIQUIEROS. Leningrad: Soviet Artist (Sovetskii Khudozhnik), 1969.

DECORATIVE ART OF THE SOUTHWESTERN INDIANS. Sides, Dorothy Smith. New York: Dover Publications, Inc., 1961.

DESIGN MOTIFS OF ANCIENT MEXICO. Enciso, Jorge. New York: Dover Publications, Inc., 1947.

DESIGNS AND PATTERNS; full title, *Designs and Patterns from Historic Ornament.* Audsley, W. and G. New York: Dover Publications, Inc., 1968.

DEUTSCHES LACHEN. Kehm, Hermann Siegfried. Leipsig: H. Fifentscher, no date.

DICTIONARY OF ART; see DICTIONARY OF TERMS OF ART.

DICTIONARY OF TERMS OF ART. Fairholt, Frederick William. London: Virtue, Hall, & Virtue, 1854.

DOG LOVER'S READER, THE. Clarke, Timothy T., ed. New York: Hart Publishing Co., Inc., 1974.

EARLY ADVERTISING ART; full title, *A Handbook of Early Advertising Art.* Hornung, Clarence P., ed. New York: Dover Publications, Inc., 1956.

ENGLAND UNDER VICTORIA; full title, *England Under Victoria: A Complete and Authentic History of our Times.* Anonymous. London: Walter Scott, no date.

ESSAYS ON POLISH GRAPHIC ARTS; full title, *Essays on Polish Graphic Arts of the First Half of the Twentieth Century.* Tananaeva, Larisa Ivanovna. Moscow: Science (Nauka), 1972.

FAWORSKI. Leningrad: Aurora-Verlag, 1970.

FETICHES AND FETICH WORSHIPERS. Baudin, Rev. P. New York: Benziger Brothers, 1885.

FIELD-BOOK OF THE REVOLUTION; full title, *The Pictorial Field-Book of the Revolution* (two vol.). Lossing, Benson J. New York: Harper & Brothers, 1860.

FIFTY YEARS OF SOVIET ART; full title, *Album: Fifty Years of Soviet Art: Graphic Arts.* Kupetsian, A., ed. Moscow: Soviet Artist (Sovetskii Khudozhnik), no date.

FRENCH ADVERTISING ART; full title, *A Sourcebook of French Advertising Art.* London: Faber & Faber, 1964.

GENERAL HISTORY; full title, *A General History for Colleges and High Schools.* Myers, P.V.N. Boston: Ginn and Company, 1894.

GIANTS OF THE REPUBLIC. Introduction by Edward Everett Hale. *n.p.,* 1897.

GOLDEN TREASURY, THE; full title, *The Golden Treasury of the History, Topography, Literature, Science, Art, and Religion of the Various Countries of the Globe, With Biographies of their Illustrious People.* Hunter, James. Philadelphia: International Publishing Co., 1887.

GRAPHIC ARTS OF LVOV. Kiev: Mistetstvo, 1971.

GREAT INDUSTRIES; full title, *The Great Industries of the United States.* Greeley, Horace, Leon Case, Edward Howland, John B. Gough, Philip Ripley, F.B. Perkins, J.B. Lyman, Albert Brisbane, Rev. E.E. Hall. Hartford: J.B. Burr & Hyde, 1872.

SOURCES continued

GUIDE TO TREES; full title, *A Guide to the Trees.* Lounsberry, Alice. New York: Frederick A. Stokes Company, 1900.

HARPER'S; full title, *Harper's New Monthly Magazine.* New York: Harper & Brothers, Vol. 2 (Dec., 1850-May, 1851); Vol. 3 (June-Nov., 1851); Vol. 5 (June-Nov., 1852); Vol. 8 (Dec., 1853-May, 1854); Vol. 10 (Dec., 1854-May, 1855); Vol. 16 (Dec., 1857-May, 1858); Vol. 17 (June-Nov., 1858); Vol. 18 (Dec., 1858-May, 1859); Vol. 20 (Dec., 1859-May, 1860); Vol. 21 (June, 1860-Nov., 1860); Vol. 30 (Dec., 1864-May, 1865); Vol. 31 (June, 1865-Nov., 1865); Vol. 32 (Dec., 1865-May, 1866); Vol. 36 (Dec., 1867-May, 1868); Vol. 37 (June, 1868-Nov., 1868); Vol. 38 (Dec., 1868-May, 1869); Vol. 40 (Dec., 1869-May, 1870); Vol. 41 (June, 1870-Nov., 1870); Vol. 42 (Dec., 1870-May, 1871); Vol. 43 (June, 1871-Nov., 1871); Vol. 44 (Dec., 1871-May, 1872); Vol. 46 (Dec., 1872-May, 1873); Vol. 47 (June, 1873-Nov., 1873); Vol. 48 (Dec., 1873-May, 1874); Vol. 49 (June, 1874-Nov., 1874); Vol. 50 (Dec., 1874-May, 1875); Vol. 51 (June, 1875-Nov., 1875); Vol. 54 (Dec., 1876-May, 1877); Vol. 66 (Dec., 1882-May, 1883); Vol. 71 (June, 1885-Nov., 1885); Vol. 103 (June, 1901-Nov., 1901).

HARPER'S ROUNDTABLE. New York: Harper & Brothers, 1896.

HARPER'S WEEKLY MAGAZINE. New York: Harper & Brothers, Jan. 1, 1881; Feb. 17, 1877.

HISTORIANS' HISTORY; full title, *The Historians' History of the World.* Williams, Henry Smith. New York: The Outlook Company, 1904.

HISTORY OF SIGNBOARDS; full title, *The History of Signboards from the Earliest Times to the Present Day.* Larwood, Jacob, and John Camden Hotten. London: John Camden Hotten, 1866.

HISTORY OF THE UNITED STATES; full title, *Pictorial History of the United States.* Northrop, Henry Davenport. J.R. Jones, 1901.

HOMES OF AMERICA, THE. Lamb, Martha J., ed. New York: D. Appleton and Co., 1879.

HORSE AND STOCK BOOK; see STANDARD HORSE AND STOCK BOOK.

ILLUSTRATED CATALOGUE OF CARRIAGES; full title, *Illustrated Catalogue of Carriages and Special Business Advertiser.* New Haven: G. & D. Cook & Co., 1860.

ILLUSTRATED LONDON NEWS, THE. London: George C. Leighton, Vol. 45 (July-Dec., 1884); Vol. 48 (Jan.-June, 1866); Vol. 49 (July-Dec., 1866).

IN A FAIR COUNTRY. Higginson, Thomas Wentworth. Boston: Lee and Shepard Publishers, 1890.

INCREDIBLE ATHLETIC FEATS. Benagh, Jim. New York: Hart Publishing Co., Inc., 1969.

INCREDIBLE STRUCTURES. Meyers, Jim. New York: Hart Publishing Co., Inc., 1975.

IN DARKEST AFRICA; full title, *In Darkest Africa; or the Quest, Rescue, and Retreat of Emin Governor of Equatoria.* Stanley, Henry M. New York: Charles Scribner's Sons, 1891.

INDIKA; full title, *Indika: The Country and People of India and Ceylon.* Hurst, John Fletcher. New York: Harper and Brothers, 1891.

INTRODUCTION TO GOTHIC ARCHITECTURE; full title, *An Introduction to the Study of Gothic Architecture.* Parker, John Henry. London: J.H. Parker, 1849.

IS IT GENUINE?; full title, *Is It Genuine? A Guide to the Identification of Eighteenth-Century English Furniture.* Crawley, W. New York: Hart Publishing Co., Inc., 1972.

JAPANESE STENCIL DESIGNS. Tuer, Andrew W. New York: Dover Publications, Inc., 1967.

KAMERNYJ THEATRE AND ITS ARTISTS. Moscow: Vol. 20, 1934.

L'ART POUR TOUS; full title, *L'Art Pour Tous, Encyclopedie de l'Art Industriel et Decoratif.* Reiber, Émile, ed. Paris: A. Morel et C., Vol. 2, 1862; Vol. 13, 1874; Vol. 14, 1875.

LESLIE'S; full title, *Frank Leslie's Popular Monthly Magazine.* New York: Frank Leslie Publishing House, Vol. 10 (Jan.-June, 1881); Vol. 12 (July-Dec., 1881); Vol. 13 (Jan.-June, 1882); Vol 14 (July-Dec., 1882); Vol. 15 (Jan.-June, 1883); Vol. 16 (July-Dec., 1883); Vol. 17 (Jan.-June, 1884); Vol. 17 (Jan.-June, 1884); Vol. 21 (Jan.-June, 1886); Vol. 23 (Jan.-June, 1887); Vol. 24 (July-Dec., 1887); Vol. 29 (Jan.-June, 1890); Individual issue 1876 (Jan-Dec.); 1881 (Jan.); 1882 (Jan.); 1879 (June); 1879 (July).

LIFE; full title, *Life Magazine.* New York: Life Publishing Co., 1960.

LIFE OF GREEKS AND ROMANS; full title, *The Life of the Greeks and Romans Described from Antique Monuments.* Guhl, E., and W. Koner. London: Chatto and Windus, no date.

LYDEKKER; full title, *The New Natural History* (six vol.). Lydekker, Richard. New York: Merrill & Baker, no date.

MANON LESCAUT; full title, *History of Manon Lescaut and of the Chevalier des Grieux.* The Abbé Prévost. Paris: The Gebbie Publishing Co., Ltd., 1895.

MARVELS OF THE NEW WEST. Thayer, William M. Norwich, Conn.: Henry Bill Publishing Co., 1889.

MASTERPIECES OF GERMAN ART, THE (two vol.). Reed, J. Eugene. Philadelphia: Gebbie and Co., no date.

MASTERPIECES OF HORROR. Morris,

Rosamund, ed. New York: Hart Publishing Co., Inc., 1966.

MEYERS LEXIKON; full title, *Meyers konnerlations-Lexikon.* Leipsig und Wien: Bibliographisches Institut, 1895.

MIKHAIL IVANOVICH PIKOV. Kuznetsova, Iuliia Pavlovna. Moscow: Soviet Artist (Sovetskii Khudozhnik), 1971.

MUNSEY'S; full title, *Munsey's Magazine.* New York: Frank A. Munsey, 18--.

NADIR ABDURAKHMANOV. Akimova, Lidiia Il'inichna. Moscow: Soviet Artist (Sovetskii Khudozhnik), 1973.

NATURAL HISTORY, AMERICA AND ASIA; see NATURAL HISTORY OF MAN, AMERICA AND ASIA.

NATURAL HISTORY OF AFRICA; see NATURAL HISTORY OF MAN, AFRICA.

NATURAL HISTORY OF MAN, AFRICA; full title, *Illustrated Natural History of Man, Africa.* Wood, Rev. J.G. Boston: Routledge & Sons, 1868.

NATURAL HISTORY OF MAN, AMERICA AND ASIA; full title, *Illustrated Natural History of Man, America and Asia.* Wood, Rev. J.G. Boston: Routledge & Sons, 1868.

NIKOLAI IVANOVICH PISKAREV. Gorlenko, N.A. Moscow: Fine Arts (Izobrazitel'nye Iskusstva), 1972.

NOTES OF A COLLECTOR. Sidorov, Aleksei Alekseievich. Leningrad: Artist of the R.S.F.S.R. (Khudozhnik R.S.F.S.R.), 1969.

OLD-FASHIONED CHRISTMAS; full title, *An Old-Fashioned Christmas in Illustration and Decoration.* Hornung, Clarence P., ed. New York: Dover Publications, Inc., 1970.

ON A MEXICAN MUSTANG; full title, *On a Mexican Mustang Through Texas.* Knox, J. Armoy, and Alex. E. Sweet. London: Chatto and Windus, 1905.

OUR VILLAGE. Mitford, Mary Russell. New York: Macmillan and Co., 1893.

PARIS IN OLD AND PRESENT TIMES. Hamerton, Philip Gilbert. Boston: Little, Brown, & Co., 1900.

PATTERN DESIGN. Christie, Archibald H. New York: Dover Publications, Inc., 1969.

PEN AND INK DRAWING. Bartlett, George Hartnell. Cambridge: Riverside Press, 1903.

PEOPLES OF THE WORLD; see THE WORLD: ITS CITIES AND PEOPLES.

PET BOOK. Barton, A. New York: Hart Publishing Co., Inc., 1958.

PICTORIAL SUNDAY BOOK, see SUNDAY BOOK.

PICTURESQUE PALESTINE (two vol.). Wilson, Colonel, ed. New York: D. Appleton and Co., 1881.

PLAYS, PLAYERS, AND PLAYWRIGHTS; full title, *Plays, Players, and Playwrights: An*

Illustrated History of the Theatre. Geisinger, Marion. New York: Hart Publishing Co., Inc., 1975.

POLAR AND TROPICAL WORLDS, THE. Hartwig, Dr. Georg Ludwig. Springfield, Mass.: C.A. Nichols & Co., 1875.

POLICE GAZETTE; full title, *The National Police Gazette.* Fox, Richard K., Ed. New York: Franklin Square Publishing, Printing and Engraving House, 1878-1897.

POSTERS OF LITHUANIA. Antanas, Gedminas, and Galkus Iuozas, eds. Lithuanian SSR: Mintis, 1971.

PUNCH; full title, *Punch, or The London Charivari.* London: The Proprietors, Vol. 12 (1847); Vol. 24 (1853); Vol. 25 (1854); Vol. 26 (1854); Vol. 29 (1855); Vol. 30 (1856); Vol. 31 (1856-1857); Vol. 32 (1857); Vol. 48 (1865); Vol. 58 (1870); Vol. 59 (1871); Vol. 62 (1872); Vol. 70 (1876); Vol. 71 (1877); Vol. 72 (1878); Vol. 73 (1879).

QUAINT CUTS; full title, *Quaint Cuts in the Chap Book Style.* Crawhall, Joseph. New York: Dover Publications, Inc., 1974

RIVERSIDE NATURAL HISTORY, THE. Kingsley, John Sterling, ed. Boston and New York: Houghton, Mifflin and Co., 1888.

RUSSIAN FOLK PICTURES. Baldina, Ol'ga. Moscow: Young Guard (Molodaia Gvardiia), 1972.

ST. NICHOLAS; full title, *St. Nicholas, An Illustrated Magazine for Young Folks.* New York: The Century Company, Vol. 9, part II, no date; Vol. 16 (1888-1889); Vol. 46, part I, no date.

SAMANTHA AT THE WORLD'S FAIR. Josiah Allen's Wife (Holley, Marietta). New York: Funk & Wagnells Co., 1893.

SARKIS MURADIAN. Urazova, Liudmila. Moscow: Soviet Artist (Sovetskii Khudozhnik), 1970.

SCRIBNER'S; full title, *Scribner's Monthly, An Illustrated Magazine for the People.* Holland, J.G., ed. New York: Scribner & Co., Vol. 3 (Nov., 1871-April, 1872); Vol. 5 (Nov., 1872-April, 1873).

SEARS CATALOGUE, 1902; full title, *The Sears, Roebuck Catalogue.* Chicago: The Sears, Roebuck Co., 1902.

SERGEI MIKHAILOVICH MOCHALOV. Soviet Union, 19--.

SHORT HISTORY OF ART, A. De Forest, Julia B. New York: Phillips & Hunt, 1881.

SOUTHWESTERN INDIAN ART; see DECORATIVE ART OF THE SOUTHWESTERN INDIANS.

STANDARD HORSE AND STOCK BOOK. Wagner, D. The Saalfield Publishing Co., 1883.

STANDARD OF PERFECTION; full title, *The American Standard of Perfection.* New York: The American Poultry Association, 1906.

STUDIO, THE; see THE STUDIO.

SUNDAY BOOK; full title, *The Pictorial Sunday Book.* Kitto, Dr. John, ed. London: The London Printing and Publishing Co., Ltd., no date.

SYMBOLS, SIGNS & SIGNETS. Lehner, Ernst. New York: Dover Publications, Inc., 1969.

THE ALDINE; full title, *The Aldine, A Typographical Art Journal.* New York: James Sutton & Co., Vol. 5, 1873.

THE EARLY WORK; full title, *The Early Work of Aubrey Beardsley.* Beardsley, Aubrey. New York: Dover Publications, Inc., 1967.

THE STUDIO. London: 1893-1901.

THE WORLD: ITS CITIES AND PEOPLES (nine vol.). Hodder, Edwin, M.F. Sweetser, Dr. Robert Brown. London: Cassell & Co., Ltd., no date.

THROUGH ASIA (two vol.). Hedin, Sven. New York: Harper & Brothers, 1899.

THOMAS HOOD; full title, *The Choice Works of Thomas Hood.* Hood, Thomas. Boston: De Wolfe, Fiske, & Co., 188-.

TRIBUTE BOOK, THE. Goodrich, Frank. New York: Derby & Miller, 1865.

VOYAGES AND TRAVELS (two vol.). Colange, Leo, ed. Boston: E.W. Walker & Co., no date.

WE ARE POSTER ARTISTS. Vatolina, Nina Nikolaevna. Moscow: Soviet Artist (Sovetskii Khudozhnik), 1969.

WONDERS OF THE WHOLE WORLD; full title, *Marvelous Wonders of the Whole World.* Northrop, Henry Davenport, ed. Philadelphia: National Publishing Company, 1886.

WORLD: ITS CITIES AND PEOPLES; see THE WORLD: ITS CITIES AND PEOPLES.

ZELL'S; full title, *Zell's Encyclopedia and Atlas* (four vol.). Colange, Leo, ed. Philadelphia: T. Ellwood Zell, Davis & Co., 1880.

ZELL'S DICTIONARY; see ZELL'S.

ZELL'S ENCYCLOPEDIA; see ZELL'S.

ZIGZAG JOURNEYS; full title, *Zigzag Journeys in Europe: Vacation Rambles in Historic Lands.* Butterworth, Hezekiah. Cambridge: Estes & Lauriat, 1879.

INDEX

INDEX

INDEX continued

INDEX continued

INDEX continued

INDEX continued

INDEX continued

INDEX continued